S0-BSV-808

751.422 Web

Webb, Frank, 1927 MPS

Webb on watercolor

3/97

WEBB

ON

ATER

OLOR

N K W E B B

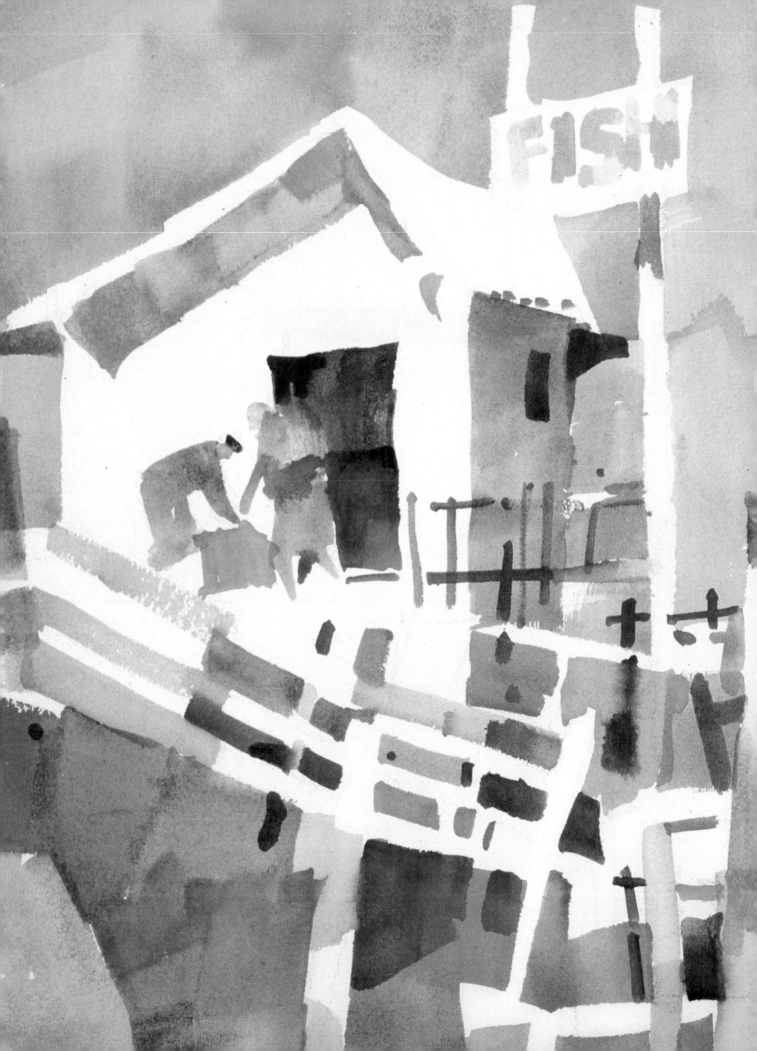

WEBB
—ON—
WATER COLOR

FRANK WEBB

Moline Public Library
MOLINE, ILLINOIS

0341850057

NORTH LIGHT BOOKS

Cincinnati, Ohio

Dedicated to the memory of my parents, Margaret Berkoben Webb and Francis Hubert Webb, Sr.

Acknowledgments

Thanks go to Barbara Webb, my wife, who has always encouraged me to paint despite a thousand obstacles. Also to Wendy Webb Kumer, my daughter, who took time from her musical art to edit my manuscript. Several others also deserve thanks, such as Greg Albert of North Light who gave wise counsel, and Barbara McGovern who expertly typed the manuscript. There were my early teachers: Carolyn Feit, Harry Hickman, John Jellico, Angelo Di Vincenzo, Vincent Nesbert, Edgar A. Whitney, and Ray Simboli. Indirect encouragement came from the thousands of collectors who own Webb paintings and the legion of students who have honored me with their attention and feedback.

Webb on Watercolor. Copyright © 1990 by Frank Webb. Printed and bound in Hong Kong. All rights reserved. No part of this book may be reproduced in any form or by any electronic or mechanical means including information storage and retrieval systems without permission in writing from the publisher, except by a reviewer, who may quote brief passages in a review. Published by North Light Books, an imprint of F&W Publications, Inc., 1507 Dana Avenue, Cincinnati, Ohio 45207. 1-800-289-0963. First edition. First paperback printing 1994.

97 96 95 94 93 5 4 3 2 1

Library of Congress Cataloging in Publication Data

Webb, Frank
 Webb on watercolor/Frank Webb.
 p. cm.
 ISBN 0-89134-478-0, paperback
 1. Watercolor painting—Technique. I. Title.
ND2420.W385 1990 90-32653
751.42'2—dc20 CIP

A complete catalog of North Light Books is available FREE by writing to the address shown below, or by calling toll-free 1-800-289-0963. To order additional copies of this book, send in retail price of the book plus $3.00 postage and handling for one book, and $1.00 for each additional book. Ohio residents add 5½% sales tax. Allow 30 days for delivery.
 North Light Books
 1507 Dana Avenue
 Cincinnati, Ohio 45207
Stock is limited on some titles; prices subject to change without notice.

Write to the above address for information on North Light Book Club, Graphic Artist's Book Club, The Artist Magazine, Decorative Artist's Workbook, HOW magazine, and North Light Art School.

PREFACE

After several printings of my previous book, *Watercolor Energies,* the publisher and I considered a major revision. I rushed into my wish list with such relish that we decided to produce a totally new book. The earlier book had generated a friendly audience, evidenced by the numerous letters and hundreds of conversations with readers who attended my workshops throughout the country.

Because of their gracious enthusiasm and encouragement and as a consequence of my increased understanding, I began anew. Once again, I want this book to impart not only technical and conceptional information, but a tone which is both devotional and philosophical.

I assume that many of you who read this are friends of *Watercolor Energies.* I treasure your empathy while greeting new readers with a warm handshake.

— Frank Webb

CONTENTS

These are the nouns of painting. You must think and see these elements for they build the physical body of your painting. The seven nouns give you a handle to the special language of painting.

Since painting is manual labor, certain practices of field and studio will affect a painting for better or for worse. Painting is in the hand and the whole body and not only in the mind. Since craftsmanship cannot be duplicated, you become unique.

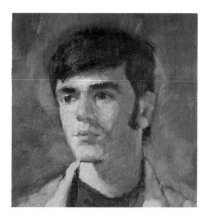

The basic visual contrast is made of tonal values. You need to see them and recreate them to do your will. Creative values will promote your style. While color might be the flesh of your picture, values are the bones. A picture is primarily made of shapes of values.

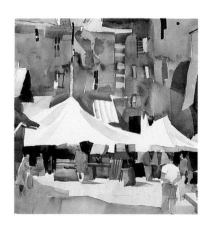

All life strives for color. It is the most personal of all art elements. The physicist says it comes via light and is made for each of us in the cones of our eyes. You must become acquainted with color as though it originates on the palette. We will study its interactions within the special and unique glories of watercolor.

Style separates you from the herd. It is largely the result of concepts, philosophy, handling of space, the degree of abstractionism vs. realism, and your technique.

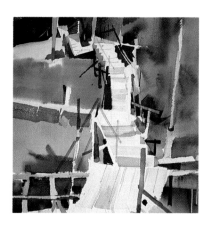

Although we live and breathe in actual space a painting creates a virtual space. You can learn to see flat and deep at the same time. The flat and the deep must be combined to express profound truths of nature in the virtual space of a picture. This is the most elusive and scholarly study of modern art. To ignore it is to forever paint naively.

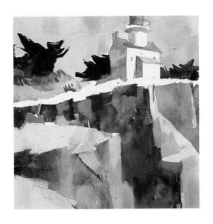

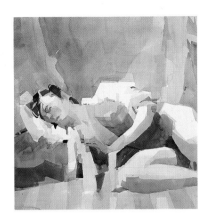

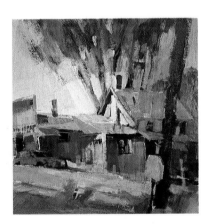

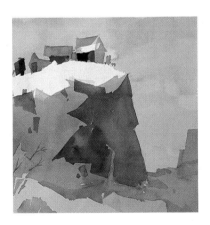

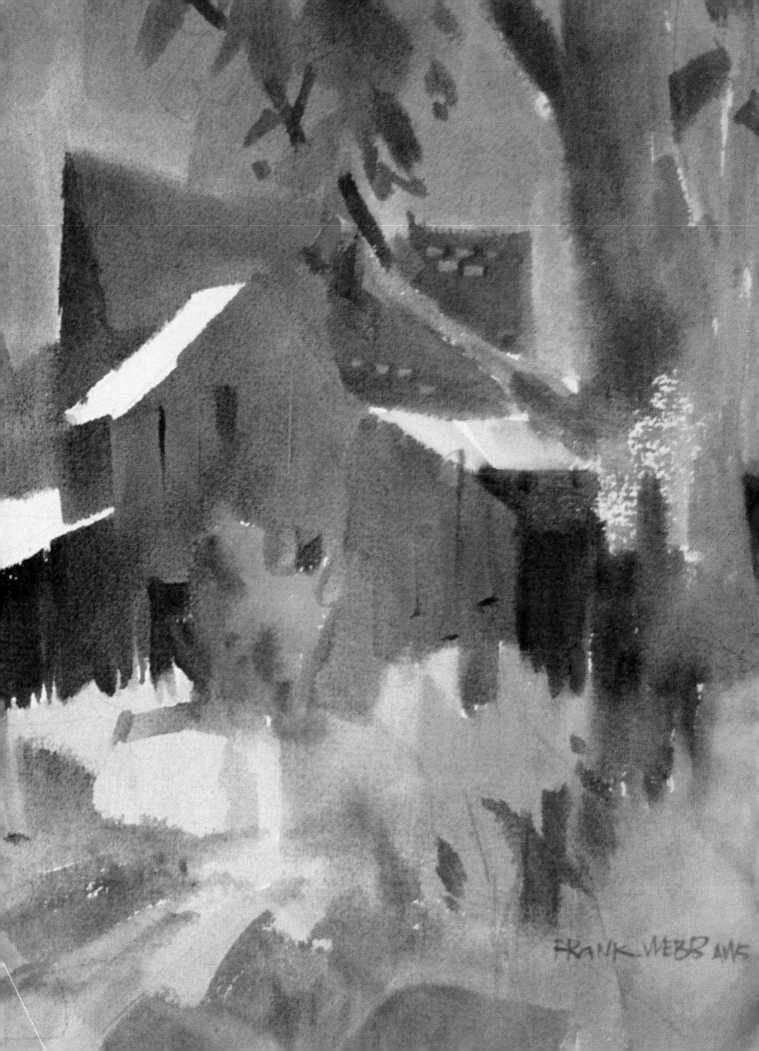

FRANK WEBB AWS

INTRODUCTION

Vague impulses lead us to paint. These stirrings include desires, beliefs, thoughts, and feelings. Each of us wants to paint more creatively, to grow independently from others, to discern our own subject matter, to find our own style, to discover our own color, and to develop a sense of criticism toward our work.

This book is aimed at self improvement—yours and mine. Some argue that art cannot be taught. You decide. Can you be helped to see? To foster good habits of craft? To fan the flames of your enthusiasm? Would an instructor be able to guide you toward long-term quality in lieu of settling for some quick fix? Could your critical powers be awakened so you know the better from the worse? Quite likely these things can be taught. Furthermore, the art bug is an infection—we pick it up from others. It is best learned through a master/apprentice system.

Since painting is more caught than taught, I want to start from convictions, for a work of art organizes itself against an artist's convictions. Each work embodies and affirms the artist's values. The work says, "This is what life is like, or should be like."

Beliefs are, then, deep seated dispositional habits of mind and body and they constitute the fundamental framework within which we apprehend, interpret, and respond to the world.

—Leonard Meyer

My Convictions

Motivation precedes action
Each painting ought to proceed from the world that is to the world as it should be. In other words, paint possibilities. It's more than your eye — it's the idea you must have behind the eye.

It is of the utmost importance that you have a genuine feeling for or interest in your subject. Thus armed, every action will be unified by that major idea.

Art is deliberately designed
A found object such as a piece of driftwood might provoke an aesthetic response but it is not art. Nor is art a mere copy of a beautiful object. Art is a deliberate recreation of a new and special reality that grows from your response to life. It cannot be copied; it must be created.

Art interprets experience
Human feeling is often incommunicable until one learns to communicate through a medium of words, images, or sounds. A painting is an articulation of not only how things look, but how they feel, how they operate, and most importantly, how they go together. It renders experience alive.

Painting is a creative action
A painting has no right to take up space in the studio or on the wall unless it dares to express its creator's response to life.

The artist must respond to fresh impressions
One must have the ability to marvel. It's not that you necessarily see new objects (the world is made of cubes, cylinders, spheres, cones, and pyramids), but by way of your imagination you will see new connections and relations, new possibilities.

The job is to communicate life
The world does not really need another picture. It needs your vision of how things could be if they were in order. Perhaps nothing else in this life is so ordered, so splendid, and so complete as a work of art. Through your painting, human life is intensified and handed on to others.

The fun is in the activity itself
Every child knows that it is fun to draw and paint. Perhaps public education thwarts this instinct with its attention to verbal rather than visual education. The rewards of art are usually quite personal, since you operate at the peak of perception, appreciation and judgment. This inward achievement is satisfying even if outward success is withheld.

The quest for beauty requires craftsmanship
Painting is thinking and feeling, but painting is also by the hand and in the hand. It is a *making* more than a mere doing. There cannot be a child prodigy in painting because it takes years to develop the necessary mastery of mechanical skill. It is because painting is so tied to manual work that painters have been excluded from the liberal arts for hundreds of years.

Failure is a stimulus
The way of painting is the way of trial and error. There is no shortcut. Each of us starts from zero and cannot resume where another left off. Each false start, each utter failure, is part of the fabric of an art career. If you do not have the grit to confront your own ignorance and if you are not willing to ruin acres of paper, you are in the wrong field.

The artist lives by wits
Few pursuits are so dependent on the self. Painting is a fight for a personal life. Today our culture is dominated by mechanical and electronic triumphs that foster mass production, mass media, and mass values. This culture can brutalize one's sense of a personal life. The painter is a silent rebel among all these depersonalizing forces.

Don't wait to be noticed
Being discovered by an influential patron would be ideal, but it's best not to depend on this. Become a discoverer yourself instead of passively hoping someone out there will notice you. While the show business artist needs a big break, the visual artist needs to concentrate on faithful practice of one work after another. Good work will eventually be noticed.

A work of art is a symbol
You do not paint things but the forms of things. You cannot create skies, grass, and birds, but you can create symbols that evoke those things. Your painted symbol should not try so much to be a bird but rather it should try to say "bird." Painting is a visual language with its own syntax and you must become fluent in that language.

Each artist is self-taught
Art is primarily self-education. It proceeds by way of trial and error. You do not become a painter by graduating from a system of lessons, but by *drawing and painting*. If the class, book, or video spurs you to draw and paint, well and good.

The aim of art

A finished work of art beckons us to no course of action. Rather, it teaches us how to be. It does this by a communication of one mind to another within the limited, mimic world embodied in a work of art. This created environment is in some ways more real than the natural world since it brings nature down to human scale and is readily understandable and knowable.

You might not agree with all of these convictions, but I hope you will agree that convictions are a necessity in order for an artist to communicate to an audience. The only alternative would be to work by caprice. Theodore Levitt said, "If you don't know where you are going, any road will take you there."

If we formulate our aims we start traveling in the right direction. Most of us who paint have learned a great deal about nature, the medium, and ourselves. What is needed is not new data but a way to organize the data already in our memories. We want to be able to find a subject that works, to find a style that is really unique, and to diagnose our problems. This book is about getting it all together.

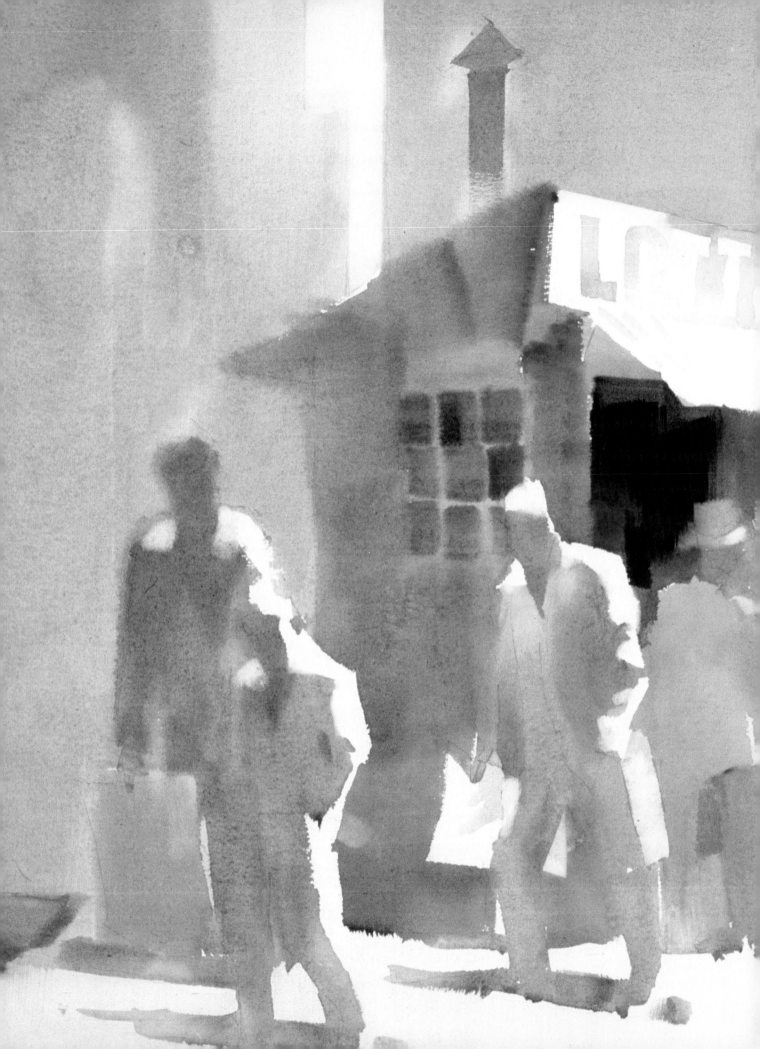

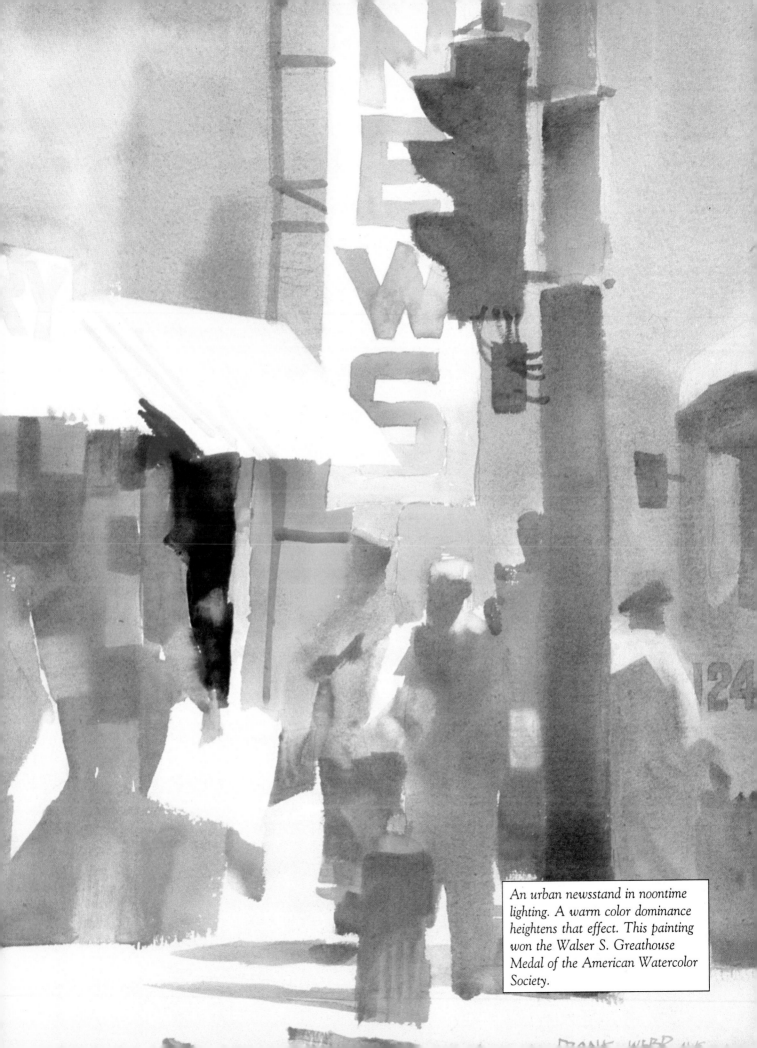

An urban newsstand in noontime lighting. A warm color dominance heightens that effect. This painting won the Walser S. Greathouse Medal of the American Watercolor Society.

This locomotive was painted in a Houston park. The color of the subject was black, but I have used color, which I think is more interesting.

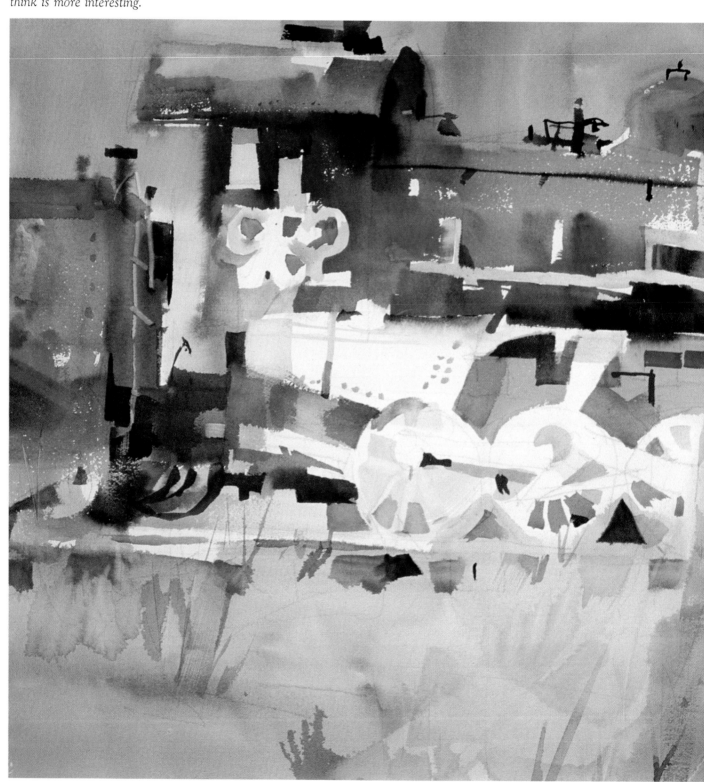

CHAPTER 1
ELEMENTS

Painting is a study of appearances. It is bound up with seeing in a special way. To practice special seeing, begin by viewing everything as flat shapes of color joined together. Temporarily tune out the objects in front of your eyes and see only patches of color. Imagine a glass picture plane between you and your subject. On that flat glass are the projected spots of color. Ignore roundness or shading for now. See light and shade also as flat, interlocking pieces of color. Once this ability is acquired, don't settle for it as a final solution. It is only a beginning.

Charles S. Peirce said, "[One] can stare stupidly at phenomena; but in the absence of imagination they will not connect themselves together in a rational way." I am not belittling painting from observations. Monet did—even Cézanne painted exclusively from observations—but one could not accuse Cézanne of merely copying a subject as a camera might. There is a tyranny of the model and many a picture is so model-bound that it falls short of being a unique work of art.

The first step in becoming more creative is learning to see passionately what is needed for the picture. This chapter and the chapters on values and color treat the importance of this specialized seeing needed by the painter. Let us briefly consider what we should see as we ponder the relationships of our subject to our paper.

In ordinary seeing, we attend to objects, whereas when we paint we must translate objects into visual symbols using art elements. These art elements are more limited than nature's elements.

So our marks on paper are only symbols of outward reality. For instance, we have no light, only a few relative values. There is no space in our flat paper—only symbols of perspective, such as overlapping shapes and diminishing sizes. There are no objects, only shapes of value and color. These great restrictions were expressed by John F. A. Taylor who said, "He labors after light with the tools of darkness."

To get us into the world of painting, we will consider the seven elements of art. These elements must become the objects of our special seeing.

1. Shape

Amateurs draw *things*. Professionals draw *shapes*. Robert Louis Stevenson said, "The world is made of such wonderful things"—true, but a painting is not made of *things*. A wonderful painting is made of wonderful *shapes*.

Close one eye and squint with the other. You are now looking at a flat world that has an affinity for your flat paper. When painting, even the most rotund and bulky objects must be recreated in simple, flat shapes. The shape of any three-dimensional object varies with our point of view and the object's illumination. The primary means of presenting shape is through value contrasts, and the secondary means include contours, colors, and textures.

Can you make a shape that no one has ever seen before? Are any of your shapes worth cutting out and pinning to the wall? Let us consider how to develop shapes that are better than those merely copied from the subject.

Making better shapes

A. Avoid squares and rounds since they are self-contained—making them difficult to integrate with their neighboring shapes.

B. Stretch shapes so they are longer in one dimension than the other. This gives character and direction to a shape.

C. Slant shapes in relation to the picture's borders. This not only initiates movement but makes more exciting background shapes (negative shapes).

D. Interlock positive shapes with other shapes or background shapes. This is accomplished by taking bites out of shapes and by sticking out pro-jections along the edges of shapes as in a jigsaw puzzle.

E. Use the most telling silhouette to characterize a particular object.

F. Create passage (linkage) from one shape to another. Usually, passages are created by deliberately overlapping a couple of objects, which ordinarily might not be overlapped from the viewer's position.

The quality of a shape's edge, or contour, can be varied to create interest.

Most artists begin shapes with outlines while others scribble from the inside out. The former is apt to get a better pattern, and the work will tend toward the inorganic, or geometric. The latter method, working from the inside out, works in the way of nature. Organic things grow from the inside outward, in convexities.

A

B

C

D

E

F

The earth itself presses outward. Such works often exude a natural look, and a sense of robust bulk. The danger of working in this mode is an uncontrolled concentration on positive shapes at the expense of negative shapes and space.

If you favor one of these modes, why not try the other to get variety in your work?

2. Size

The sizes of positive and negative shapes should be deliberately and creatively varied. Make four to seven large shapes first, with one being the largest. A good design will have a variety of sizes. This quality of scale suggests completeness.

Unless a picture is completely abstract, sizes of shapes will depend somewhat on association. Realistic linear perspective rigidly dictates sizes of known objects depending on their position in space. The creative artist finds ways to avoid the tyranny of perspective. In terms of design, size or proportion is primarily a surface division on the paper. Often, the budding artist must overcome the temptation to copy proportions exactly as seen. This is especially true in landscapes where acres of land and great volumes of empty space thwart a design. When drawing a figure, if the artist is too close to a model, parts of the body closest to the artist will take on a distorted appearance. Furthermore, when close up the artist must look up or down, thus dealing with two separate picture planes.

Wharf No. One, 22″ × 30″. Notice the different sizes — not only of buildings but of value shapes. The pieces of white are differently sized, with one piece of white larger than others. The pieces of dark alternate in size. Darks under the pier add up to one large piece across the paper (as flagstones in a walkway). A variety of sizes gives a design a feeling of completeness. Some of the sizes should be large, others middle sized and some small. This principle of scale is valid on a postage stamp design and on an outdoor advertising billboard.

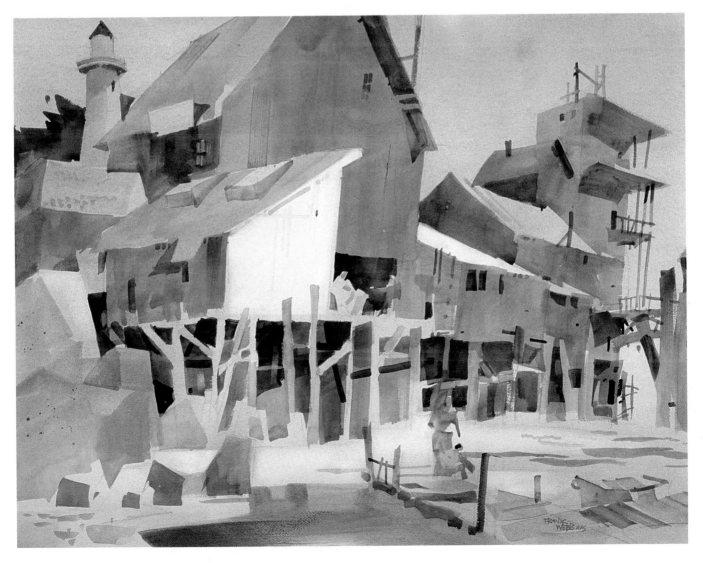

Line's most essential design characteristic is shown in this drawing as contrast between straight and curved. A preliminary investigation such as this helps you to build interest into your picture.

3. Line

Line exists in the sense of a shape's boundary and in a calligraphic sense. The calligraphic sense of line is line as a path. As an art element, line is considered a contour or the edge of a shape of value or color, not merely the outline of an object. In this sense line has only two characteristics— curved and straight. The contrast between these opposites should be used creatively. A curve is more exciting when it is placed near a straight line and vice versa.

A line might be parallel to the picture plane or it might appear to turn toward the observer or to back away. A spiraling line has the most variety, as in an arabesque. Broken line as found in the works of Cézanne and Van Gogh initiates openings for circulation with a background.

Most of us begin a drawing or a painting with a line. It is the most direct means to divide a surface.

This line study is made of segments. The openness of the system fosters circulation. The most obviously important plane changes should be indicated. To see the finished paintings of this Mexican market, see pages 68-69.

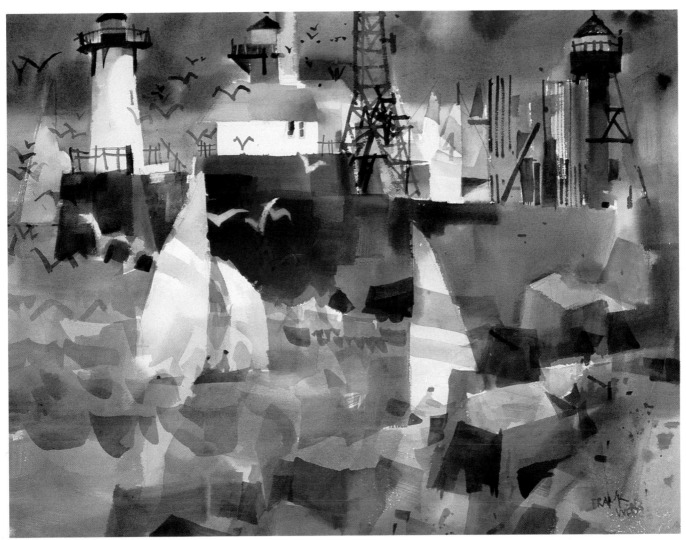

Two Lights at Duluth, 22" × 30". A combination of straights and curves makes this subject more interesting. The straights dominate.

Curves are not limited to explicit curves. Sometimes a curve is implied.

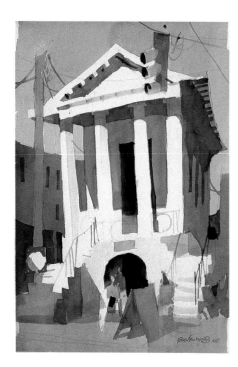

Market, Charleston, 22" × 15". Verticality rules the day here. Verticals are especially necessary when the vertical format is employed.

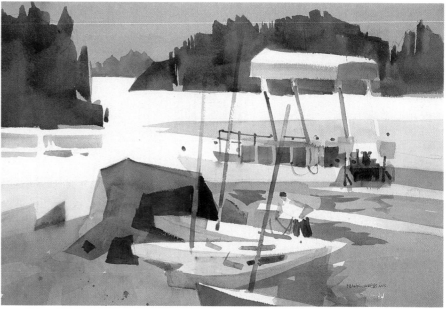

Pocono Pines Boat Club, 15" × 22". This painting contains all three directions, but the horizontal dominates and unifies this work.

4. Direction

Any good shape or line has a direction. In relation to the picture borders there are only three directions: vertical, horizontal, and oblique. A horizontal suggests repose and stability. The vertical expresses dignity and growth. The oblique direction is the great energizer. It initiates movement in the two-dimensional realm as well as in three-dimensional depth. Emphasize one of these three directions in each painting. Subject matter often suggests direction. A beach is horizontal, a waterfall might be vertical, while a horse and rider will require obliques. The proportion of the picture itself contributes to expressiveness. We call this the *format* (discussed more fully in Chapter 7).

Become the director in each of your paintings. Do not expect the subject to dictate direction. The subject might suggest, but you must see the dominant direction as a means of expressing your idea.

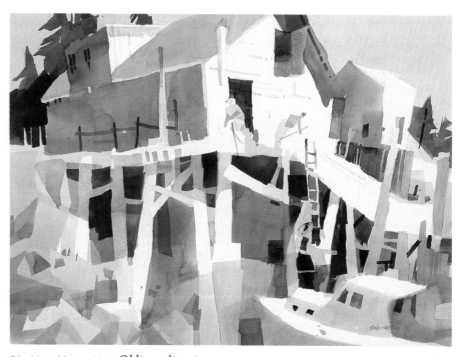

Dip Net, 22" × 30". Oblique directions are in charge—they add vitality and movement.

5. Texture

The obvious response to texture is the sense of touch. Rough, smooth, slimy, dry, wet, and other qualities are experienced at a young age by way of touch. Later, they are comprehended visually—as though we touch through the eye. Since texture is visual to us, it exists as an art element. Even your paper or canvas has the textures of smooth or rough and wet or dry.

Besides visual versus tactile, there is another duality—the texture of *content*, where the artist copies nature's texture, versus the texture of *form*, where the artist uses texture for design purposes. In a Matisse, we see the texture of form, while in a Norman Rockwell we see the texture of content.

The media contribute to the texture of form. In oil, an impasto declares its direction and interaction. In a drawing, the paper will often show a certain grain. In watercolor, paper, paint, and brush all contribute to texture. A very characteristic watercolor texture is a sedimentary wash.

Granulation is sometimes called sedimentary wash or a settled wash. Certain paints are made of heavy pigment particles that tend to unite into tiny clusters while suspended in a fluid wash. They dry into an obvious texture peculiar to watercolor. The most well known of these paints are: manganese blue, cerulean blue, some brands of ultramarine blue, viridian green, and cobalt violet. This close-up shows the presence of cobalt violet in a wash.

Contrasts of texture will enliven areas of a painting, especially where the addition of a new shape, value, or color is impractical. Beware of trying to substitute texture in instances where there is a deficiency in value allocation.

6. Value

William Morris Hunt said, "It's impossible to make a picture without values. Values are the basis. If they are not, tell me what is the basis."

Since the artist not only must see values, but must think and feel them, and because the values he sees are not necessarily the best ones for a good painting, values deserve a special study (see Chapter 3).

7. Color

Color is the most personal of the art elements. While a drawing or a value painting might appeal to our intelligence, color (like music) appeals directly to our emotions. Since color is the climax of painting, it is treated separately in Chapter 4.

The seven elements of visual art enable us to see, think, and feel with the appropriate art words. You'll find relationships among the elements discussed in captions throughout this book and, most exhaustively, in Chapter 10, Diagnosis.

Overleaf. From St. Hillary's, 15″ × 22″. This was painted on a hillside overlooking the San Francisco Bay. The bay was chosen to serve as the white value. A little manganese blue adds a sedimentary quality to the washes.

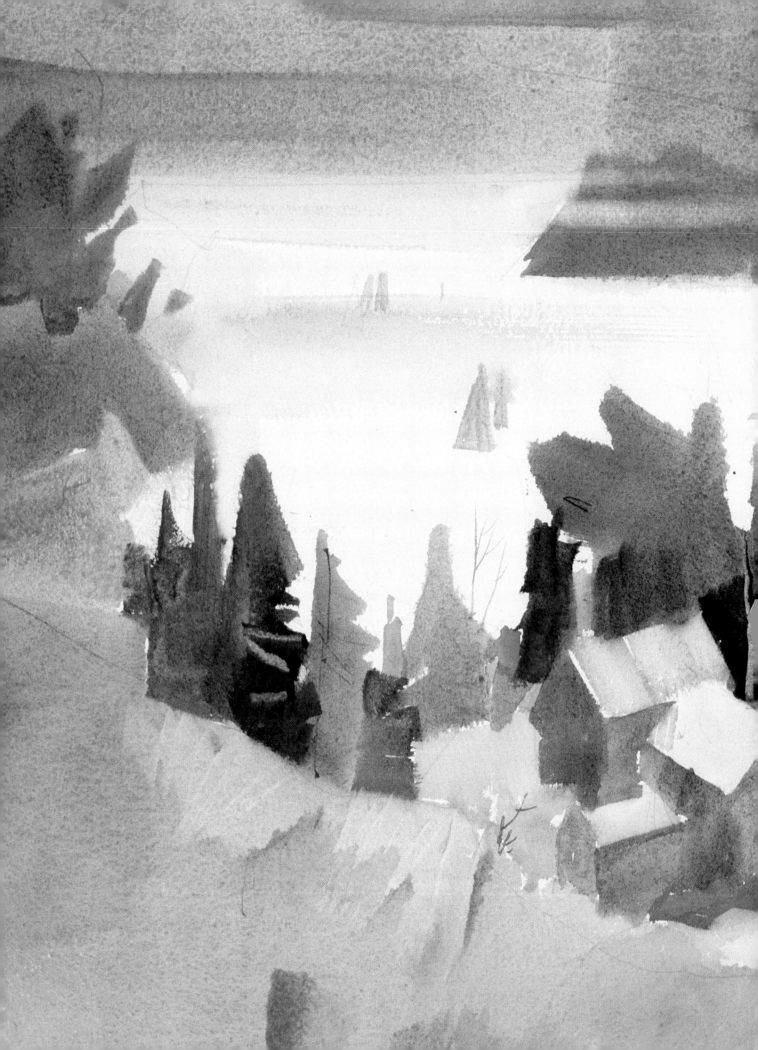

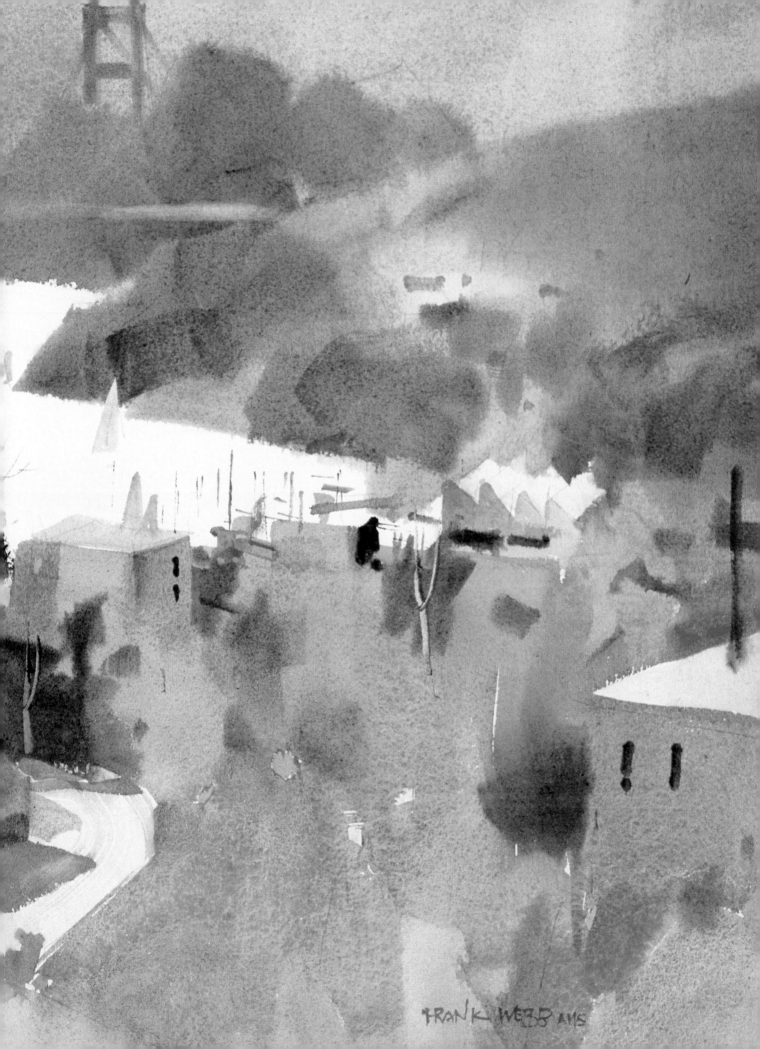

FRANK WEBB AWS

Here's how to make curves with a brush that are free yet decisive: *1. For small curves place your wrist on the paper and use it for a compass point. 2. The elbow as a compass gives a more generous arc. 3. To really swing in a large radius use the shoulder as the center. 4. The largest curves are made by swinging the whole body from the hips or from the feet. Note: It often helps to extend the little finger of your painting hand, letting it ride on the paper to control the thickness of line being drawn by the brush.*

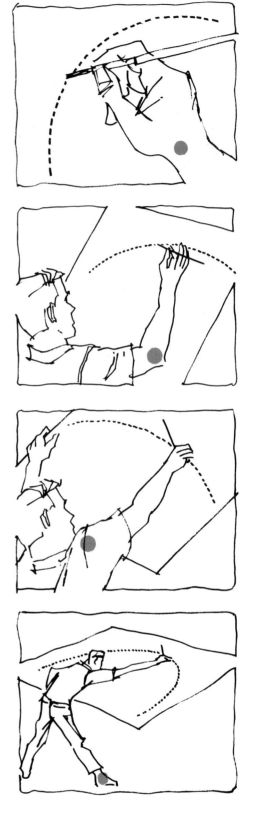

MECHANICS

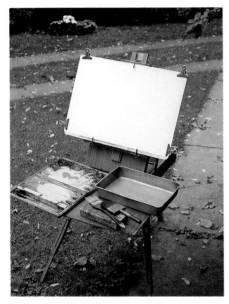

French easel with a plywood insert shelf. The drawing board may be set at any angle between vertical and horizontal.

Since painting involves manual labor as well as feeling and thinking, craftsmanship is a necessary means to an end. Materials and instruments become extensions of the artist's body. Craft can be learned, since it is the acquisition of good habits and brooding care. Let's look at the mechanics of painting, the equipment, and practices of our craft.

Outdoor or studio painting?

I almost never paint outdoors except when making a demo for an outdoor workshop. The trouble I find with working on location is that the eye sees too much. John Sloan calls the procedure of copying what you see "Tick-Tock" drawing. You look at the subject . . . "tick" . . . and then you make a mark on your drawing . . . "tock." Tick, tock, tick, tock. It may become a mechanical operation with no intervention of the mind or the

heart. Furthermore, light changes rapidly outdoors.

Most of my paintings are made in the studio where I stand at an adjustable draftsman's table, guided by drawings that have been made on location. Though I am enthusiastic about nature's storehouse of visual data, I don't feel the need to paint while looking at the subject. For me, a more imaginative and exciting picture results from a redesigned pattern made from an on-the-spot sketch.

Even in a life class where light does not change there are "on location" liabilities. The painter's mood and interest can change or the posture and the mood of the model may undergo a slump. The model's color may even change as the blood drains to the lower extremities.

It takes sharp discipline for the painter to stick to a main idea while working from a model or a subject.

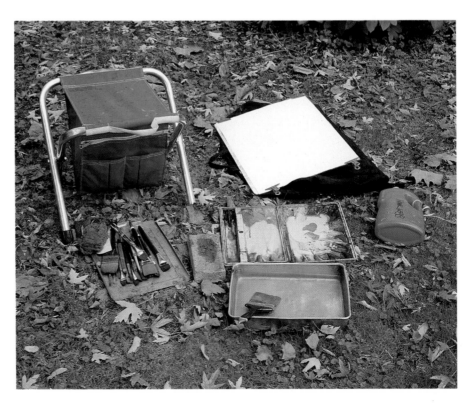

The ground level setup requires a minimum of gear. The campstool has pockets. My board rests on a shoulder bag that holds all my gear, including the campstool. A campstool allows you to swing your strokes from the shoulder and to see your work whole.

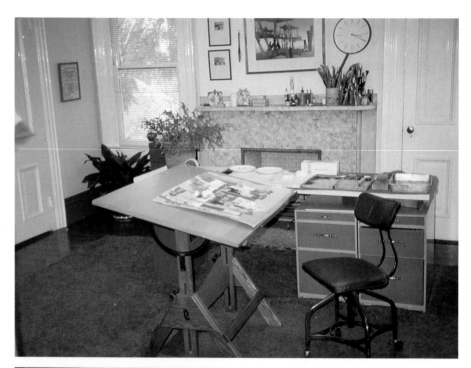

You'll need to experiment with a variety of locations and situations to see which ones work best for you.

Easel

Paper supported in an almost vertical position by an easel creates a certain amount of controlled run for your paints. Gravity and hydraulics mingle colors and settle pigments. You'll find there are other advantages to working with an easel. You'll be able to walk back from your painting to appraise it during execution, and outdoors, sunshine on the paper can be avoided by turning the easel so the paper is in shade. In life painting from observation of a model, it's practical to have the paper parallel to the picture plane.

Working at ground level

There are also advantages to working horizontally. The board on the ground and the artist on a campstool gives great freedom for arm movement and gear is easily placed all around. Wind problems are minimized, except on sandy terrain. At ground level, most painters prop their boards at an angle to control washes.

My studio is not confined to one room. Here is my painting studio, which houses my drawing table. The table is adjustable and kept at a twenty-degree slant, perfect for watercolor. I always stand at arm's length when working. Left. My instruments are at my right.

This third floor studio is used in several ways, mainly for mat cutting and framing. My mat cutting is usually limited to two sizes. I also frame only to these sizes.

My typical photographic arrangement entails placing a thin sailcloth over the floodlights to help minimize hot spots and reflections on the camera lens. I usually make several shots of each painting to avoid having to make duplicates later.

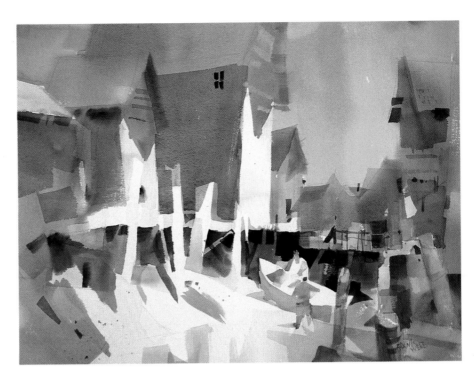

Sequence of operations

Transparent watercolor relies on the paper for white. Therefore, whites should be planned and left mostly untouched while the midvalues and darks are painted. It is possible to wash out a white, but it is more impressive to save them deliberately. It also pays to paint large areas first, since they make or break the painting. The four to seven largest areas should be given the best shapes and the most distinguished values and colors you can make. Nothing will save a painting if those largest areas are not beautiful. Last in order are details and calligraphy.

Edge treatment

Soft edges can easily be made on wet paper. If you are working on a dry area and wish to soften a freshly painted edge, dip a pointed brush in clear water, shake it off, and wet the edge. This must be done immediately, while the painted passage is still fresh.

To soften a dried hard edge, use an abrasive eraser or try scrubbing the edge with a stub of an oil painter's small bristle brush.

Dock Square, 22″ × 30″. The whites read clearly against the midvalues. They usually have to be invented. The first step I take is to plan those simple large areas of value. With practice you begin to see that way. **Below.** *The same picture is broken into the large patterns that it contains.*

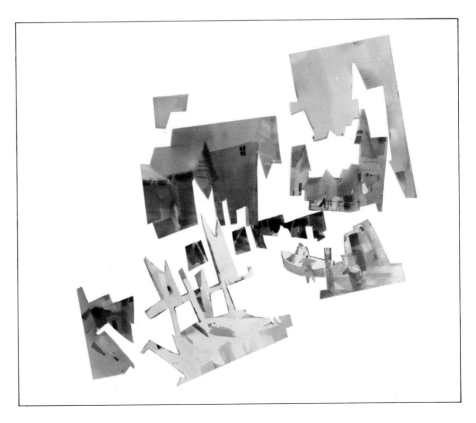

MECHANICS

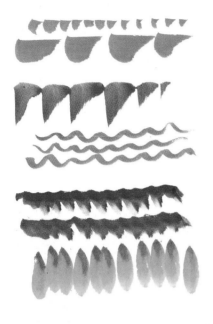

Here are direct marks made by a pointed round brush.

Brush handling

Try holding your brush on the end of the handle. It will give you freedom and breadth. I even hold my pencil on the eraser end.

A flat brush is capable of making a wide range of shapes. One versatile brush manipulation, of which many painters seem unaware, is twirling. This movement is similar to rolling a pencil between the thumb and fingers. Twirling enables you to make triangular marks (both long and short), finish touches or square corners, and paint scalloped edges.

Left. These are marks of the small lettering brush. This brush is round at the ferrule but has a chisel edge when shaped on the palette.

A script liner made these delineations.

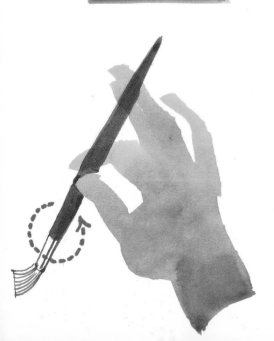

You can twirl a brush by rolling it between your fingers. In theory, you would make a one-inch circular shape as you twirled a one-inch flat brush.

The flat brush is capable of many kinds of marks. These examples at right were made by twirling the brush. *A.* Twirling to make triangles. *B.* Twirling while moving across to make long tapering shapes. *C.* Twirling while turning a circle to make a controlled thickness. *D.* Twirling to sharpen corners. *E.* These marks often serve as the basis for calligraphic lettering. They are usually made with the flat brush twirled to about a thirty degree angle. There are also some slight twirlings of the brush which deviate from the thirty degree angle, such as the swash on the "R" and "Q."

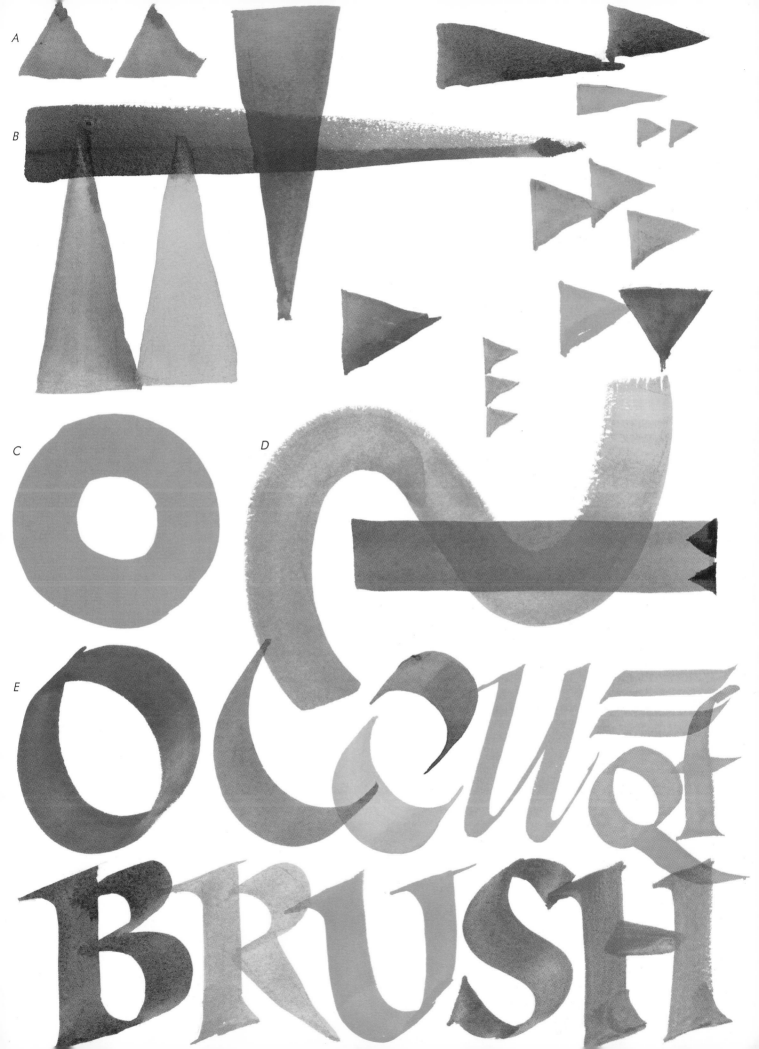

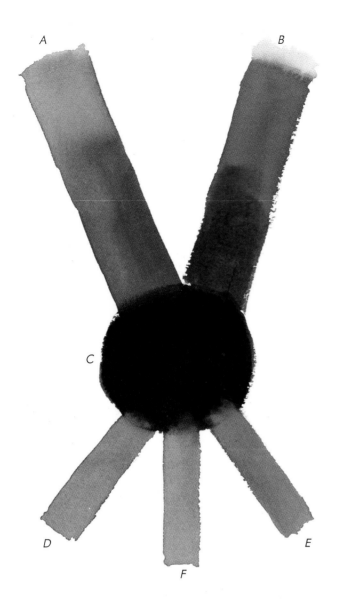

Many watercolor paintings are weak in values because the painters fail to make rich darks. Here is a sample of the richest dark you can make with two clear colors — alizarin crimson and phthalo green. They combine to make a luminous, non-muddy dark.

Alizarin crimson (A) is added to phthalo green (B) to make a rich dark (C). The resultant dark is then warmed up with additional alizarin on the left side as revealed by the undertone (D). The dark is cooled on the right by the addition of green as revealed by the undertone (E). The bottom center undertone (F) shows the almost neutral effect of the two colors when their influence is equalized.

Making dark values

A very dark value must be made with a thick application of paint. If you use pigmented paint for this, it tends to become opaque. To get a more luminous dark, mix darks from dye paint, such as phthalo green, phthalo blue and alizarin. Dyes allow the light of the paper to come through, giving a glow to even the darkest passages.

Wetting paper

Thousands of painters staple paper to boards and others stretch and tape presoaked paper. I simply attach paper to a same-size masonite board using Bulldog clips at the corners. When working wet into wet, soak the paper front and back with a painting roller or sponge, then re-move some of the surface water with a squeezed sponge or paint roller. I prefer 140-pound cold-pressed paper. For me, 300-pound is too thick, holds too much water, and is hard to flatten when it dries with buckling. The 140-pound is just the right thickness for wet into wet since it dries partially or fully while you're painting.

Fast vs. slow drying

Slowest drying takes place in damp weather or fog, especially if you are working on wet paper. In very dry weather and in direct sunlight a stroke on dry paper begins to dry at once. If you become accustomed to working on both wet and dry paper, you will be able to accommodate weather conditions.

Materials

Brushes

The resilience of a brush depends upon the kind of hair it's made from. The softest are squirrel hair and sometimes camel hair (pony). Some of these brushes might be so tender they cannot break the surface tension of dry paper, but they are perfect for a second application of a contrasting color on a fresh, wet underlayer. Sable brushes are a little stiffer than squirrel hair. Sables are good for almost any operation, though they are expensive and are not available in large sizes. Stiffer yet are the ox hairs. These are great for large wash brushes when sable would be not only expensive, but of insufficient length for a suitable construction. The most resilient brushes are the synthetic brushes. There are also brushes available that are made of combinations of hair.

Hair length and the thickness of a brush will change its behavior. Words cannot describe these differences, but you'll find each brush does certain jobs better than others. If you enjoy making spunky punctuations with a small brush as I do, you might try a synthetic lettering brush with long hair. Although they are rounded at the ferrule, the flat ends chisel nicely. This style of brush is available in three lengths of hair. The longest is the lettering brush. The medium length is a showcard brush, and the short length is a rigger. Flat brushes ought to be tested in water to examine their ability to chisel. I do 95 percent of my work with 3-inch and 2-inch flat brushes. This is a personal tradition.

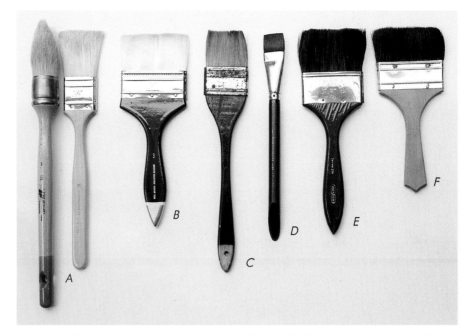

These brushes are my mainstay. The large three-inch flats do most of the work. I use the large synthetics when I need their resilience for breaking the surface tension of dry paper. The softer flats of squirrel hair are good for a lighter touch when painting a second layer atop a fresh wash without churning up the first layer. For stripes and calligraphy I use lettering brushes. The range of resilience of brushes from stiffness to softness is: A. Bristle B. Synthetic C. Combination D. Ox-ear (sabeline) E. Sable F. Squirrel or pony.

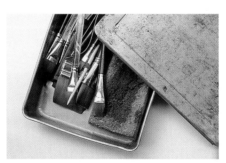

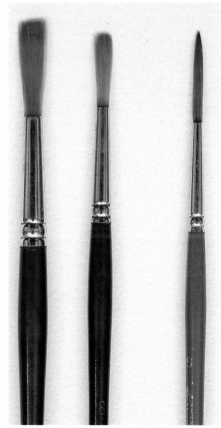

Above. My water container is a flat cake pan. It has a sliding metal lid which makes the pan a great carrying case for brushes plus sponges and other items. I place all brushes facing in one direction and pack the pan so the brushes rest on their handle ends rather than their hair ends. Brushes are cleaned quickly and thoroughly by banging the brush against the water in the bottom of the shallow pan.

Right. I use these brushes for calligraphic strokes. On the left are two synthetic lettering brushes and on the right a long-haired pointed brush called a script liner.

Palette

Over the years, I have enjoyed using several palettes including Jones, Robert E. Wood, Pike, Capri, O'Hara, and Holbein palettes, as well as a plain dinner plate. Since I prefer a flat palette I recently introduced a Webb palette to fill this need. This new palette has huge slots to accommodate a large, flat brush moving in sideways. Thus, the painter can be assured of decisive color without the uncertainty of dipping into wells. On a flat surface, sullied water runs off the mound of paint so there is clean paint available at all times.

Paint brands

There are several excellent brands of paint available. Each is equally permanent if they are labeled *artists' watercolor,* though most brands also offer and identify certain impermanent colors. Brands differ in price, tinting strength, and subtleties of hue, vehicle, viscosity, and solubility. The last two characteristics are almost never discussed by painters or manufacturers. I choose certain colors of certain brands for the viscosity and solubility characteristics. Solubility is the paint's ability to be diluted or softened in order to get it into the brush. Freshly squeezed paint is the most soluble. When away from the studio I avoid brands of paint that are too runny on my flat palette.

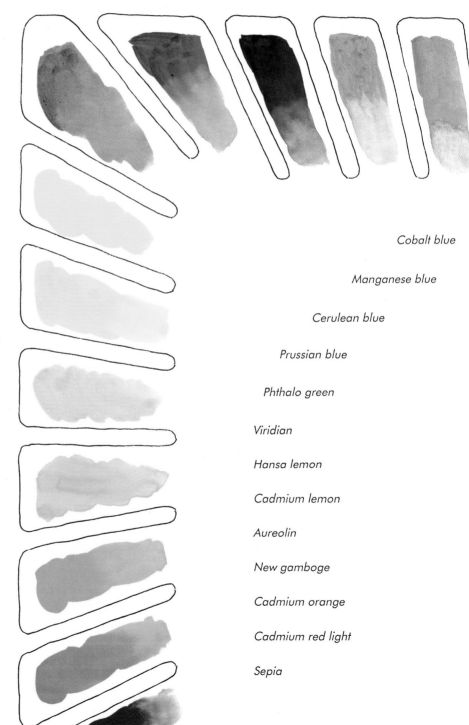

Cobalt blue

Manganese blue

Cerulean blue

Prussian blue

Phthalo green

Viridian

Hansa lemon

Cadmium lemon

Aureolin

New gamboge

Cadmium orange

Cadmium red light

Sepia

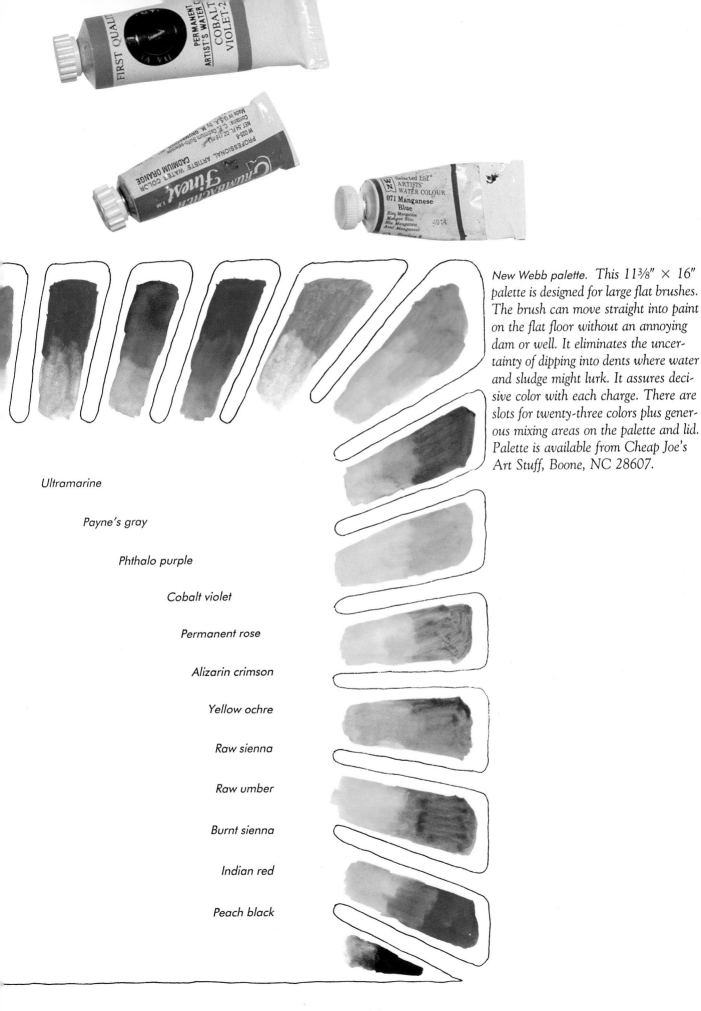

New Webb palette. This 11⅜″ × 16″ palette is designed for large flat brushes. The brush can move straight into paint on the flat floor without an annoying dam or well. It eliminates the uncertainty of dipping into dents where water and sludge might lurk. It assures decisive color with each charge. There are slots for twenty-three colors plus generous mixing areas on the palette and lid. Palette is available from Cheap Joe's Art Stuff, Boone, NC 28607.

Ultramarine

Payne's gray

Phthalo purple

Cobalt violet

Permanent rose

Alizarin crimson

Yellow ochre

Raw sienna

Raw umber

Burnt sienna

Indian red

Peach black

Transparency

Artists' paint is most often made of organic or inorganic pigment dispersed in a vehicle of gum arabic, glycerine, and other ingredients. When made into paint they display differences of texture, gloss, toptone and undertone. If a paint label carries the word *hue* or *tint* it is not genuine, but a mixture, though the mixture is usually made from genuine pigments. Most watercolor paint is pigmented, that is, it's made of tiny particles that appear as a powder before the vehicle is added. There are also non-pigmented paints made of dye.

Dyes are the most transparent of all paint since they impart hue and value without pigment. The most common artists' color dyes are: alizarin crimson, quinacridone red, phthalo blue, Prussian blue, phthalo green, gamboge, and Hansa lemon yellow. Technically, Prussian blue and gamboge are not dyes but are similar in characteristics.

Painters are sometimes concerned whether a paint is staining or non-staining. This characteristic is important if one wishes to wash out areas of dried paint. Generally the dye colors are staining since they penetrate the fibers of paper, while pigmented paint tends to lie on the surface. For this reason, when painting in layers, use dyes on the first layers of a painting. Use pigmented paints for the top layers where their microscopic particles impart their glory unbesmirched by overlying stains that rob them of their reflective, jewel-like iridescence.

If you plan to wash off paint, then avoid dyes and work with the non-staining pigmented paints. These are the most transparent of the pigmented paints: viridian, raw sienna, cobalt blue, rose madder genuine, burnt sienna, and aureolin yellow. In contrast, the most opaque pigmented paints are ultramarine blue, cerulean blue, Indian red, and Naples yellow.

Cobalt violet paint was allowed to dry. Then, using a synthetic flat, I made three or four strokes with clear water, which lifted this non-staining paint.

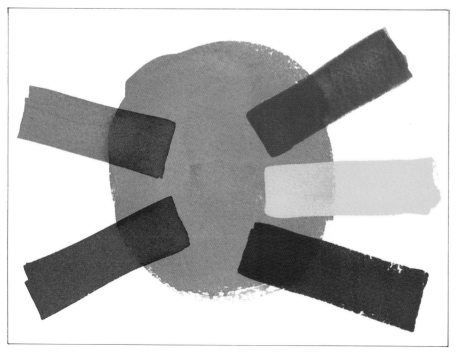

Bright colors were superimposed on a dry gray wash. The alizarin and phthalo blue at left reveal their almost utter transparency. Cerulean blue, Naples yellow, and Indian red display their opacity.

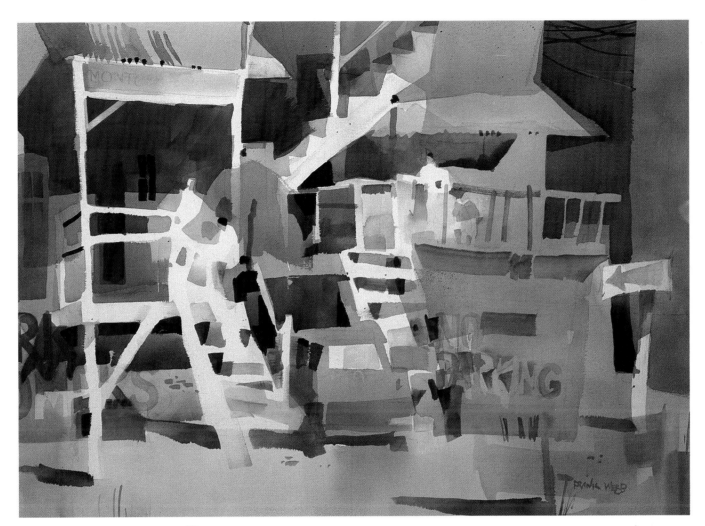

Decorah Backstreet, 22″ × 30″. Trans-
parency is demonstrated in this layered
painting. Alizarin and black were mixed
and most of the sheet was covered with
a flat wash of this mixture. Such a dye
paint gives maximum clarity, which does
not sully washes applied later.

Overleaf. Feed Mill, 22″ × 30″. Callig-
raphy depends on symbols. Symbols are
objects or marks that refer to something
outside themselves. Watercolor painters
normally develop a personal set of
symbols.

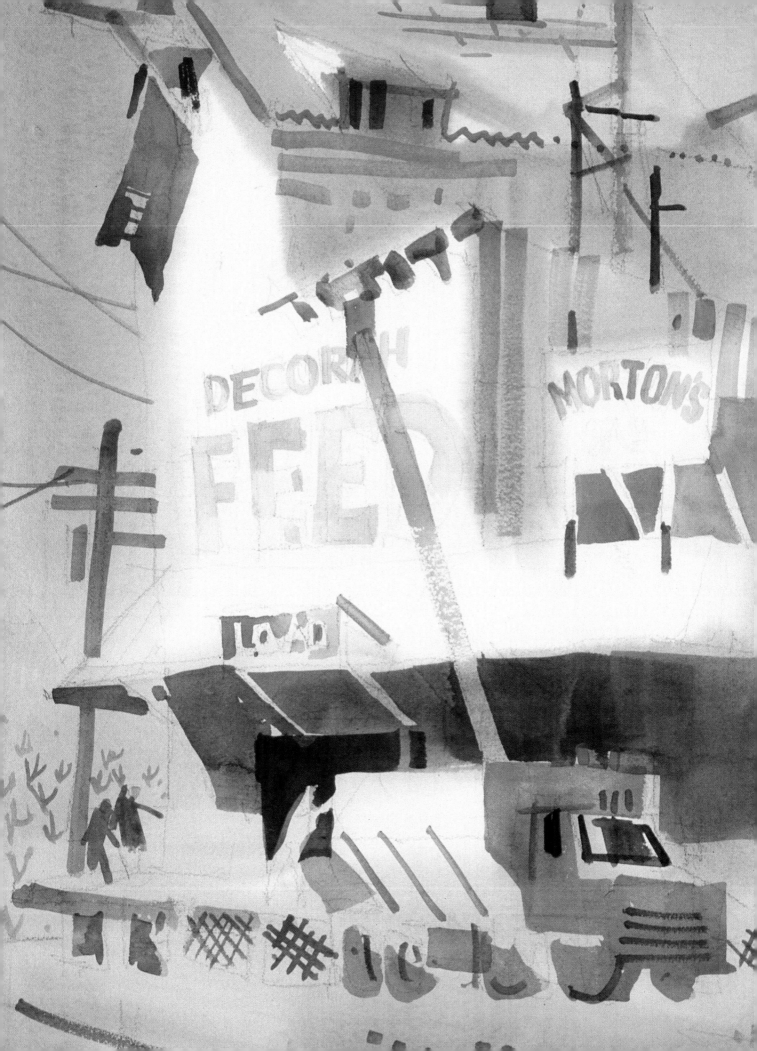

FRANK WEBB AWS

	1	2	3
WHITE			
HIGHLIGHT			
LIGHT			
LOW LIGHT			
MIDVALUE			
HIGH DARK			
DARK			
LOW DARK			
BLACK		FOR A HIGH KEY	FOR A LOW KEY

CHAPTER 3
VALUES

1. Nine value steps were named by Denman Ross in 1907. Most artists plan with a smaller number of values.
2. I use three values for my pencil planning. Notice the one largest interval.
3. This scale is more suited to a low key painting where subdued light is desired. In both 2 and 3 the extremes of black and white give maximum contrast.
Note: Revival of the names of the nine values seems practical since there is no agreement among artists and scientists at which end of the scale to start when assigning numbers.

Values are intervals on the scale of light to dark. You must be able to think of them apart from color and texture. Values in nature are the result of illumination (light and shade) and of local value. Local value is the relative lightness of snow or the relative darkness of a fir tree. Another kind of value is the arbitrary value pattern used by the creative artist for reasons of design and expressiveness (see Chapter 7).

If you want to look at nature's values, or your painting's values, you can photograph your subject in black and white or view it through a blue or red glass, which suppresses most other colors. You can make a video and play it back in black and white. However, the easiest way to see values is to look through the squinting eye.

When painting, values should be recreated to design the new reality a picture requires. Values give existence to drawings and give color a foundation. A line drawing needs no values, but if you have a sensitive appreciation of drawing you realize that a contour line is not merely an edge of an object, but a line between two values. The most realistic use of value is light and shade based on observations of natural light or made under a single source of artificial light.

The following is a consideration of the use of values to render three-dimensional form on a flat surface. The two modes are *chiaroscuro* (Italian for light and shade) and *modeling*. Aesthetics and design problems will be set aside briefly while dealing with rendering volume.

Chiaroscuro vs. modeling

These two modes are somewhat opposed, so I will briefly summarize them before discussion.

In chiaroscuro, the artist copies the values he sees on the model. He expects to reveal the planes of the model by capturing light and shadow. It is a perceptual procedure because it is based on what is seen.

In modeling, the artist establishes the planes of the model as he conceives them. He uses different values to differentiate these planes. It is a conceptual procedure because it is based on what is known.

Chiaroscuro

When attending to chiaroscuro, the artist is trying to capture light more than objects. With light and shade he expects to express the planes of the form. It is a perceptual study closely allied with photography. Paradoxically, chiaroscuro tends to conceal the form as it seeks to reveal form since it is a groping after shadows and atmosphere. It is lopsidedly perceptual at the expense of the conceptual. At its best it gives us a Leonardo.

Single light source

Chiaroscuro and naturalism go hand in hand as they reveal things under a single light and, most importantly, as though in a single moment in time. A model under a single light source will show values separated into three broad categories: (1) The *light*, which also includes the highlight. (2) *Half-tones*, which are located at the edges of the light where it nears the shade. It is usually prudent to make these

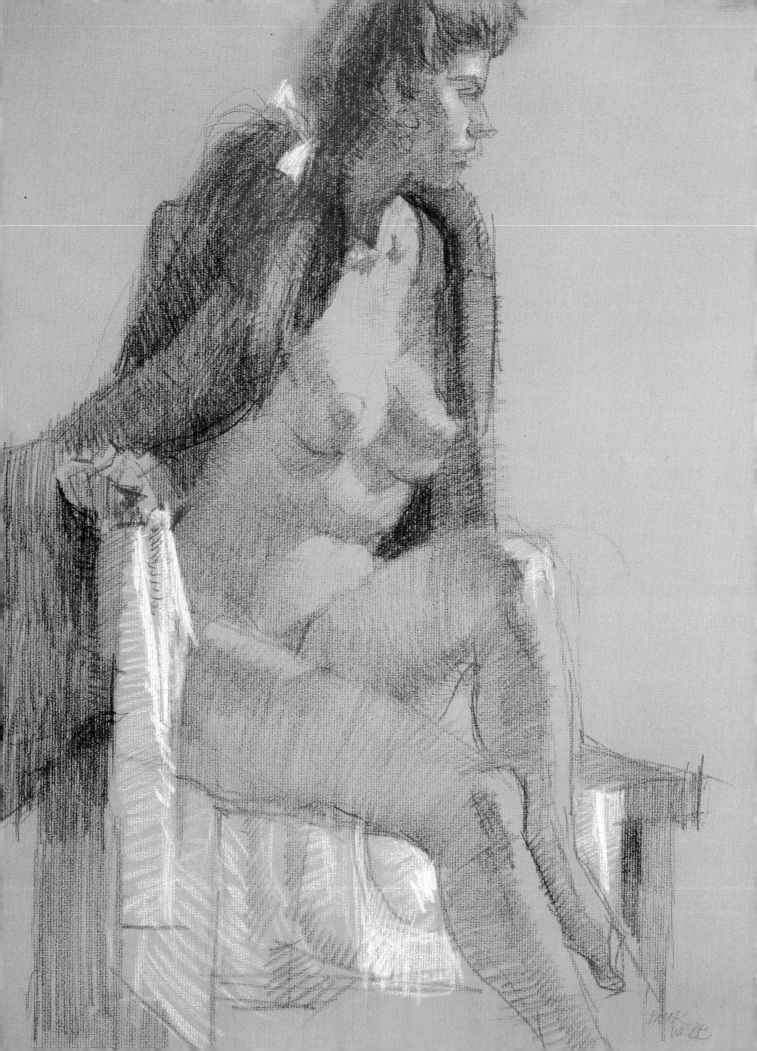

Left. This value study started with toned paper; white chalk expresses white and highlight while darker chalks complete the range of values.

Right. These eggs were in a moderate light from a single, direct source. In a much stronger light the halftones would be diminished, creating an almost black and white contrast. If a softer light were used, the edges of the cast shadow would be much softer, halftones would abound, there would be less reflected light, and the contrast between the light and shade would be reduced.

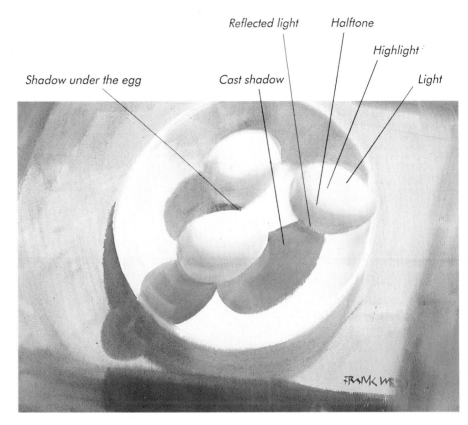

Shadow under the egg Cast shadow Reflected light Halftone Highlight Light

values lighter than they appear to be, as they belong to the province of light, not shade. Keep the big lights separate from the big shade. Furthermore, texture and color are components of halftones and are similarly treated as children of light. (3) *Shade* is a consequence of an object turning away from direct illumination. On the shade side is often a reflection or "light bounce" coming in from other objects. If these reflected lights are overstated, they can destroy the unity of the shade. The value of the reflected light should not reach the intensity of any light or halftone on the light side.

Another aspect of shade is cast shadow, which is a dark value projected on a plane on which illumination is interrupted. When observing the model, always compare several values to appraise a value. Try to get a feeling for each value by comparing it to at least two others.

Accomplished artists often elimi-nate or limit the cast shadows on a model since they are usually destructive. A badly placed light source on a model also can be destructive, requiring the artist to imagine a more proper light.

When drawing in a representational mode, generally throw the light from one direction. Your drawing should suggest this even if the light on the model is from several sources.

Remember these two truths: Halftones must be lightened to keep them part of the light, and reflected light should be dark enough that it stays in the shade. The adjustment allows the simple and readable contrast to convey conviction to the viewer through gathering the light and opposing it to the total shade. Correct seeing helps. Don't just stare into the light or into the shade. Try to get both in one visual grasp. Adjustments must be made because of the limited values at our disposal.

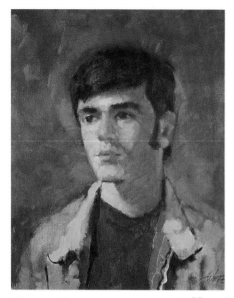

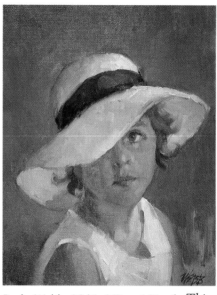

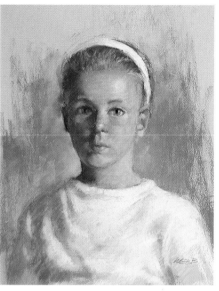

Chris Webb, 1970, 20″ × 16″, oil. Here is a typical chiaroscuro effect. The simple lights are held against the simple shades. Color changes also help to differentiate minor changes of planes.

Becky Webb, 1965, 20″ × 16″, oil. This portrait is also the result of painting light and shade, though here all the flesh tones are in the halftone range, thus the planes are expressed within a very close value range.

Wendy Webb, 1970, 20″ × 15″, pastel. The values in this painting are also the result of chiaroscuro. Pastel offers an opportunity to carefully study values and colors through a methodical buildup of pigment.

The Missouri at Bismarck, 22″ × 15″. As usual outdoors, the basic light comes down from the sky. This makes all vertical planes and oblique planes, such as mountains, darker than the planes that face the sky.

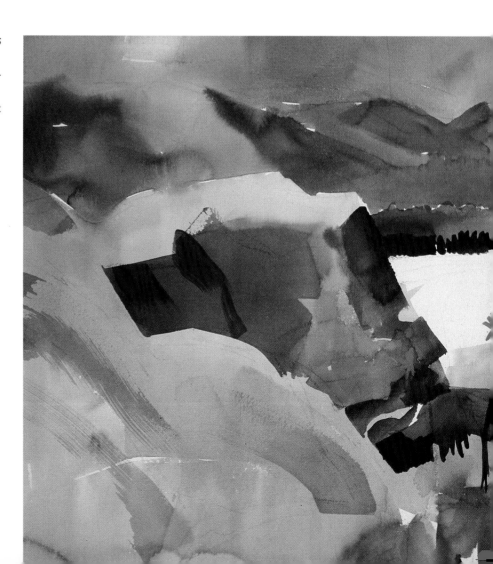

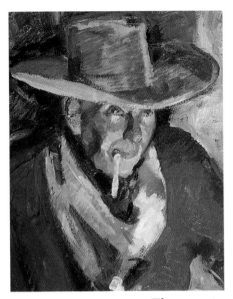

Harry Hickman, 1947, oil. This portrait of one of my favorite art teachers was made using a single light source, placed low to suggest a campfire. Artists often enjoy painting a model in various costumes. Mr. Hickman was an excellent landscape painter.

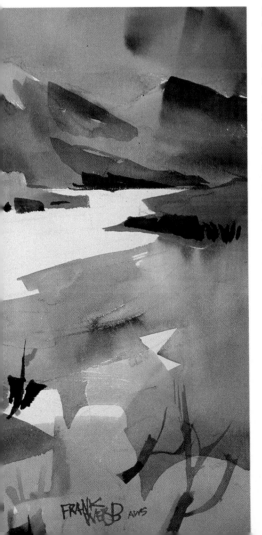

Outdoor chiaroscuro

The characteristics discussed so far are true outdoors as well, except on overcast days when the relationships are very subtle. Also, outdoor light may be so intense that value ranges need to be simplified. Outdoors, nature shows herself more in the manner of the silhouette than in chiaroscuro. By squinting, you will see large separate pieces of contrasting value. One of the unifying qualities of chiaroscuro is that it blesses and ties all objects together within a unified light, color, and intensity, no matter how unrelated one object is to another.

Weaknesses of chiaroscuro

Kenyon Cox said that chiaroscuro conceals the body while modeling insists upon the body. Just because light and shade are so mysterious and absorbing, they tend to take the place of design, drawing, and even color, and are dangerous tools. John Sloan went so far as to label this kind of painting as eyesight painting.

Over-reliance on chiaroscuro can result in loss of control over the pictorial space. Since pictorial space is of primary importance, be sensitive to the spatial discord of volumes tumbling forward out of the picture. While there is no pat formula to help adjust a too robust chiaroscuro, here are some tips.

• Subordinate chiaroscuro to local value and values used for design's sake.
• Flatten large areas of light and shade so that many of these planes will appear to be parallel to the picture plane. Especially reduce any over-insistent gradation that appears on cylindrical and spherical surfaces. These values should usually be flattened and the edges kept fairly hard, otherwise you have a painting full of sausages.
• Build passages or links from one value shape or area to another.
• Model with contrasts of warm and cool color while restricting value differences.

Modeling

When the light is more diffused, as in outdoor light on a gray day or with a model indoors under a battery of fluorescent ceiling lights, the artist will often have to rely on modeling (or rendering). There are also countless times when the artist has no model or cannot go on location, but must rely on previous observations, knowledge of his subject, and understanding of light. This is a time for modeling. Modeling does not seek to explain illumination or atmospheric nuances, but uses differences of value to show where a plane changes. In the modeled drawing, the artist looks at the model, formulates a concept of the planes and then uses values to express them. This is the reverse of chiaroscuro, where the artist copies the observed tones from the model expecting these value nuances to express the planes.

Large plane changes usually are understood only with a good knowledge of structure and previous acquaintance with chiaroscuro drawings. Thus armed, the artist can define the figure with outlined planes and then give value contrasts to add visual conviction.

Since modeled drawings are more conceptual than perceptual, they are less realistic to the eye, but are almost more real to the mind. Many works do not separate neatly into the categories of modeling and chiaroscuro, but are combined.

Granite Quarry, 22″ × 30″. There was little use in chasing shadow shapes all over the scene. Rather I indicated the major planes, giving them the shapes I preferred, using values to describe these planes. My feeling about quarries is that they are already abstract. The problem as I see it is to avoid copying the ready-made and imagine the shapes and values that belong in my picture.

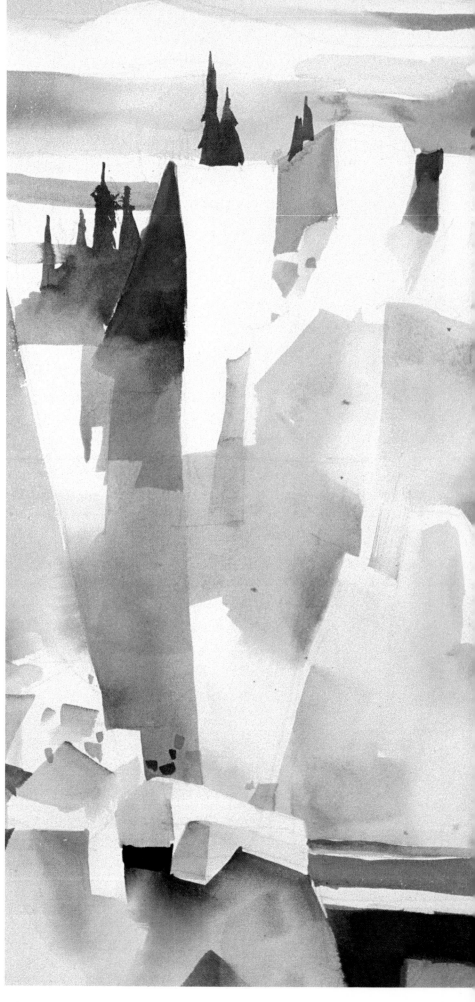

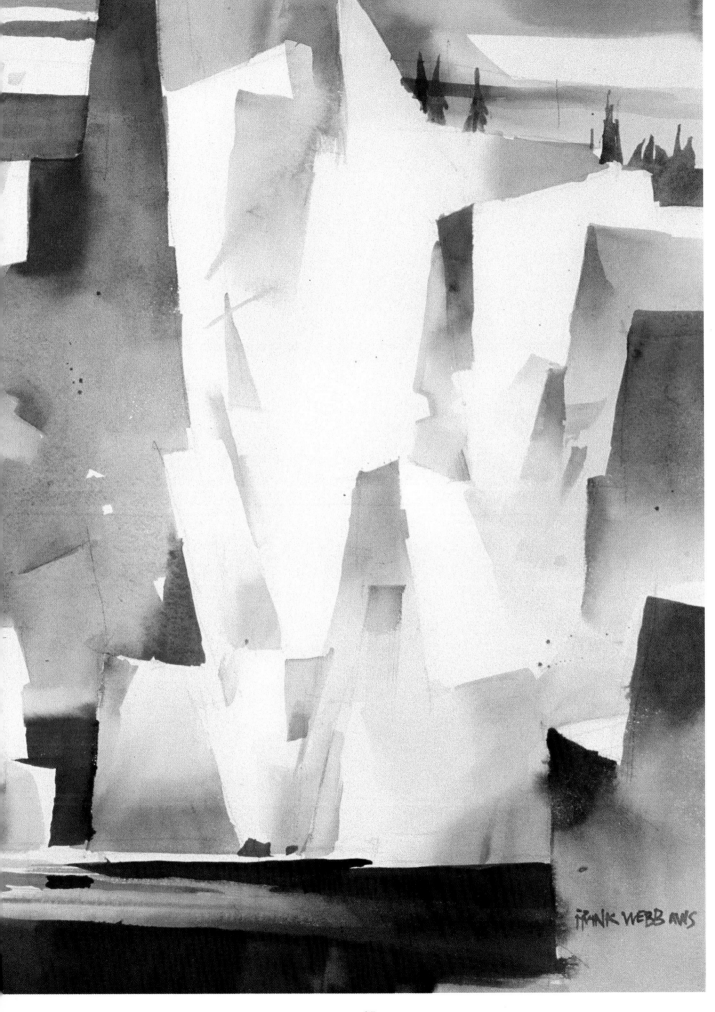

FRANK WEBB AWS

37

Local value

Local value is the value of objects independent of illumination. For instance, a dark coat will be classed as dark whether you are outdoors in sunlight or in a dimly lit room. You might wish to suppress or eliminate local value when making a figure study of one figure against one background. However, in a more complex picture or in a landscape, the use of different local values helps to separate objects and creates more latitude for designing big shapes. Enlist local value to separate and also to combine areas as called for by your picture.

Landscape values

Because of the limitations of paint, you can't duplicate all the nuances of lights and darks that you can see. If you try to match every value difference you will end up with a picture that is either too dark or too light. You must discriminate and must reduce the thousand values of nature to your smaller scale of nine steps. Generally you must aim to show your nuances among the lights, or among the midvalues or among the darks. In each case, the other end of the scale must be impoverished. It is a matter of sacrifice.

Consider Rembrandt. He did not copy every value he saw but chose a chord of several light values and a couple of dark values, eliminating

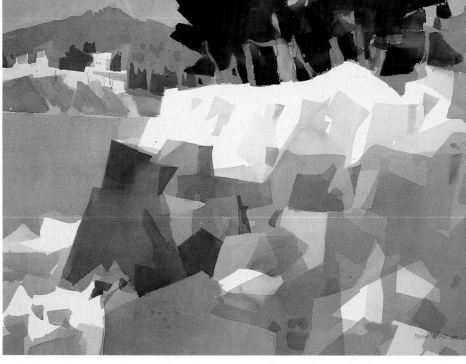

midvalues. It is not the model or the light, but the artist's encounter and selection of what best expresses his vision. You must choose your own scale of values.

Eliot O'Hara taught a lesson in the limitations of attempting to match color values outdoors. The student was told to paint strips of tints and shades of several different colors on plain white paper. This paper was then placed outside so the colors were in shadow. The student would try to match the colors as they appeared in real shadow, on white paper in sunlight. You'll find that it is possible to mix colors to match the yellows and oranges as they appear in shadow, but it is difficult or impossible to further darken already dark colors. If you attempt this exercise

you will soon learn the limitations of paint.

Value intervals

A painting with white as the highest value and black as the lowest value has a major interval. A painting that goes only from light gray to dark gray has a minor interval. A minor interval is quiet in its effect. The term "interval" is closely allied with the next term we'll discuss — "key."

Key

If most of a picture's values are light, it is said to be "high key." The reverse is a low key, when most of the values are dark. A subject can suggest the key of a picture. For example, a forest interior is low key while a beach is high key.

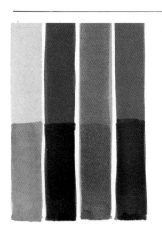
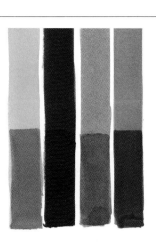

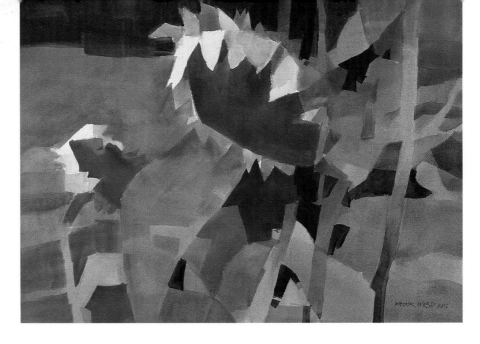

Left. *Lover's Point, 22″ × 30″.* The local value of these coastal trees is very dark. I used that dark to dramatize the light-struck rocks. While I ignored local color, I did use local values to differentiate the major areas. Chiaroscuro is almost absent in this painting.

Sunflowers at Dusk, 22″ × 30″. This low key painting has most of its values below middle. There do not seem to be many low key purist watercolor paintings. Certainly the paint is less fluid when it must be put down with less water.

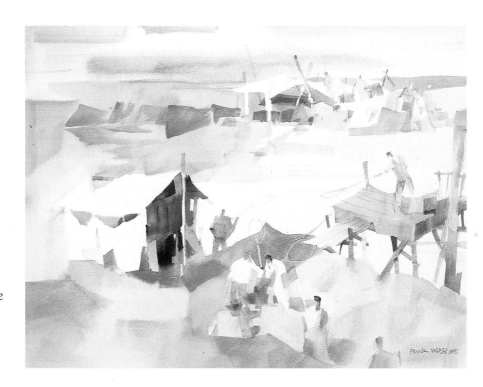

The Dalles, 22″ × 30″. A high key. Most values here are above midvalue. A watercolor usually will require untouched whites when the midvalues are this high. I put whites into the water, the Columbia River. This painting received the Vivian Chevillon award of the Midwest Watercolor Society.

Here is an example of Eliot O'Hara's experiment. The upper half shows the original colors that were placed in shadow. The lower half shows the attempt to match the look of the colors as they appeared in shadow. Notice how absolutely impossible it is to shade black.

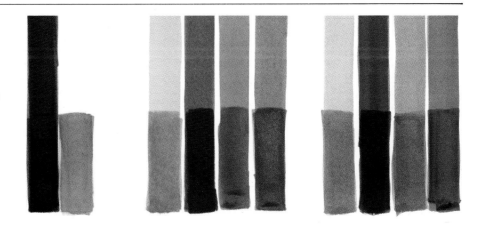

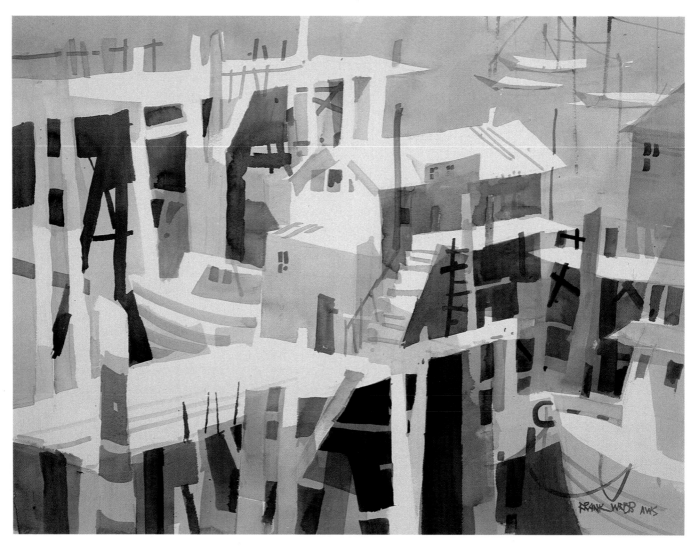

Captain Randy's Landing, 22" × 30".
There is often fog here at Monterey.
Although it is subtle, this painting uses
darker values close up at the bottom
while the distance gets a little lighter.

Watercolor's fickle values

Watercolor paint always dries lighter in value and weaker in color intensity than it appears when first applied to paper. You must therefore make all values darker and colors brighter than you wish them to be. This may be the reason there are so many paintings with weak values. The problem can only be solved by experimenting with adjusting value differences between fresh wash areas and dry washes. If the value looks right when first applied, it will dry wrong.

In opaque watercolor painting (gouache) the opposite occurs. All values get darker as they dry. It is quite a trick to get used to shifting between these media.

Atmospheric values

The bluish haze of air creates an effect like several curtains of light blue gauze. Distant objects become flat and blue in close values, while color becomes less intense. Artists use aerial perspective to capture these effects. Many actually ignore naturalistic aerial perspective to achieve a more shallow space in their paintings.

Arbitrary values

Creative artists are always sensitive to handling space and vision in unique ways. The cubists, for instance, used values to express slipping planes, several viewpoints, and a fractured picture plane. You need not go to that extreme, but you shouldn't hesitate to use value for design's sake.

Push-pull values

You can use value contrast to create the effect of a push or pull movement in your painting. Most of this movement results from using graded values in the negative space around the positive shapes. For variety's sake these contrasts should be alternated. Airbrushing is the most obvious medium to produce push back values. Watercolor is also appropriate. For an example of push-pull, see page 82. A flat crayon or graphite stick can produce a push-pull value in one stroke.

Value pattern

Thus far we have discussed nature's values, chiaroscuro, modeling, and some of the effects and limitations of media. When actually confronting a particular scene or a model, what is needed is a *visual*, not a verbal, concept. Many artists make a rough pencil sketch of a value pattern. It might be based on chiaroscuro, or modeling, or a combination. Often, it will rely even more on local value. Since value making is selecting and creating visual contrasts, sketching helps an artist to think visually with a pencil or any medium that can make three or four values (see Chapter 7).

Top. Since watercolor gradates so easily, push-pull values are a natural. Bottom. A flat litho crayon on its side makes a gradated value in one stroke.

Overleaf. Campbell's Barge Line, 22" × 30". Light rakes across the boats to make interesting white shapes and exciting cast shadows. The light on the Allegheny River was not really from this direction. I made my own light and shade. If you have drawn boxes and barrels, then you know how light behaves, and you are not stuck when facing unsympathetic light direction on your subject.

Ironequoit Marina, 15" × 22". Negative painting is the chief effect here. When spatial effects are paramount in a painting, it is wise to restrict color. Cubist paintings, for instance, rarely go beyond tans and grays.

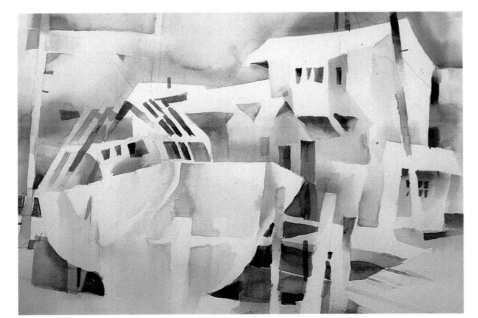

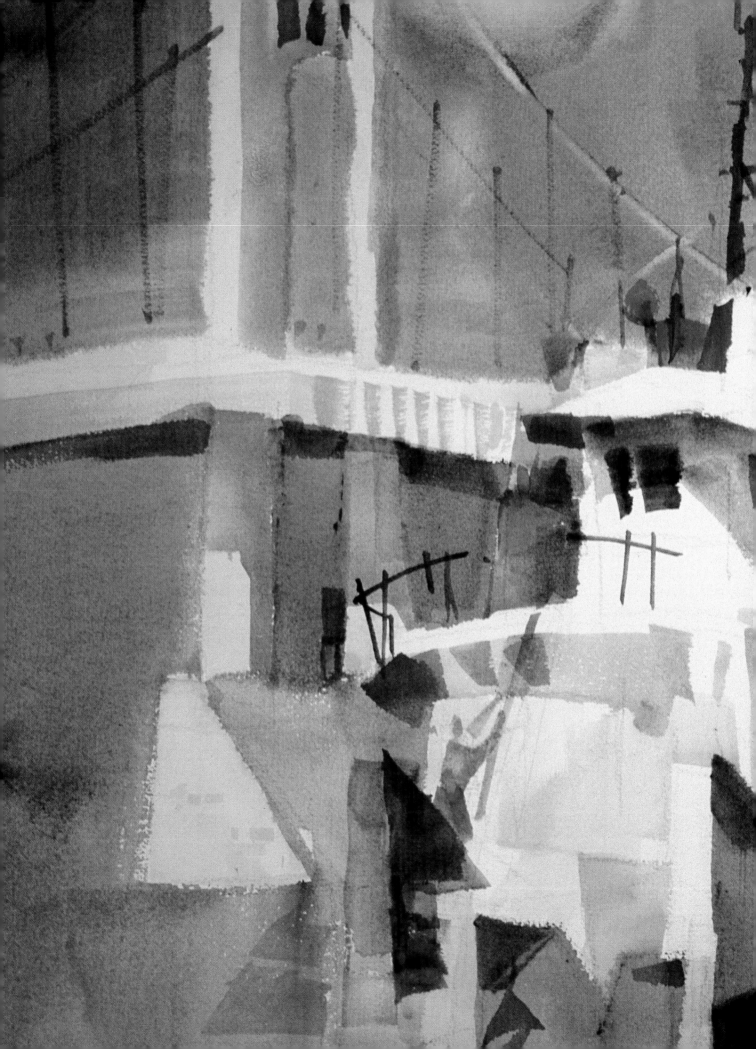

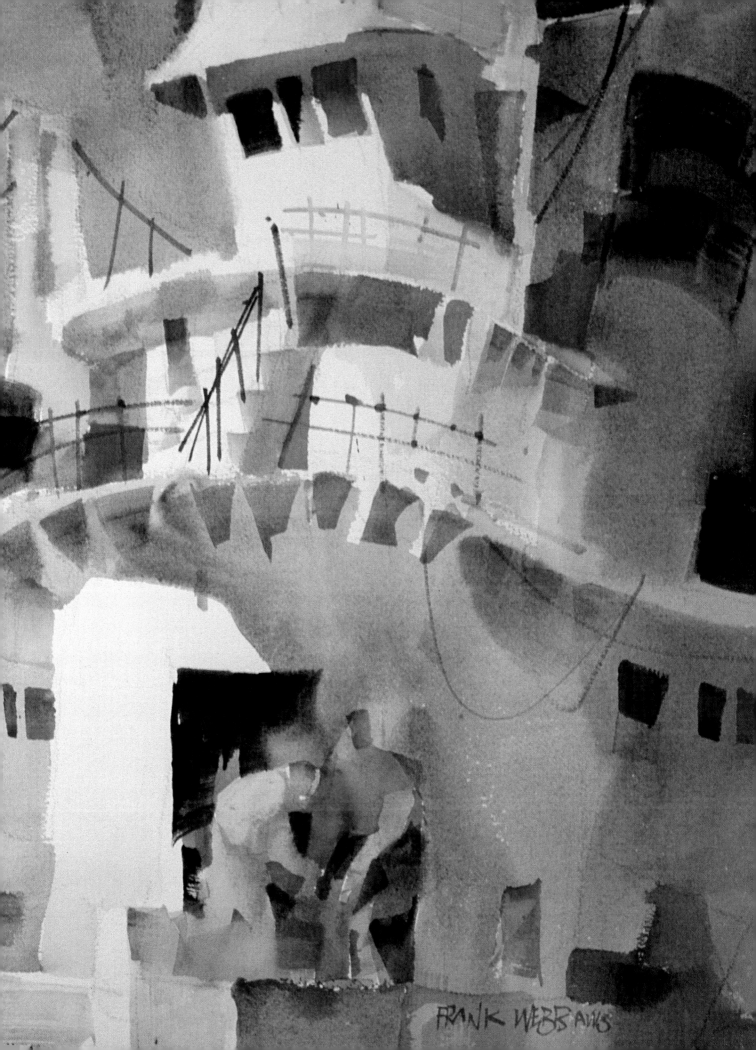

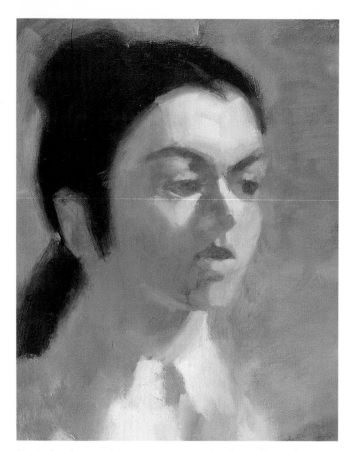

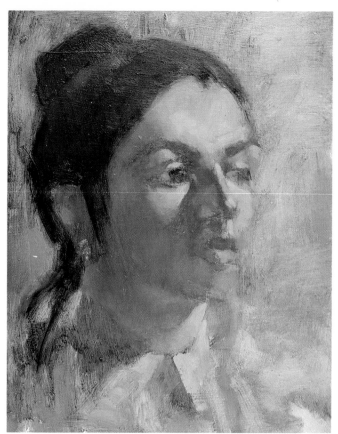

Optical color results in seeing one color through another, a common feature of water. However, since the Middle Ages, artists have used oil glazes to produce optical color. The gray underpainting (grisaille) is made of terre verte and white. Values are kept light to impart luminosity to the painted glazes that follow.

The grisaille is left to show in the halftones of the face. Some scumbles are also applied. A scumble is a semiopaque application of a light color on a darker portion of the underpainting.

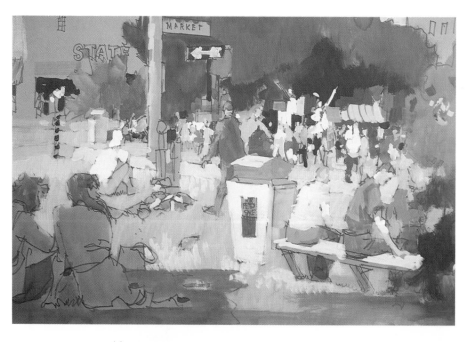

Market Square Concert, 20″ × 30″. This gouache study (opaque watercolor) relies mostly on toptone effects as do most opaque paintings. Gouaches are more successful in the higher keys. The ground of this painting was the gray-green back of an illustration board. Markers were used to initiate the job. Beware of the impermanence of some markers.

CHAPTER 4
COLOR

Watercolors with dark toptones reveal their undertones when mixed with clear water so the white of the paper shows through. Above are burnt sienna, ultramarine dark, phthalo green, phthalo purple, and phthalo blue. Burnt sienna is the most peculiar of all. It is salmon when mixed with white, fiery orange when diluted with water, or a dark mahogany when full strength.

No matter what feel you have for color, its three characteristics—hue, value, and intensity—must be thought about and manipulated.

Color terms

Hue is the red, yellow, and blue of paint.

Value refers to the lightness or darkness of a color.

Intensity refers to the color's strength or weakness between bright and gray.

Luminosity is the painting's ability to give off light. It generally derives from the light within and beneath—such as the white of watercolor paper under the paint, or the white ground of a primer under oil paint.

Tinting strength refers to a paint color's ability to retain its identity in mixture, tinting, or in shading.

Complements are colors found directly across from each on the color wheel.

Tint means a light value of any hue, usually made by diluting a color with a solvent (or water) or by adding white. It is incorrect to speak of a light "shade" of color—tint is the correct word.

Shade is a dark value or dark of a hue, often made by adding black, a complement, or other darker colors.

Pigment is a dry powder product or particles of color that are used as a

raw material to make paint.

Paint is pigment mixed with a vehicle. It can also be a dye mixed with an inert base.

Paint quality is a richness of the painted surface, the result of a direct and decisive technique.

Simultaneous contrast is an apparent change in hue, value, or intensity induced by adjacent colors.

Vibration is the effect on the retina resulting when two colors of maximum intensity and equal value are placed side by side.

Toptone (masstone) is a mound of paint on the palette or a very thick application on a painting that will often show up darker and not reveal its brightest color. This is especially true of alizarin crimson, phthalo blue, and phthalo green.

Undertone is when certain paint colors with a dark toptone are diluted with a solvent, have white added, or are drawn out in a thin layer with a knife, thus revealing the undertone. Purist watercolor technique is almost exclusively undertone.

Optical color is color mixed by the eye. For example, in pointillism, small unblended touches of color appear to blend when seen from a distance. Another optical mixture takes place when one color shows through a second layer of glazed transparent color.

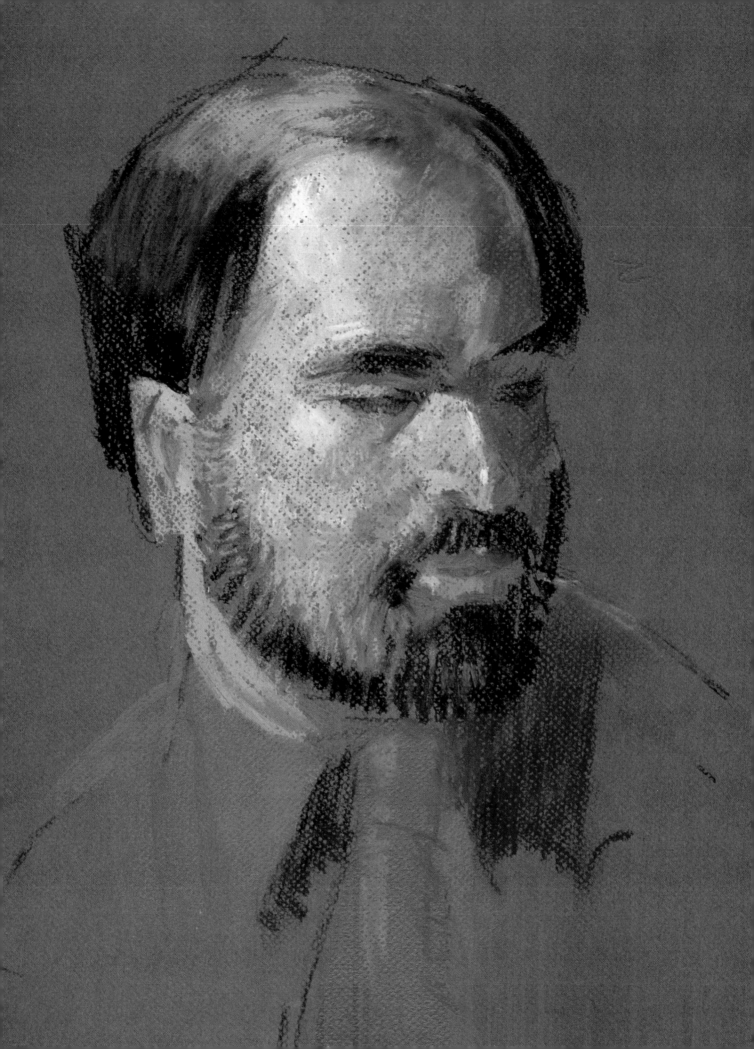

Left. Natural color is best studied in pastel, since pastel is pure color not darkened by a paint vehicle.

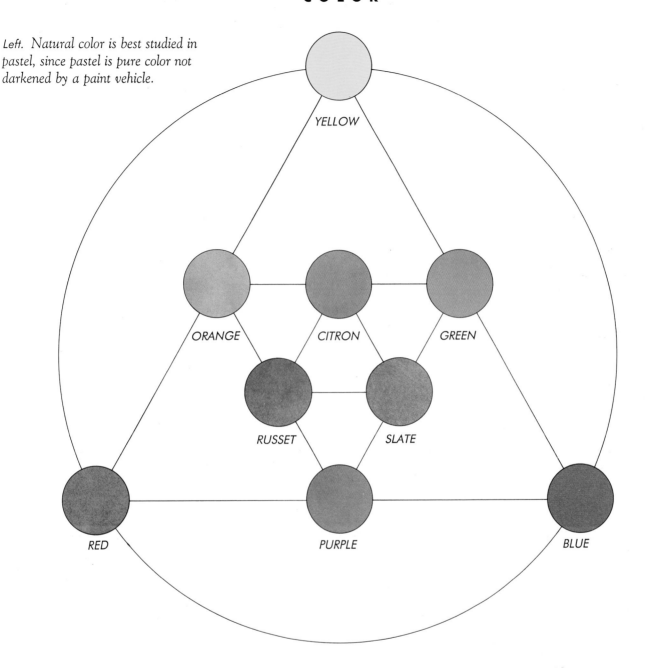

Watercolor wheel

This wheel is based on paint primaries of Hansa yellow, quinacridone red, and phthalo blue. The distance of the color from the center to the outer circle represents intensity, the center being neutral gray or zero intensity, while 100 percent intensity is found on the outside circle. The secondaries — orange, green, and purple — are mixed from the primaries. Notice how they are not in the outside circle of the brightest intensity since they are mixed and therefore grayer. Even further inward, closer to grayness, are the three neutral tertiaries — russet, citron, and slate — made from mixtures of the three secondaries. Notice that the three tertiaries are low intensity primaries. Citron is a low intensity yellow, russet is a low intensity red, and slate is a low intensity blue. This color wheel is for theory only. It shows the three generations and their structural relationships. The three primaries were chosen for their clearness (dyes) and because they are the most versatile in mixing toward the warm or toward the cool.

Neutral tertiaries made from ready-made secondaries. A. Citron is made from cadmium orange plus emerald green. B. Slate is made from phthalo purple and emerald green. C. Russet is made from phthalo purple and cadmium orange. One can almost guarantee harmony with tertiaries since each of them contains parts of all primaries.

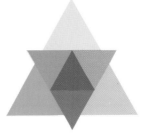

Lithographer's process colors are shown overprinted to indicate how three primaries are surprinted to mix color. To maintain clarity, the colors have been lightened to 70 percent process yellow, 70 percent process red, and 50 percent process blue. In printing production, a black is also introduced.

An extreme enlargement of the lithographer's four-color halftone screen showing juxtaposition and overlapping to give optical mixtures. All paintings in this book are printed in this fashion.

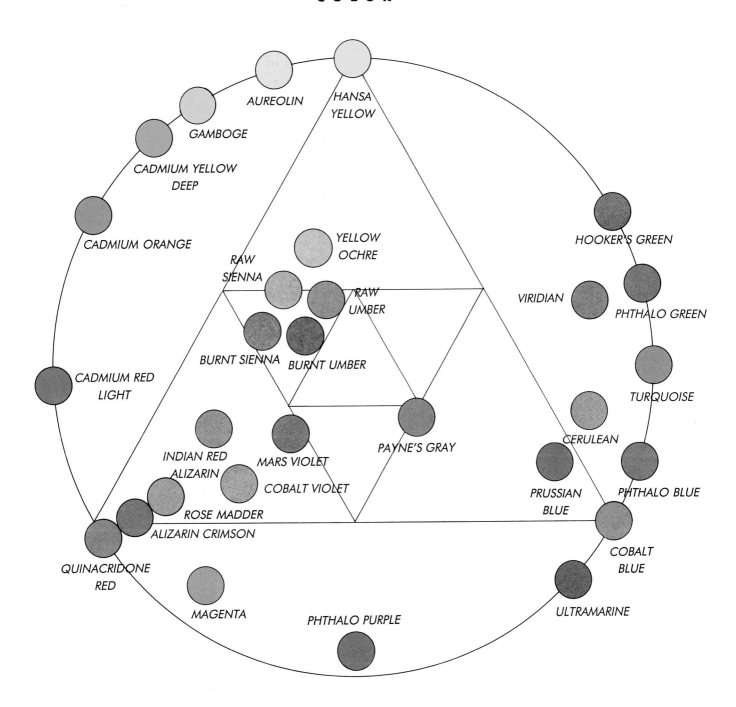

Paint wheel

On the paint wheel above I have placed most of the popular watercolors. The outside circle contains high intensity hues while the center triangle is neutral gray. In actual practice you will notice that many ready-made greens and oranges (secondaries) are just as high in intensity as the primaries. Therefore, they are placed on the outer ring with the brights. Notice also how Payne's gray, raw umber, and Mars violet are close to

the tertiary positions. Many of the colors shown here are tinted so the reader can see the hues more clearly.

What throws us off in actual practice of watercolor is that while a paint might be diagrammatically placed near the neutral tertiaries, its tinting strength and its undertone might make it almost as influential as a primary or secondary.

If your color aims have been haphazard, why not copy this diagram and place the paint from your palette

in position on it?

Note: I use paint made by several manufacturers, often switching brands and adding or subtracting colors from my palette. Therefore, I try not to project my thinking based on any proprietary names except that Hansa yellow and Phthalo crimson are Grumbacher colors. In actual practice, I choose my brands for each color's specific characteristics of solubility, viscosity, hue, sedimentation, transparency, and availability.

Contrasts

Warm vs. cool

The Impressionist's practice of juxtaposing small touches of contrasting color resulted in lively stimulation in the beholder's eye. Though few of us wish to paint in dots, we can appropriate some of the scintillation of broken color by mingling warm with cool. We can do this by:

1. Painting wet warm into wet cool or vice versa. This procedure requires a soft touch with the second application so the first layer of paint is not churned up.

2. We can place patch against patch. This mosaic is similar to Impressionist color but employs soft edges between contrasting hues. The softness results from paint applications made on a damp, but not wet, paper. A fused edge is easily made between two wet applications.

3. We can apply wet warm over dry cool or vice versa. The appearance of the two layers is a result of seeing one hue through a transparent glaze. The mixture is made in the beholder's eye.

Hue vs. hue

Anyone can dip into different hues. The problem is to get a unity of color in one painting. Making one hue dominant is the fastest way. The dominant hue will occupy most of the picture. Opposing hues are introduced for interest, but they should not challenge the dominance. If one hue isn't dominant, then at least make the picture dominantly warm or dominantly cool.

1. Wet cool into wet warm.

2. Patch against patch.

3. Wet over dry (layering).

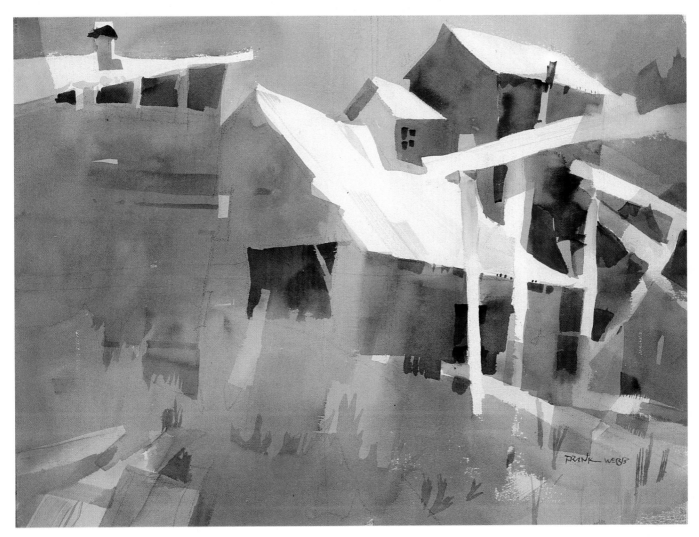

West Wardsboro Lumber, 22" × 30".
A yellow hue unifies this painting. Of
course there are some purples to make
the yellow more exciting, but yellow
dominates other hues.

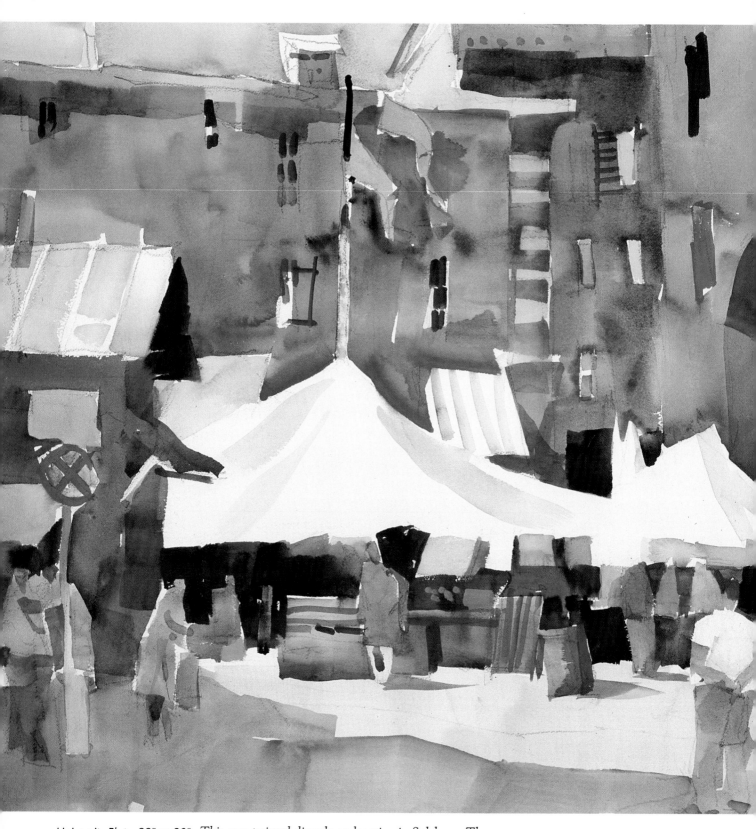

University Platz, 22" × 30". This was painted directly on location in Salzburg. The wide variety of intensities of colors helps to add interest. The somber colors make the bright ones sing. Of course, these are not the actual colors. I have made my own color chord and have added banners and other details but have stayed within the parameters of the representational mode.

Bright vs. dull

Intensity of color is one characteristic often ignored. A painting will be more interesting if you vary the intensities. Contrast the weak against the strong. Reserve high intensity colors for smaller shapes and details near the center of interest. Most large areas should be made up of neutralized colors.

Light vs. dark

Value contrast has been discussed in Chapter 3. Each paint color has its specific value (yellow for instance is a light value). It is imperative for you to control value and be able to manipulate hues, values, and intensities of all your colors.

Complementary contrasts

Color excitement comes from the use of complementaries. Their color opposition suggests completeness. One color in the pair should be dominant in size or in intensity.

Simultaneous contrast

Color is affected by its context. You can make a gray area look purple if you paint yellow around it.

If you close one eye and squint through the other, you will see the neutral gray center takes on a green at top and a red at bottom.

Four modes of painted color

Local color
Early painters used color descriptively, painting blue sky and green grass.

Impressionist
Color is used to give optical mixtures while the separate colors give atmospheric effects.

Expressionist
Color is used at high intensity to foster emotional responses.

Constructive color
Color can be manipulated to suggest spatial sensations. Warm colors appear closer, cool colors further away. Also, intense color seems to come forward while less intense color recedes.

Color dominance
One of the surest ways to unify a painting is to make one color dominant. One hue and its near neighbors should occupy most of the picture. Disunity results when many competing colors are used in equal amounts.

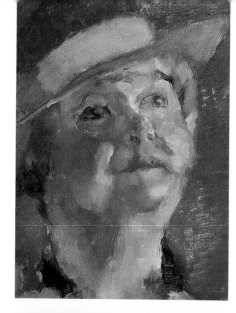

All Red Up, 14" × 11". There is obvious red dominance in this oil portrait sketch. As usual there is a complementary color (green) lurking on the shade side.

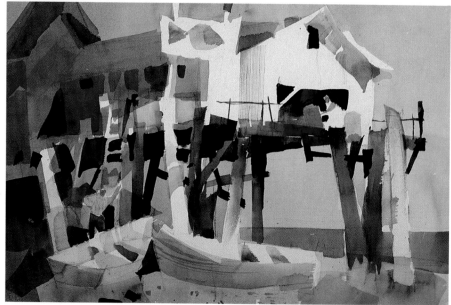

These two paintings were made up of the same subject using a yellow dominance in one and a blue in the other.

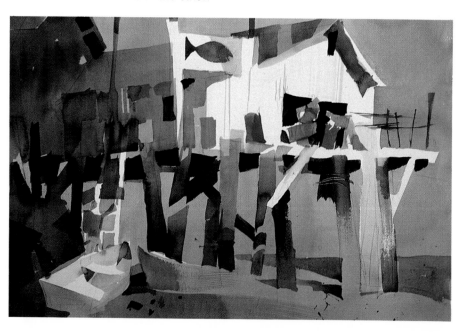

Whites and darks with color

In any medium, white, gray, and black are resting places and a reference for color. In the entire range of values, white is most attractive because it is the metaphor for light, knowledge, and deity. While physicists might exclude white and black from color theory, those who paint know that in our subtractive mixtures we often resort to using these as part of any color scheme.

Color modeling

Traditionally, the artist models the bulk of an object by using value changes to suggest the effect of light and shade. Chapter 3 indicates that value intervals are quickly exhausted. When a value difference is not obtainable, we may model with a hue or an intensity change, thereby greatly extending the range of surface modulations.

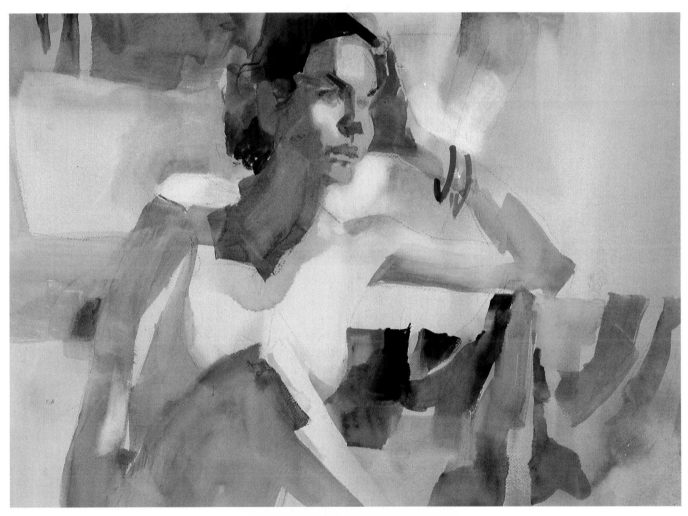

Above. *I used changes in color to model the thigh because my subject matter lacked distinct value differences. Keeping a value but changing the hue is one way to achieve simplicity.*

Right. *The red tone is mingled alizarin and cadmium red light. The yellow is lemon and gamboge. The subtle interaction of straddled color activates the passages.*

Color straddling

A color can be straddled by substituting its two immediate color wheel neighbors — such as mingling yellow and red on the paper to make an exciting orange. Or, even simpler, when painting a large red area mingle alizarin crimson and its near neighbor, cadmium red light. This subtle interaction adds interest.

Color repeats

No single color in a painting will be integrated until it is echoed elsewhere. Circulation and unity will result from your repeats. In nature, color repeats are seen as bounces or reflections. As in music, you will want to make variations on your theme. When repeating a color, change its size, intensity, value; even the hue can change a little. The result will be a resemblance more than a mechanical repeat.

Gradation

A *hue* can be gradated toward another hue without changing its value or intensity. A *value* of a color can be gradated toward lighter or darker without changing its hue or intensity. The *intensity* of a color can be gradated from dull to bright or vice versa without changing its hue or value.

Thus, we see that hue, value, and intensity are mutually exclusive. Each can be shifted or gradated up or down independently or combined with the others. Gradation can be used to avoid monotony, bring an area to culmination, and to reduce contrast. A color made dark with a color other than black might create a stronger contrast if it is warmer or cooler than adjacent hues. An increased amount of hue or chroma toward a juncture of shapes will increase brilliance while the value remains constant. Or, to soften a clash at the juncture of two colors each might be gradated toward the other.

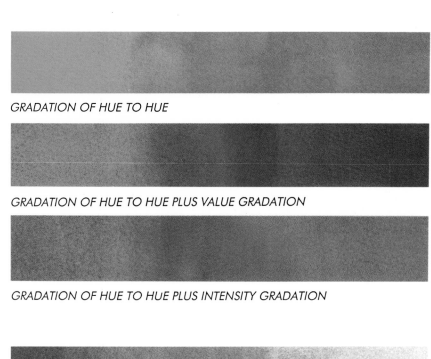

GRADATION OF HUE TO HUE

GRADATION OF HUE TO HUE PLUS VALUE GRADATION

GRADATION OF HUE TO HUE PLUS INTENSITY GRADATION

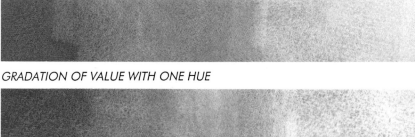

GRADATION OF VALUE WITH ONE HUE

GRADATION OF VALUE PLUS HUE GRADATION

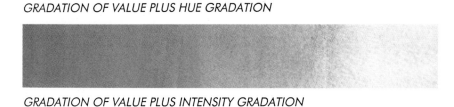

GRADATION OF VALUE PLUS INTENSITY GRADATION

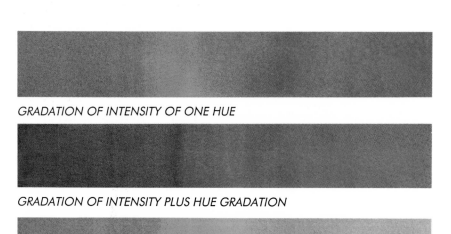

GRADATION OF INTENSITY OF ONE HUE

GRADATION OF INTENSITY PLUS HUE GRADATION

GRADATION OF INTENSITY PLUS VALUE GRADATION

Midvalues

Most color at high intensity resides in the midvalue range. Yellow (highest value) and purple (lowest value) are exceptions. If you seek strong, decisive color in your painting, you should plan your values to display a dominance of midvalues.

Freshness

Color in watercolor is almost always most beautiful when there is a minimum of mixing and fudging. It is livelier when mixed on the paper. You cannot judge a puddle of color on the palette as the oil painter does. It can be judged best when it is on the paper with its companions.

Limited palettes

A wide range of color values and intensities can be made of simple triads and limited palettes. The only inappropriate limited palettes I can imagine are those which cannot be mixed to provide a full range of values. Since purest watercolor is uncomplicated and has no body, almost any two or three contrasting colors can be intermixed at will. Some of my favorite limited palettes are:

Burnt sienna	Viridian
Phthalo blue	Cadmium red light
Phthalo blue	Yellow ochre
Alizarin crimson	Burnt sienna
Gamboge	Payne's gray
Phthalo purple	Cobalt blue
Cadmium orange	Indian red
Viridian	Yellow ochre

When using colors to recreate a general harmony of tones in nature, one loses it by painfully exact imitation, one keeps it by recreating in an equivalent color range, and that may be not exactly, or far from exactly, like the model. Always and intelligently to make use of the beautiful, which the colors form of their own accord, when one breaks them on the palette. I repeat — to start from one's palette, from one's own knowledge of color — harmony is quite different from following nature mechanically and obsequiously.

— Van Gogh

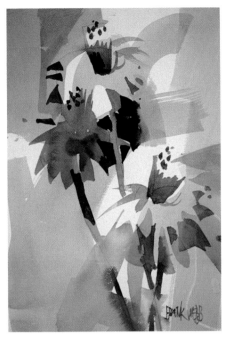

This small painting is made with two colors, burnt sienna and Prussian blue. I have used only burnt sienna at full intensity in small areas. Notice how the colors combine to make green. I think it's best to choose a warm and a cool color that will make a rich dark.

Left. When a blue edge meets a yellow edge a sharp difference results. When each color is gradated toward the other their juncture is less obvious though the edge is still just as hard.

When yellow meets red violet the edge is also sharp. If you increase the intensity between the two, there is a more brilliant contrast. Thus we see that some junctures can be suppressed while others can be intensified. These manipulations give great latitude to the use of color.

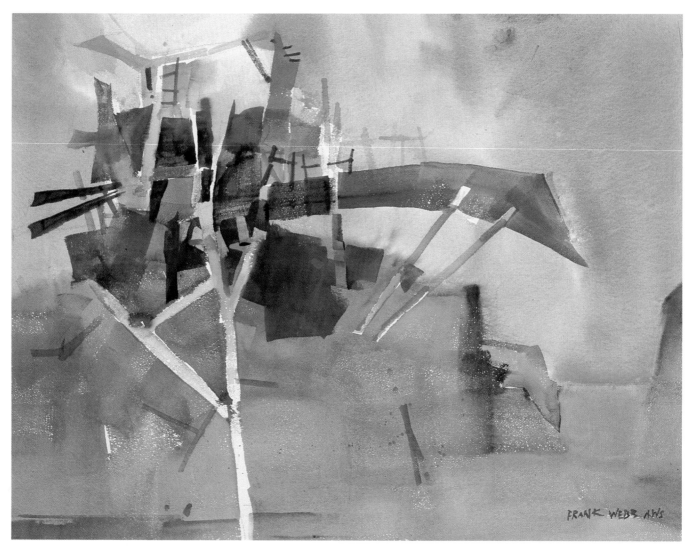

Salmon Fishing Platform on the Columbia River, 22″ × 30″. Here, I imagined backlighting and suggested radiant light by using heightened color. Often it's rewarding to use color without restraint.

Decisive color

"If you cannot pronounce a word, say it loud," said Will Strunk. In the same spirit, reach for frank color — color that is not sullied by fear. Indecisive color is bad color. That is not to say that gray does not have a use — but even gray should be made deliberately and not by fudging and repeated corrections. If you try to conquer wrong color by slapping right color on top, you will end with an undistinguished performance.

Visualize, don't copy

Creativity requires us to make our own shapes, values, and color. Color comes from you and your palette, not from the subject. Try to formulate a special color strategy for each painting. It is better to be wrong than indecisive.

Typical foundations are:
A. ULTRAMARINE + BURNT SIENNA
B. COBALT BLUE + INDIAN RED
C. VIRIDIAN + ALIZARIN
D. VIRIDIAN + BURNT SIENNA

Color changes within a value

You can vary colors galore within one value shape. This is further evidence that value organization is more fundamental than color. If you find it impractical to make a value gradation across a large area, give that uneventful area a color gradation or an intensity gradation.

Foundation color

Most painters use favorite combinations of colors to serve as the value base for large areas. Typically, smaller, more contrasting color gems are then added. One of the most common of such foundations is ultramarine blue and burnt sienna.

Walk into any exhibition and spot these blue/brown descendants. If you always use this foundation to begin, why not experiment with others? Some I have tried are cobalt and Indian red, viridian and alizarin, or viridian and burnt sienna. Using a pair of colors that includes a warm and a cool is the most practical. The purpose of a foundation color is to achieve the desired value with a hint of its warmth or coolness while initiating coherence among the large areas.

Consolidate warms and cools

In value allocations lights must be gathered together and opposed to the gathered darks. So, in color, concentrate first and foremost on gathering the warms and playing them against the collected cools. Chaos rules when the concentration is focused on little contrasts of value or color while ignoring contrasts of large groupings.

Use a light touch

Nothing will so flatten and kill color as an overzealous mixing on the palette. It is much more exciting to mingle colors on the paper where hydraulics, capillary action, gravity, and surface tension encourage natural, irregular mixtures. Your brush movements should take on the light touch of a fluttering butterfly wing.

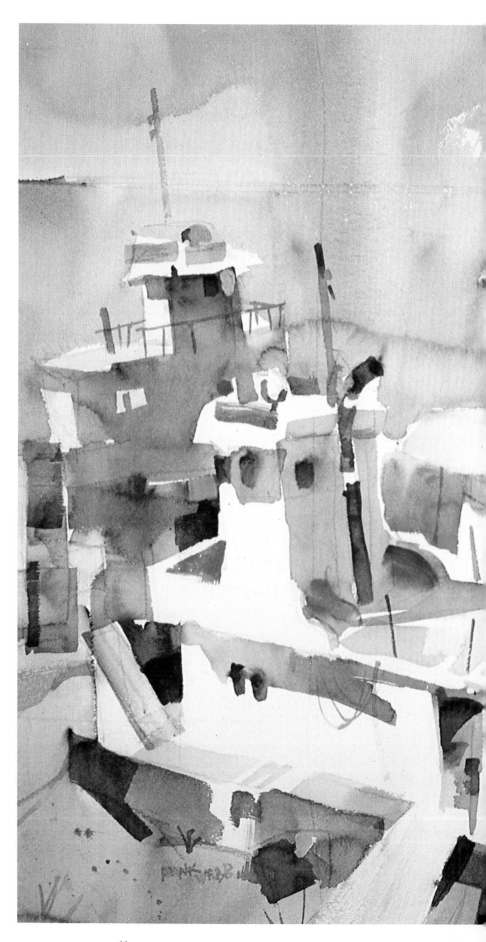

The Monongahela Visits the Chick Grimm, 22" × 30". A directly painted subject on dry paper. I went in with large flat brushes aiming to put on the last coat first. A dominance of cool yellows is excited by subordinate cools. In the collection of Wausau Insurance Co.

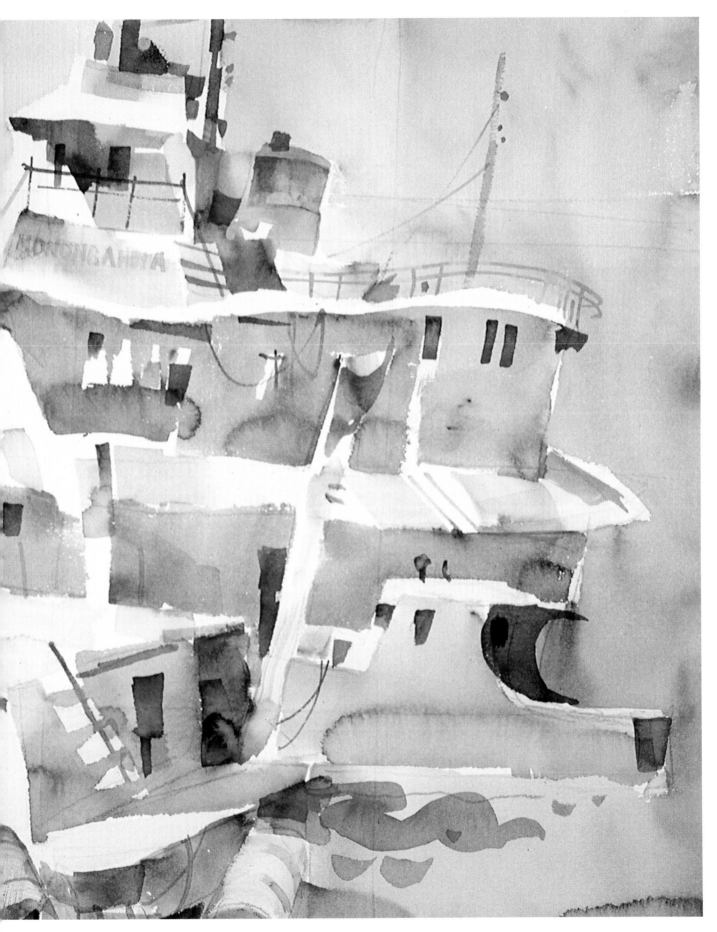

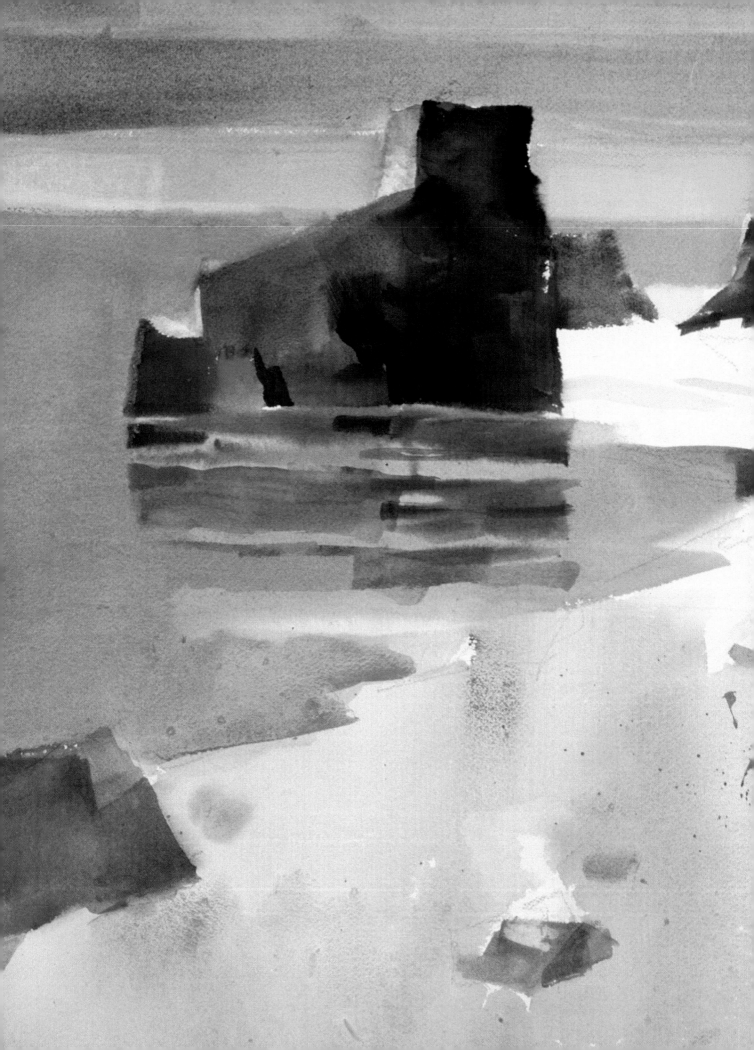

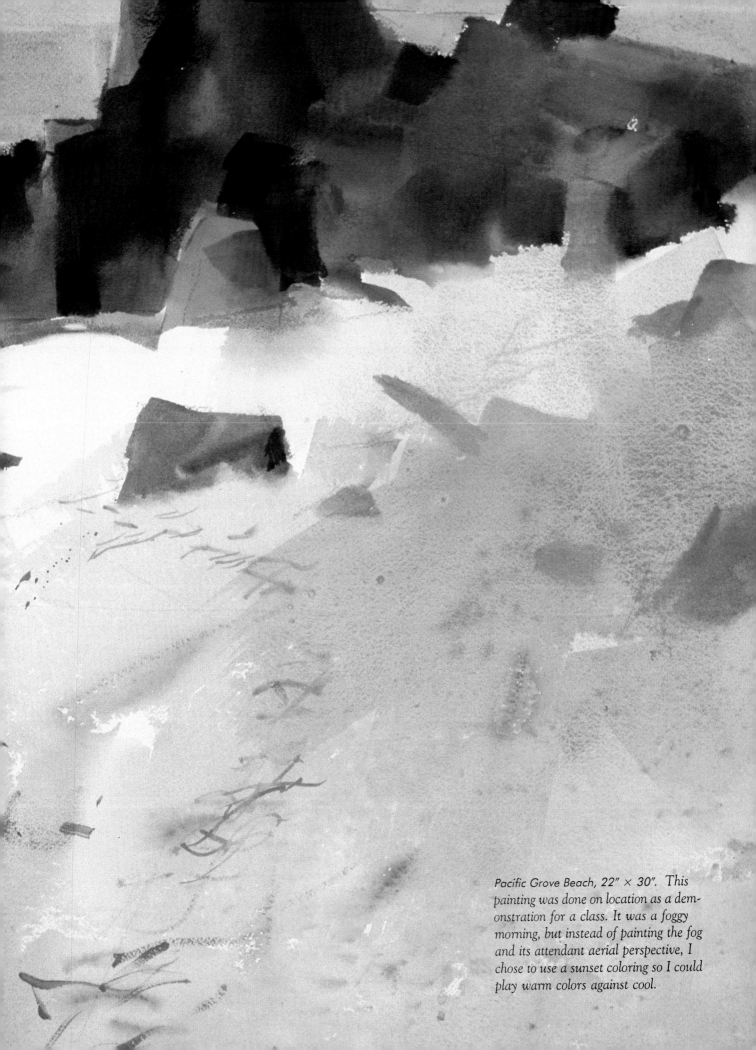

Pacific Grove Beach, 22″ × 30″. This painting was done on location as a demonstration for a class. It was a foggy morning, but instead of painting the fog and its attendant aerial perspective, I chose to use a sunset coloring so I could play warm colors against cool.

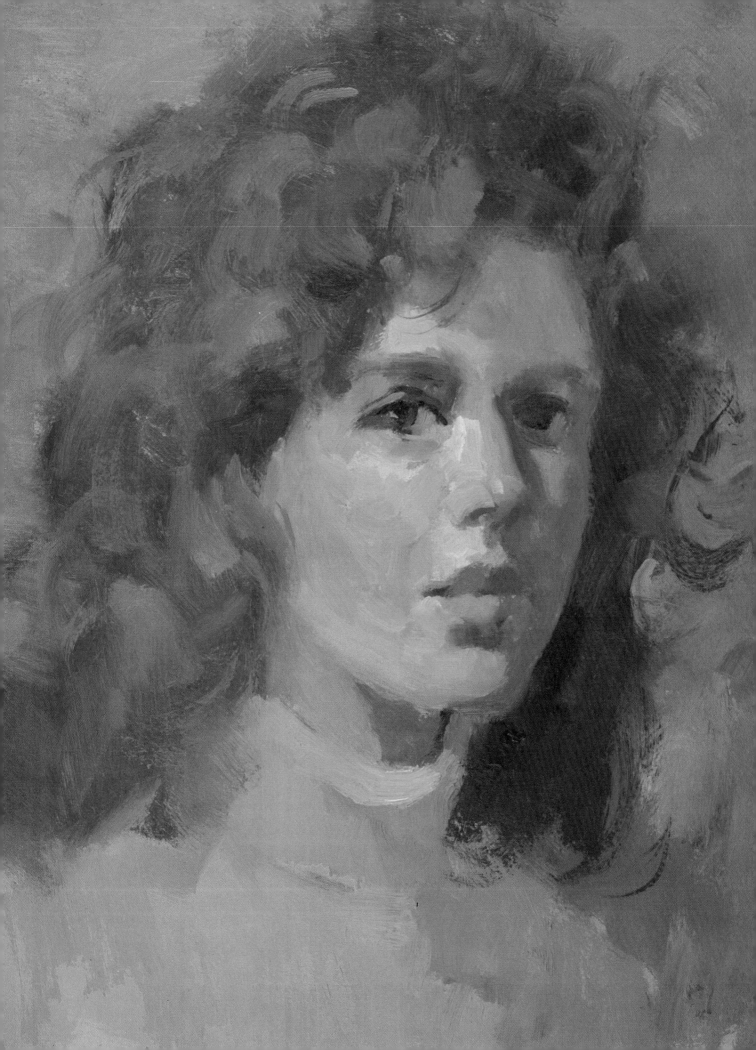

CHAPTER 5
STYLE

Many an artist undergoes an identity crisis while seeking a style. But style is not like a clothing fashion which you can put on. It is not something added to your painting. Uniqueness comes from birth and through growing and working. It is the fruit of sincerity, industry, and consistency. Style is character.

Your grasp of what is behind mere appearance will eventually condense and intensify certain qualities, making your work unique. Style is the inevitable result of pain and anguish. We suffer as we give up lesser parts of ourselves. The discipline of the arts demands these renunciations which we are loath to yield.

As one cannot make love by proxy, neither can one paint with one eye on the style of another. Art and style are always dependent on sincerity. Insincerity, such as painting only for money or for popularity, will always thwart style and quality.

Take stock of the self

Are you a virtuoso or a composer? The former concentrates on skill and performance while the latter is chiefly concerned with creative concepts.

Are you a classicist with a mind toward what the world should be? A romantic worrying about how you would like the world to be? Or are you an expressionist knowing how the world feels?

Do you need to make a living at art? Are you willing to serve a long apprenticeship? Are you a self-starter? Are you spontaneous or orderly?

If you can become acquainted with yourself, you have some clues of where your work should be headed.

Freedom vs. restraint

What makes the kite fly? The wind? No, not the wind, for if you cut the string, down it comes. Is it the string? No, the string does not lift the kite. The kite flies on that delicate border between freedom and restraint. Art is spawned from that straddling position which furnishes the necessary tension.

Total spontaneity is chaotic while total order is boring. Nevertheless we cannot live in total chaos and who would ever choose regimentation? In life as in art we need to combine chance and order.

One artist starts with chance and works toward order. The other starts from order and hopes to introduce chance and spontaneity. Both artists aim to synthesize form and content.

Seeing vs. knowing

This distinction, advanced by Bernard Berenson, divides one art style from another. The Egyptians drew what they knew and did not draw a unified figure of a human from one stationary point. In contrast, the Impressionists looked so intently that they gave up knowing. Your style will relate directly to the manner in which you combine your seeing and knowing. Correct what you see with what you know. What you know is, in large part, a summary of a thousand previous seeings.

Intuitive painting

To paint intuitively is to paint by way of impulse. This intuition (insight or inspiration) comes as accelerated thinking. It is seeing directly to the heart of the matter. If you have ever run downhill on a rough, rocky terrain, you are confident that your feet will find appropriate facets of stone even while hurtling through air. Your whole body participates in the risk of finding secure footing. Often a similar inspiration comes to the painter who has lurched into a painting pell-mell. The rush of immediacy and the tension between failure and gaining equilibrium provoke excitement. The more experience the painter has, the more likely an intuition will come.

Creativity often enlists our intuition so that our preconsciousness or subconsciousness can see, conceive, and execute in extraordinary ways, making our work unique.

The values that reside in art are anarchic, they are every man's loves and hates and his momentary divine revelation. The apprehension of such values is intuitive; but it is not a built-in intuition, not something with which one is born. Intuition in art is actually the result of (long) prolonged tuition.

—Ben Shahn

This study at left is made of white objects on a white table with a window furnishing back light. It is fairly representational. Warms and cools are introduced into shade and shadows, for this is the only opportunity to introduce color.

Following this experience I made two semi-abstract studies to explore space and shape. The center painting suggested a device that I used in the painting on the right. It is a perspectival plane on the table top, imagined as a white paper or cloth, at odds with the vanishing points and parallel to the picture's borders. This ambiguous device flattens the space at the same time that depth is implied.

Abstract vs. realism

An early definition of the real is that it occupied a given position in space. In art the word realism started as a philosophic term with Courbet and referred to the repudiation of idealism. Today it seems to mean any painting that represents natural appearances. Paintings are thought to be more realistic when they parade painstaking details.

Abstract art depends on form (design) and color, which might be partly or wholly independent of a subject.

No one can say where abstractionism begins. Abstractionism results from the artist emphasizing certain qualities and not others. The selected qualities are deemed to be more significant. They are the images

of feeling. Abstraction is actually found in all realistic paintings, but the realist is more interested in literal *representations* while the abstractionist seeks emotional *presentation*.

The realist seems more interested in "things" while the abstractionist seeks "form."

The abstract in any painting is a bridge for the communication of some of your storehouse of feeling and personality. More specifically, it is a bridge that connects the outer world with your inner reality. It will usually convey some of the wonder and some of the mystery. I am not discussing pure abstract painting, but abstract in the sense that any value, shape, size, color, or texture deviates from nature. The abstract results also from the artist's attending to chosen

qualities while correspondingly ignoring other actual or possible qualities.

Here are some of the practical qualities that come with abstract underpinnings.

Equalized surface tension. This is the order of the elements as a dynamic equilibrium, felt apart from the depiction of subject.

Expression in terms of the chosen medium. This has to do with the wetness of watercolor, the flatness of the paper, the linear feeling of pencil work, the value nuances of charcoal, and a variety of other characteristics.

Rhythmic dynamic form. This is the movement of the elements within the border — in a two-dimensional sense as well as push and pull into depth. It is felt as emotion-tension rather than seen.

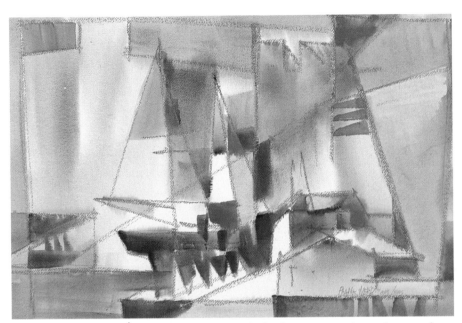

Perry's Flagship at Erie, 15" × 22". Space is cubed, edges are straight, and rectangles dominate the triangles. The painting was begun with wax red crayon, which resisted water later when washes were applied.

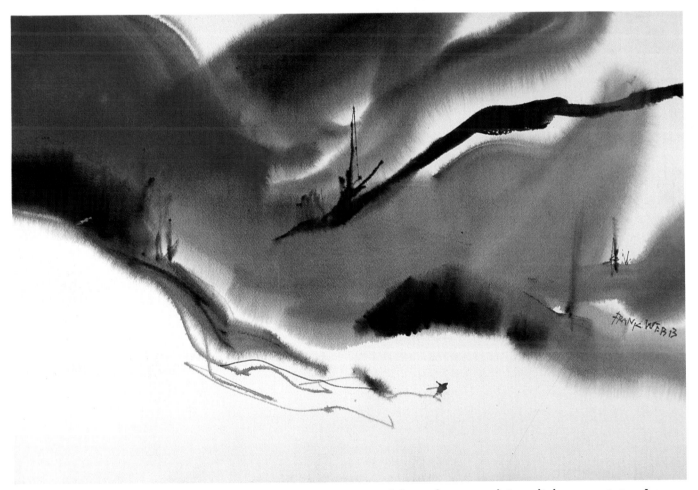

Seven Springs, 15" × 22". A large abstract wash is applied to a wet paper. Interlocking gestures suggest pictorial movement. The skier is minimized to express the vastness of the hill and sky.

Synthesis of abstraction and realism

It is easiest to combine abstraction and realism by starting your painting with seeing, thinking, and planning abstractly. Realistic data may then be added as you desire. If you do the reverse and begin with imitating appearances and facts, you will likely begrudge the loss of your "drawing" while trying to impose design.

Philosophically, you should confront the picture with the attitude of "what do I need here?" in place of "what is out there?" You must feel the need of the value, shape, line, color, direction, texture, or size that will make your picture live. In a nutshell, do not paint things, paint conditions, impressions, ideas, or senses. Do not paint "what is," paint "what could be" and even more importantly, "what ought to be."

Realism and abstractionism are not enemies. They eat out of the same dish; but their digestive systems are different.
— Leo Stein

While recreating your new reality, use the wonderful appearances you see in the world, but recreate them in the forms of feeling. Paint it not only in the manner of what it looks like, but what it feel likes.

In a synthesis, representative data comes from *out there*, while the abstract design comes from *inside*. This combination separates a work of art from the everydayness of experience and, paradoxically, gives the work an alien feeling while at the same time it is mercilessly intimate.

Below and at right are four interpretations of a Mexican market at Taxco. In each of these the aim is to create a unity belonging to that picture only. These variations were each made with reference to one drawing.

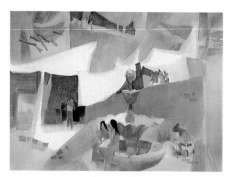

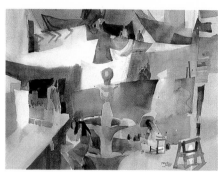

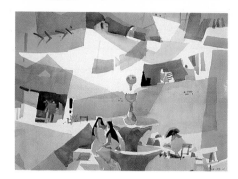

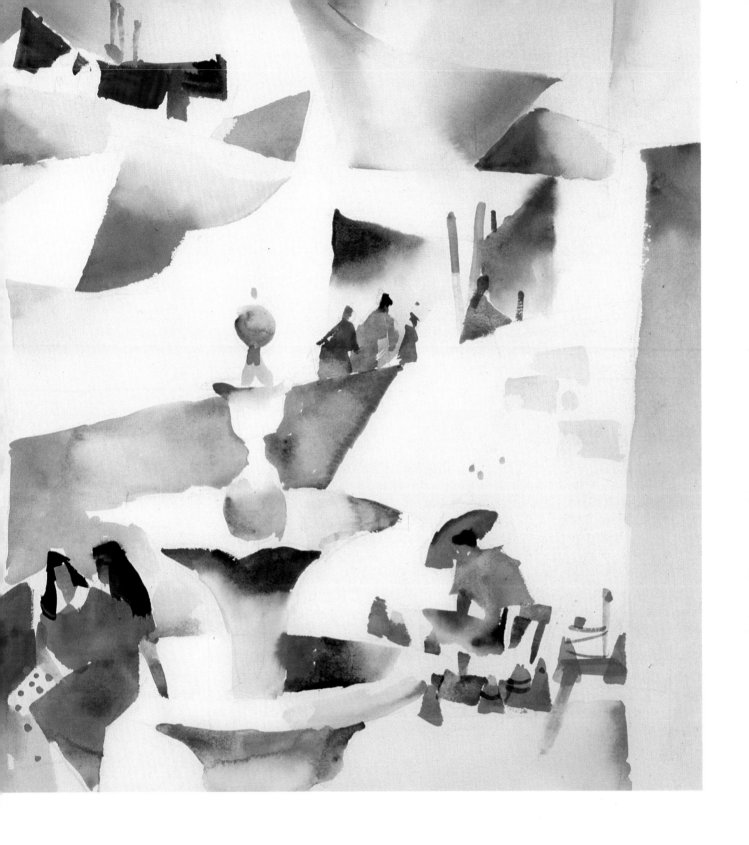

69

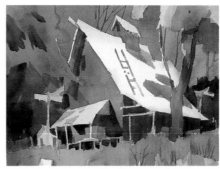

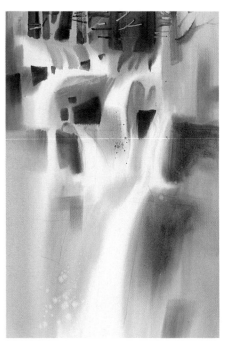

A comparison of sugar houses shows the one at left to be a little less abstract than the one at right. Some construction changes were also introduced.

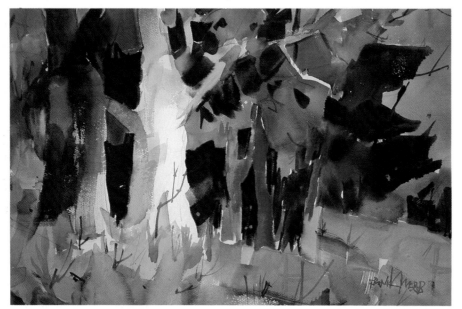

Twin Falls, 30" × 22". I wanted to show the gesture of water using wet into wet to express wetness with a minimum of detail. Trees at the top are abstracted to the same degree as the water shapes. Rocks are only hinted at as hard-edge shapes that are primarily placed to punctuate the white dashing water.

This forest, seen from the edge of a meadow, shows a consistent handling of foliage; the shapes are related to one another.

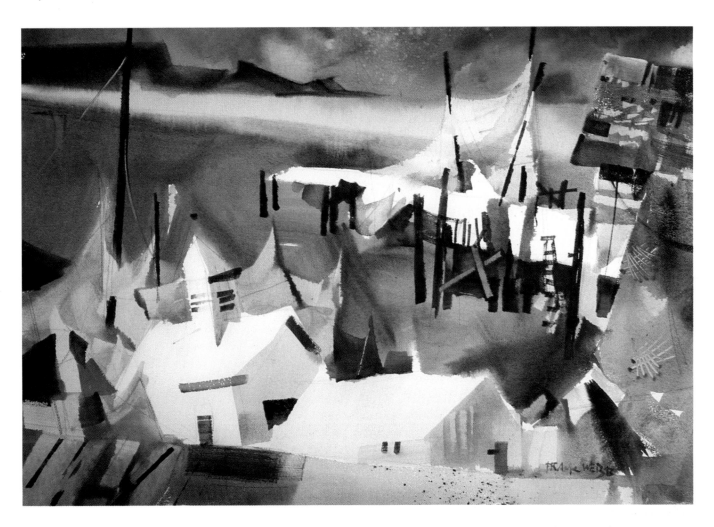

Consistency

The shapes, values and color of a painting must maintain a consistent degree of realism or abstractionism. If your shapes are exaggerated and distorted for the sake of expressiveness or creativity, then your value and color chords should depart in the same degree. If your drawing remains representational, then your employ-ment of light and shade should be circumspect and your color allied closely with local color.

Consistency also must be maintained from one part of a painting to another. You cannot have an abstract sky vaulting over a realistic meadow.

Consistency is the only criterion in art.
— James K. Fiebleman

The Harbor, 22″ × 30″. Here I have somewhat ignored linear perspective, I hope with consistency. The houses at bottom normally would require a much lower horizon. In thumbing my nose at perspective here I have even tipped the horizon. Some painters will not go this far, and others go much farther. You must find your own point on the spectrum.

Omit unnecessary parts

Style is more a matter of what is subtracted than what is added. Follow the rule of parsimony and do not change a value until you have to. Then the change of direction or value will be significant. When values or contours are similar, combine them. Don't hatch out new color everywhere. All effects of contrast in a painting are gotten by sacrifice. Seek the poetry of the unsaid.

Above all, develop sincerity; it is the key to originality, and it is easier on the psyche than cutting off your ear. Style is not novelty. Sincerity exacts a cost. It means being you, in spite of trends. It is the only way you will eventually be separated from those who run with the pack.

Never put more than two waves in a picture; it's fussy.

—Winslow Homer

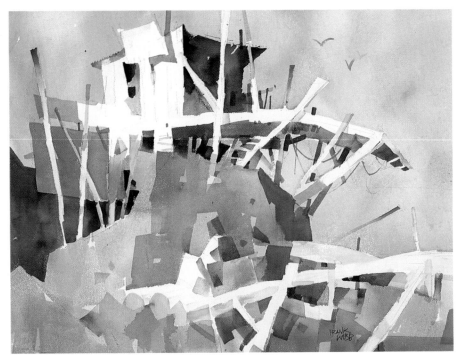

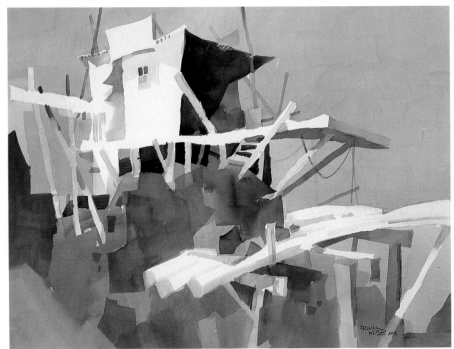

The Dalles, 22″ × 30″. There is a separate unity in both of these, though they are of the same subject. The top has a color patch concept while the bottom is a flat, layered approach. The trick is to adhere to the concept you bring to the painting. Transparent watercolor does not easily adapt to a shift in idiom during execution. I learn much from experimenting with a single subject in a series of paintings.

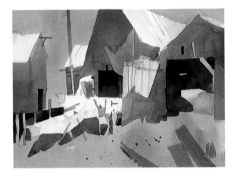

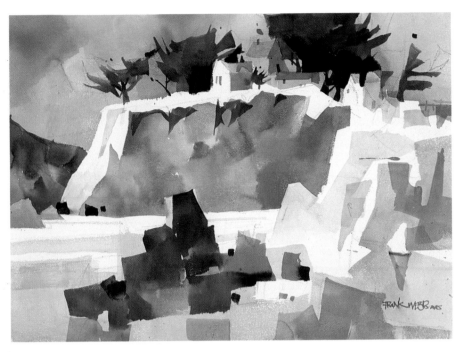

Above. Biddeford Pool, 11" × 14". This painting is simplified by conceiving the shadow-shade shapes as an abstract, interlocking entity. I imagined that the opened door at the center provided a light-struck relief. The white shapes were consolidated and carefully shaped also. This is an example of the admonition, "Think more—draw less."

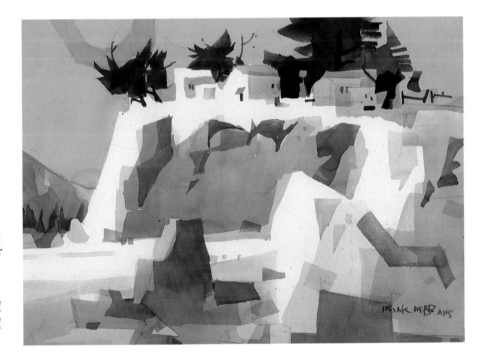

Lover's Point Revisited, 22" × 30". Like the previous comparison, each of these approaches is true to itself. At top right, the patches create color-breaks throughout, setting up vibrations in the viewer's retina. This can suggest the brilliance of outdoor light even though we can't match its brightness. On the bottom, I rely on shape almost exclusively with all hard edges. A certain subtlety is gained by layering contrasting colors.

Bear Run at Fallingwater, 22″ × 30″. In abstracting this familiar motif I felt the need for yellow at the top. In the middle of the execution I decided to use it for the trees—not a logical color for tree trunks in western Pennsylvania, but then in art, people might have wings. Perhaps the color is a little more arbitrary than the degree of abstraction in the shapes, space, and lines. In that sense this picture might be inconsistent. We should listen to our inner promptings for they lead us beyond the futility of fact to the threshold of art.

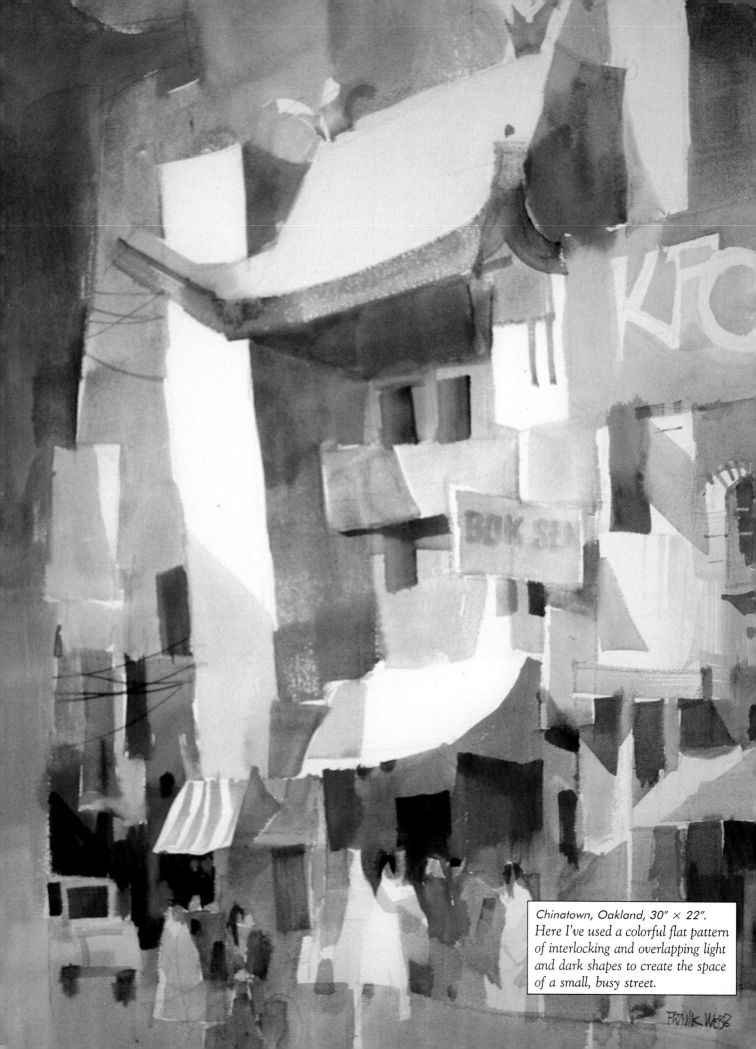

Chinatown, Oakland, 30" × 22".
Here I've used a colorful flat pattern
of interlocking and overlapping light
and dark shapes to create the space
of a small, busy street.

FRANK WEBB

SPACE

Whenever we create a painting (even a bad one) we're creating space. Not actual space, but virtual space—the effect or the illusion of space. Just as the theatergoer willingly takes the events of a play as real, so the human mind is willing to perceive space in a painting.

There are a number of ways to create the effect of space. Most artists begin by using perspective. But, if you remember your first drawing of railroad tracks (two lines converging at the center of your paper), perspective can make you tumble headlong into what looks like infinity. Perspective, of course, can be controlled, but it often thwarts a creative impulse and adds dead areas to a painting.

You may have also tried to express the bulk of volume of objects in space through chiaroscuro by using gradations of light and dark, another well-established and effective technique. But this can stuff a painting with objects bursting out of the picture frame. You're also left with forms very often set against a void for a background.

Instead, look at the many contemporary artworks that don't depend on perspective or chiaroscuro to create space. Painters from Paul Cézanne to the present have treated space by becoming aware of and emphasizing the flatness of the picture plane, often by painting with shapes that are parallel to this plane. Of course, totally flat works can appear superficially decorative and fragmentary, but used in the right way, the flat dimension of painting can present a more lively,

meaningful rendition of what we see and interpret.

This leads us to one of the most important problems in visual art: How to integrate the two opposing dimensions, the flat and the deep. How do we organize a painting to create the illusion of space without using chiaroscuro or perspective?

What follows are seven tips for building this space in your painting. But before you begin, try a few new seeing habits. Looking at a motif, close one eye and squint the other. Imagine a pane of glass set up just in front of the motif. You'll see the shapes of value and color flatten on this plane. Most of the visual trivia will disappear, and the usually ignored negative spaces will take on a new impact. You are now seeing shapes that can find an environment on a flat sheet of paper—your painting. This new way of seeing will help you interpret actual space in a new way.

Opening the picture

Painting is a visual language, but unlike the spoken or the written word it has no sequence. Its all-at-onceness is seen immediately and in total. As a spatial organization it does not dissolve in time as do music and speech. Because it is complete and all-at-once, there is a limit to your ability to influence the viewer's path of vision. The most obvious way to engender this visual movement is by creating a clear opening to this path in your painting.

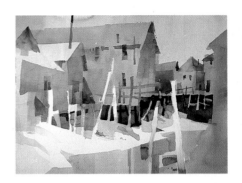

Kennebunkport, 22″ × 30″. The spatial concept of this painting is a classic movement. The picture is opened at the bottom with a movement obliquely to the right and toward deep space. En route, the path circles back on itself and partially returns. It comes to equilibrium at the center of interest in the middle distance. This effective path is an inward moving spiral that coils back toward the viewer. If a return is omitted, the painting lacks an inner rhythm and counterpoise.

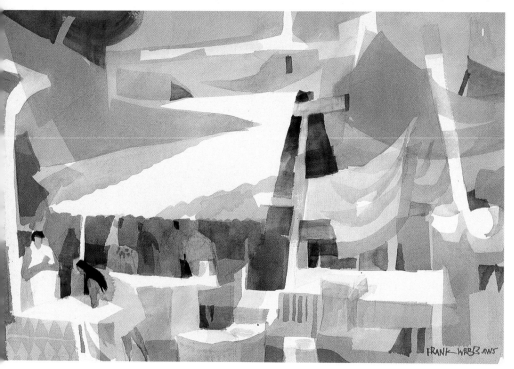

The classic opening is a movement inward from left or right at the bottom border. From there it sweeps across overlapped planes toward depth, then turns and comes partially forward. Though this is not a formula for initiating a painting it is a concept of pictorial space which might guide you to feel pictorial space as a miniature solar system where all attractions are in dynamic equilibrium.

The purpose of the feeling of return is to limit depth so that the picture space is shallow, somewhat like a shadow box. This flattening and simplifying of space enables us to keep control. Each movement into depth is compensated for by a return. Thus equilibrium between flatness and depth is maintained.

When comparing these two paintings of a Mexican market, notice how this one is flat and totally hard edged. To some extent this contributes to its abstract, decorative look.

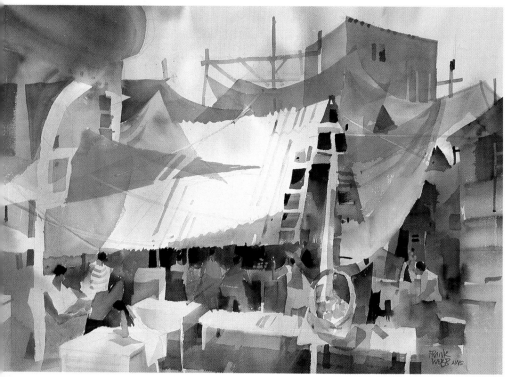

Market, 22" × 30". In this version of the same subject the space is fluid with lost and found edges plus gradations throughout.

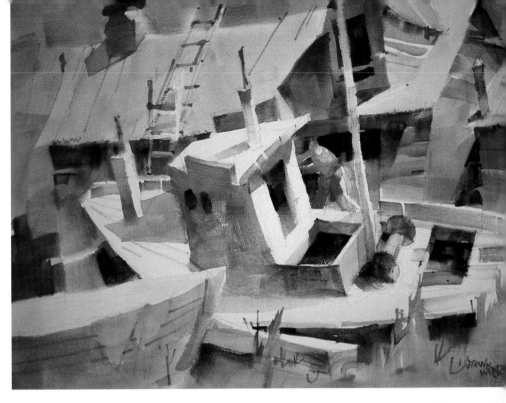

*Beached at China Camp, 22″ × 30″.
The large forms here overlap to create
spatial depth. The oblique plane of the
boat conveys its rocking, floating es-
sence—even when beached.*

Stress a flat pattern

The skeleton of any picture is its pat-
tern of a few large flat shapes and
areas. These large shapes are usually
presented with simple light/dark
value contrasts. This pattern can be
the positive and negative areas of a
scene, it can be the result of light and
shade, of the local color and value of
objects, or a combination of all three.
Either way, it helps to consider this
two-dimensional aspect of shape for
the larger solution of creating space
with overlapping shapes and other
techniques.

For pattern's sake, some visual
data must be eliminated or greatly
simplified. Even when the painter
works from a model, it clarifies the
aim to ask, "How can I simplify the
light and shade into a readable pat-
tern of flat values, which in them-
selves are interesting shapes?" In
short, do not paint objects, moods, or
events. Paint patterns.

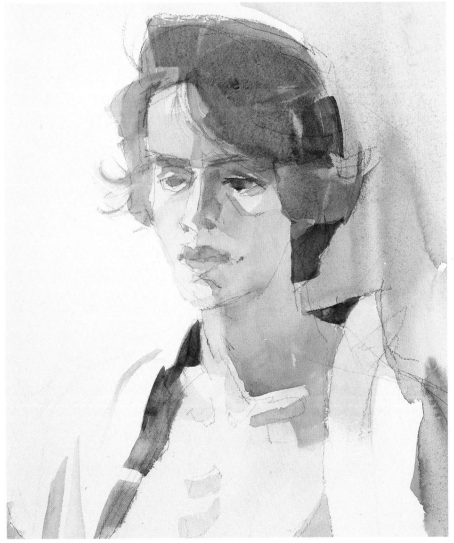

*Simplification of a painting into a pat-
tern of a few large, flat shapes and areas
is at the heart of good composition, and
it sets the stage for spatial techniques
such as overlapping. In this detail of a
figure painting, I envisioned the shadows
and figure as flat shapes. Seeing it this
way made it easy to paint the figure as
a strong, positive shape against the sim-
ple white background.*

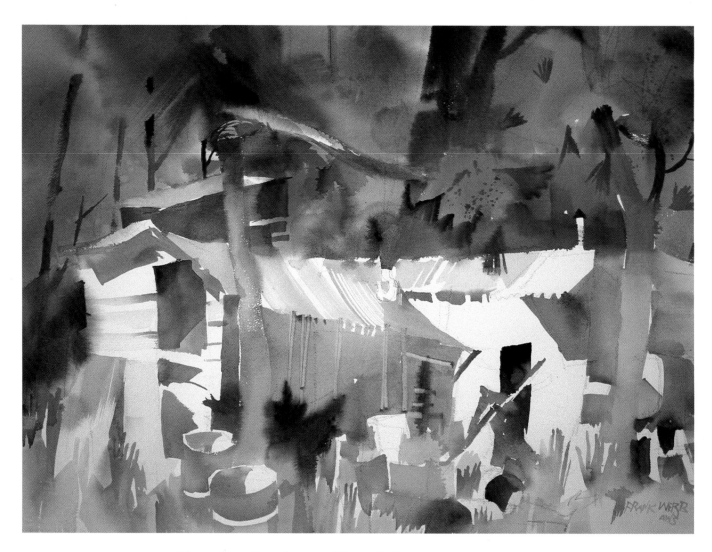

The Jungle Shop, 15" × 22". The most expressive and direct spatial sensations in this painting result from overlapping the shapes of the foliage. Flat, simplified brush strokes are interlocked with other strokes that are parallel to the picture plane. Almost every shape is overlapped.

Overlap and interlock

In the design of your painting, interlock shape with shape in a jigsaw puzzle fashion. This will unify the painting and intensify its two-dimensional flatness. Then, to create depth, partially overlap these shapes to indicate to the viewer which is in front of the other. When one shape overlaps another, no other spatial device will countermand this powerful effect. Look at each shape in your painting and ask, "Can I shift another shape to overlap this one?" or "Can I add a new shape to overlap it?"

Deliberately set up some shapes parallel to the picture plane. This again will enhance the effect of depth. The beauty of these flat planes is that the picture space will remain open to a creative use of value and color. Rather than passively copying the model or motif, reorganize size relationships and shift positions of the elements in the picture to take advantage of overlapping. Build your own space just as you would build your own shapes.

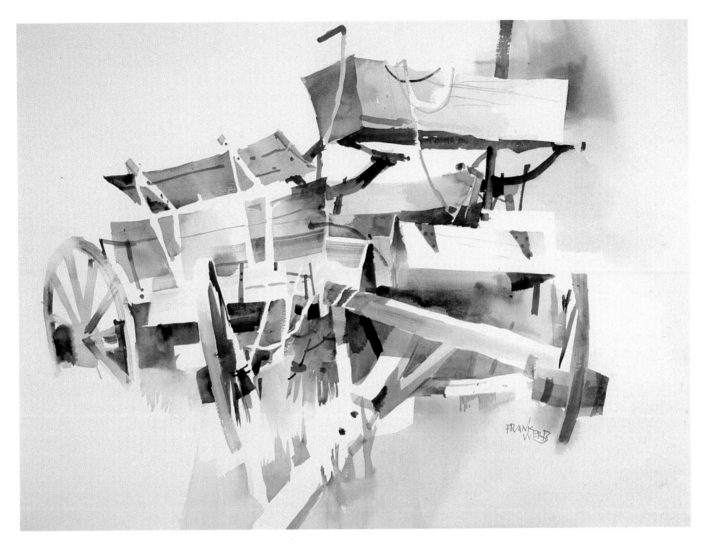

Create passage

While scanning the perimeter of any shape, look for areas where its value becomes very similar to the value of an adjacent shape or space. At such a juncture, minimize or eliminate the edge. This provides circulation; your eye is invited to pass through the connected areas, which might otherwise be isolated with an edge. It also results in bigger, better overall shapes while weaving your painting together.

When two shapes are connected in this manner, one of the shapes will generally be closer in space than the other. But where the contour or edge is eliminated, the combined shapes will seem to lie in the same plane and in the same position in depth. These areas will also feel as though they are parallel to the picture plane. These two effects can add a dynamic spatial quality to your work. Check the work of Cézanne for this feature. Follow the contour of almost any shape in one of his paintings and see where he allows areas of value or color to fuse together. Art is a study of when to put together and when to take apart.

Wagon Whites, 22" × 30". This painting has rivers of white that unite the background with the subject. Passages of this kind link pieces of a painting together. This painting won the Mary Pleissner Memorial award of the American Watercolor Society.

Push back space with arbitrary values

If you deliberately darken a value that lies behind a light shape or object, the darker value will recede in space and push the lighter shape forward. This concept seems to work best when the background is light or white, and the color is somewhat understated. Reversing this ploy is almost equally effective.

Pushback values are usually graded; after an edge is established, the value is discreetly faded away. Remember, too, that when a shape or area is pushed back it creates a space, whether its shape or value indicates that it is an object or just deep atmosphere. I use the term "arbitrary" to describe these "pushbacks" because value and color in this procedure are not used to render things realistically, but are created by the artist who wishes to use space as a creative idea.

Establish planes

We are familiar with planes as they occur on the landscape or as facets which describe a cut diamond. These planes are very useful for adding conviction to our concept and presentation of surfaces. Negative spaces can also be conceived as planes and as solid volumes rather than merely empty space.

It's good to have definite convictions as to whether a plane is parallel to the picture plane, or whether it turns obliquely away from the surface into depth. Try to visualize an axis for each plane, so that these movements can be felt and related over the entire picture.

Geometrize

Flabby, irresolute, or boring shapes of objects or spaces can be vitalized by conceiving them as spheres, cones, cubes, or cylinders. Academic art schools historically taught this to

Wilson's Mill, VI, 22" × 30". Here I've used pushback values. The subject is quite large on the paper. Using pushback values allows plenty of white to circulate through the picture. The subject is lost and found everywhere. The essence is a reciprocity of object and space. The distinction between them is minimized.

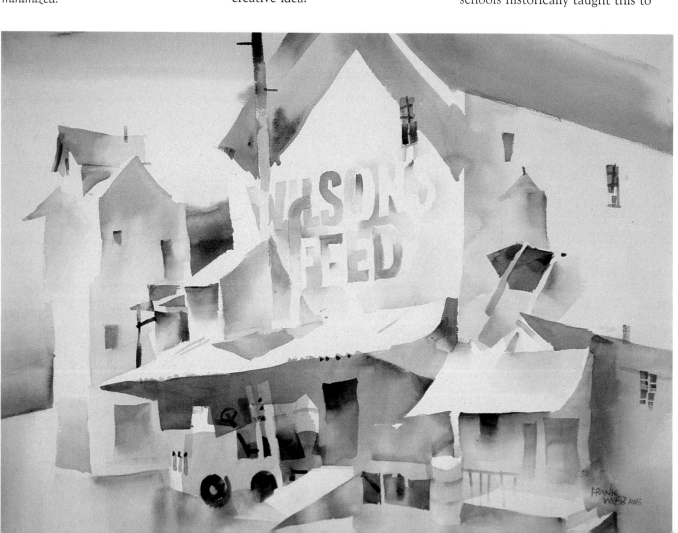

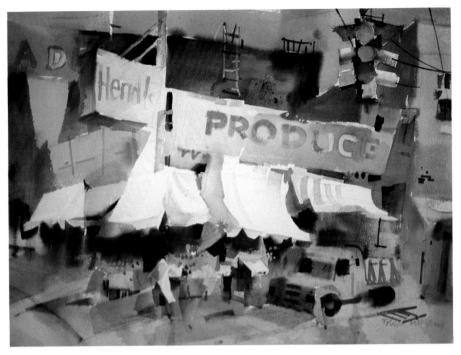

Pittsburgh's Market Square, 22" × 30".
In this painting, I tried to capture the spatial sensations any of us enjoy in a city square. The space itself provides relief from the blocks stuffed with buildings and helps us get a fresh view. I tried to express the cube-like volumes under the awnings. Try to imagine the shapes of the volumes of space as they interact with your subject.

clinch the "thereness" of mass or volume. Use this same concept to add conviction to negative shapes or spaces. The most nebulous areas on any paintings are apt to be the skies. The sky in many paintings is often a smudge of blue stuffed into an area with some clouds for good measure. A sky can be given the same conviction as a mountain if you conceive it as a geometrical shape (see below left).

Today, there are many ideas about creating pictorial space not known in the past, such as overlapping transparent planes, montage, and imposed calligraphy. Photography has also conditioned us to accept the close-up view and the extremely high or low viewpoint. The most exciting discovery of modern art may be the use of color as a major means of creating space. The balancing of opposing forces of objects and space is felt by the artist as emotional tension. The person who beholds the work of art experiences these tensions not only through the eye but also in the musculature, nervous system and the viscera. This means that the artist thinks with the whole body. As you try to carve out your own spaces, remember that your mental, physical, and emotional self are fused into each painting. Every painting is a portrait of its author.

A picture is first of all a product of the imagination of the artist; it must never be a copy. If then two or three natural accents can be added, obviously no harm is done. The air we see in the paintings of the old masters is never the air we breathe.

—Degas

Space and space again, is the infinite deity which surrounds us and in which we ourselves are contained.

—Max Beckmann

SKY AS A
CEILING

SKY AS A
CYCLORAMA

SKY AS A
BACKDROP

SKY AS A
HEMISPHERE

SKY AS A
HALF CYLINDER

SKY AS A
BOX

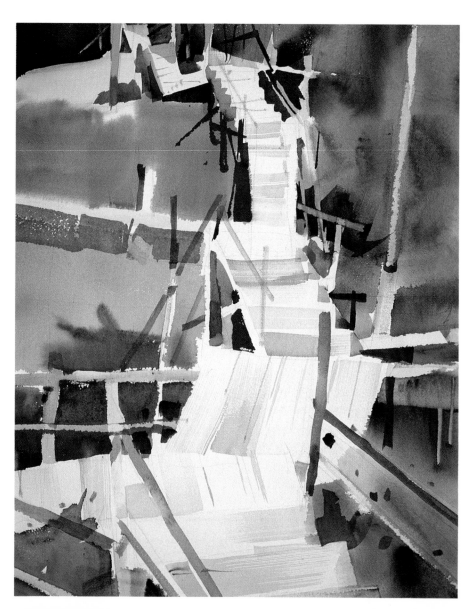

Panther Hollow Stairs, 30″ × 22″. "Downhillness" is expressed with overlapping planes of the landings that alternate rhythmically in direction. Like a spider web, the rails and posts anchor the action to the borders of the painting.

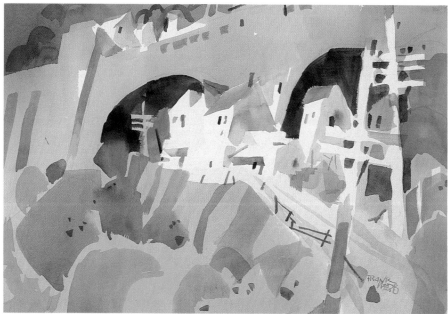

Pittsburgh Hillside, 15″ × 22″. Large calligraphic brush shapes suggest a tree-covered hill. As a result, flatness and depth are synthesized.

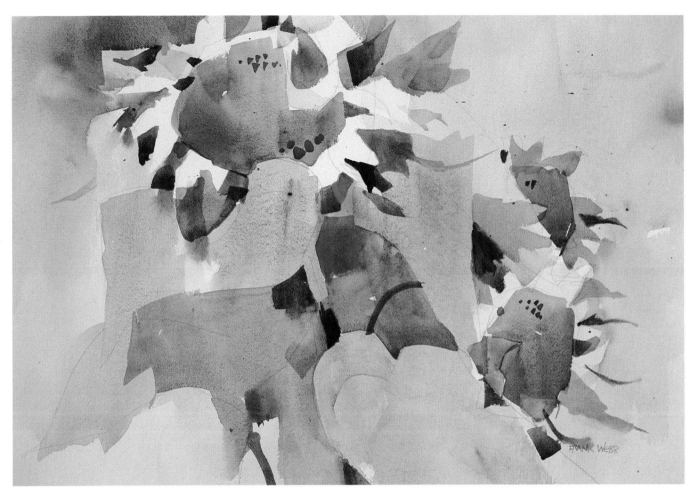

Dakota Sunflowers, 15" × 22". This was painted with a limited palette of burnt sienna and viridian. Negative shapes around the petals were darkened to create a center of interest.

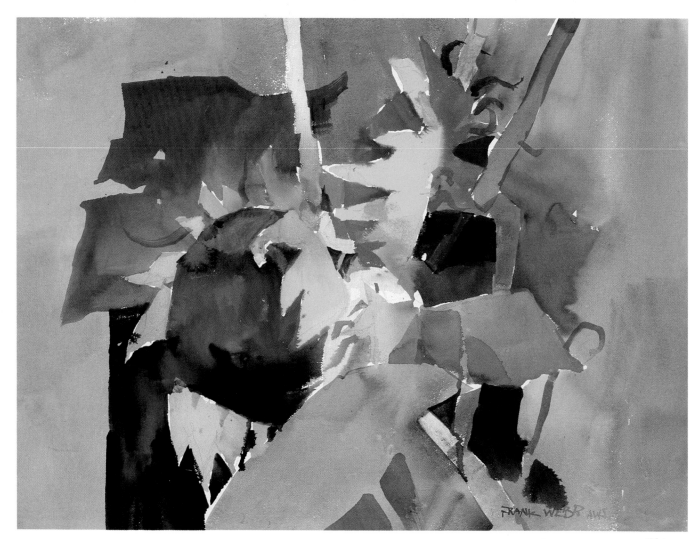

Vermont Sunflowers, 22" × 30". This finished painting was made from the pencil sketch at right. I worked from the drawing even though I remained under the shadow of the huge plant. Flowers are generally thought of as fragile and fresh, soft and high key. For that reason it is less trite to give a flower painting some sonorous deep tones and hard edges. This painting exploits interlocking shapes. It could be stated as a principle that when painting any shape, you should take out bites along the edge as well as making some projections from the edge.

CHAPTER 7
PLANNING

Drawing should not only be fun, but instructive. It teaches courage, wit, personal style, and taste. I quote Degas: "There is courage indeed in launching a frontal attack upon the main structure and the main lines of nature, and cowardice in approaching by facets and details: art is really a battle." Nothing addresses the main structure as directly as a simple pencil drawing. And even if the structure eludes the sketcher, isn't it better to discover failure sooner and to find alternatives?

Start with seeing
Study a motif closely and then close your eyes. What you see with your eyes closed is the concept — shorn of all unnecessary parts — as a machine should have no unnecessary parts. Drawing is a more portable, faster, intimate way to study. Learn to paint with a pencil.

Advantages of a pencil pattern
The pencil is the great teacher which guides between chance and order, making a synthesis between abstract and representation, between high or low key, between objects and shapes, between light and relative values, between flatness and depth, and between curves and straights.

To *see* where you are about to go (however darkly) is better than reliance on vague mental intentions. You must see to judge. The *rough* sketch gives you a preview to judge. It will not dissolve as a mental image does. Make several roughs and you have the option of choosing the best one. Those who immediately paint do not have that choice.

By postponing color and rendering, you focus 100 percent of your attention on design. I do not go on with a painting until I am excited by the design possibilities. This ensures fewer rejections of the final work.

The small rough conveys most of the important decisions. Values and colors can be placed later on the painting with conviction and immediacy without the revising, washing out, overpainting, overworking, and pussyfooting that result from painting without visual intentions.

The artist does not draw what he sees, but what he must make others see.
—Degas

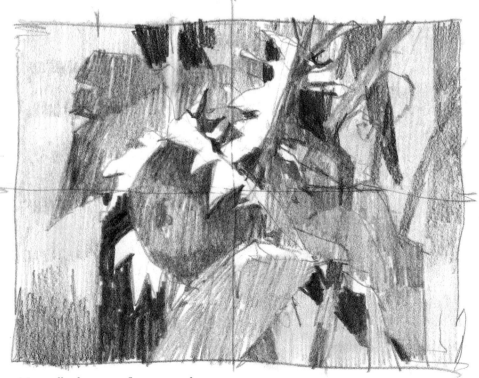

Normally, large sunflowers are heavy and so droop downward from their stalks. Here in pencil, I planned to have one drooping, but flanked by another facing upright. Pencil experiments show the way to plausible options.

This drawing was made in Westport, Connecticut, for use in a motion picture. It was made on the spot, on camera, and served as the basis for the on-camera demonstration painting. It always helps me to know whether or not I have a good design before I paint.

A forest interior was roughed-in with a soft pencil, followed by a Payne's gray wash to speed up the process. Finally, darks were struck in with a black marker.

Pencil and gray wash are used to study possibilities of a marina in Benicia, California. See how the darks are used as parentheses to hold the subject and to introduce and dramatize the whites.

When I saw this ornamental house in the Catskills, I decided to make a calligraphic painting. With this in mind, I conceived my subject in pencil while exploring all possible ways to emphasize and create dots, dashes, ribbons, hatchings, stabbings, pulsations, and other graphic effects I might use to animate my surface. For the most part, I avoid the mundane use of running contour lines around objects — for my taste, that is not calligraphy.

Lake of the Falls, Wisconsin. This paint-
ing presented an opportunity to make a
fine shape out of the white water. The
gesture and the interlocking of that
white shape is the motive for this draw-
ing. I could have used any colors to
paint this, as long as I kept these values
as distinct as they are.

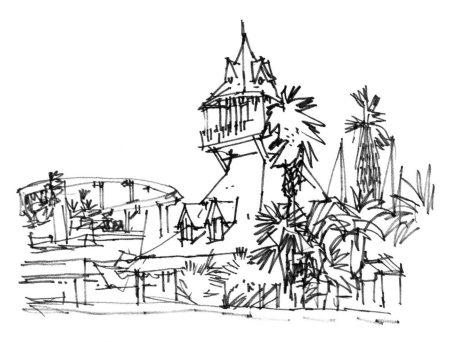

A subject in San Diego is studied in
marker line. Line might be suitable for
a drawing, but before I would paint this
in any medium I would make a value
pattern.

Choosing a subject

Find a subject that interests you. You should have some delight or awe to communicate, some purpose. Most of us would be better off if we started with our first response. You might wear out a set of tires looking for yet better subjects.

Procedure

You can use various tools for a preliminary study of value patterns. Graphite is one of the most common. Use a soft grade, such as 6B. Vine charcoal used with charcoal pencil does a splendid job if you enjoy working in a larger format. Markers are available in grays as well as black. Monochrome watercolor wash also speeds up the process.

Make a borderline frame on your sketch paper about 5″ × 7″ or smaller. The proportion of this should match your intended painting format. Don't just use the edge of the sketch paper to serve as your border. It is best to make a special borderline which will clearly reveal your largest flat shapes. Values may go directly on the drawing or they may be considered on an overlay of tracing paper.

As an alternate procedure, begin with a rubbed all-over midvalue of charcoal, use a kneaded eraser to lift out whites, and finish with dark values.

Value allocation

Since whites are so important, I usually shape them first and place them well so they are not in the center and not too near a border. Whites usually must be invented—they are not out there to be copied. To make this all-important white readable, your next step is to surround the well-shaped white with a midvalue or two. Finally, darks are strategically shaped and placed to dramatize the whites. The shapes, sizes, and directions of these value pieces should be your creation. Try to combine the darks and combine the whites. If you have several whites (or darks) vary their sizes, making one size largest and give them shifting and alternate positions. Try scribbling your midvalues in a vertical direction. This emphasizes flat pattern and eliminates movements into depth, which result if you make slanting strokes.

Many students bypass making value patterns because they literally cannot see values while looking at full color. Joseph Albers said, "Very few are able to distinguish higher and lower light intensity between different hues." When working on location with students, it is common to see them "sketching" with outlines, while ignoring the midvalues. Often large areas of white are also left in the sky and foreground. These powerful expanses of white prevent the student from seeing whole.

In any natural motif, the eye will be fooled when it first spies a small piece of light within dark, or a piece of dark surrounded by light. The student is inclined to exaggerate that contrast while the professional will reduce the contrast.

No two tones of equal size or intensity should appear above one another or side by side; their arrangement should be shifting and alternate. There should be a decided difference between the tones. The number of tones should be as few as possible.

—Bridgman

WHITE LIGHT MIDVALUE BLACK

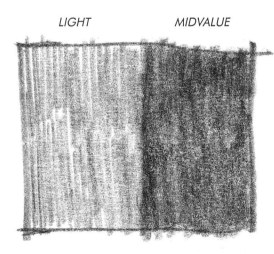

These are the only values you need in a pattern sketch. There are only four. Since each will drift a value or so during execution, it's important to keep them simple and separate. Don't let your whites get so smudgy that they join your midvalues, and the same goes for the other values.

Transcribing a rough to watercolor paper

A small drawing can be projected onto watercolor paper with an opaque projector, or you can make a photo transparency to project. I use a traditional method of imposing a simple grid that quarters both the sketch and the watercolor paper. I use a 2B pencil from my transcriptions. While you are transcribing your design, try not to think of the contours as objects, but think of them as dividing your paper into sizes, shapes, and directions. I think of them mostly as lines where two values come together.

Comprehensive study

Sometimes it is fruitful to make a larger preliminary painting in monochrome. This can help you get acquainted with potential problems. Perhaps the chief contribution of a monochrome painting is that it allows small details to be considered more easily. Illustrators often resort to the procedure when their drawings must be accurate. In these instances it is advantageous to work on semitransparent visual paper — laying fresh sheets over and redrawing. Sometimes it is helpful to cut out sections and tape them into new places. Visualizing paper can be placed over any elaborate line drawing for use in making alternate value schemes.

Working from photos

If you include video and film, then you realize that many people spend up to a quarter of their lives looking at photography. It is therefore the art of our time, with most of the popula-

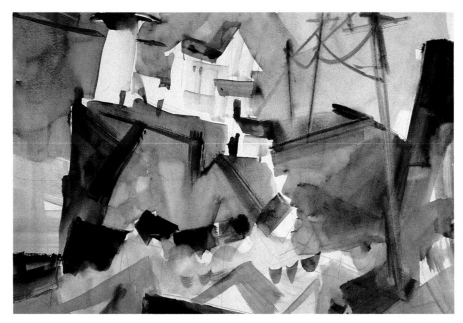

A 15" × 22" wash drawing explores not only values and shapes, but may suggest brush strokes as well.

tion being conditioned to view photographs as the standard for pictures. Small wonder that many painters find a ready-made market if their works have a photographic look.

Some painters say they benefit from seeing their subjects appear on flat prints, whereas they feel disoriented in actual swirling space. They also feel the need for detail, which a photo documents.

I seldom paint from photos. If I photograph a scene I love, when the print comes in, what I loved is never there. The sizes are all wrong and if the photo was taken on a sunny day, the shadows are all black.

Despite these shortcomings, there is no faster or more complete way to record the activity of light. For me, this is a photo's most obvious benefit.

Whether we work from direct observation, or from a photo, we will still be responsible for creating more than grubbing after facts.

This is an array of ballpoint thumbnail sketches. They preview big gestures and shapes. If those big areas are not well designed, there is little use in going on. No qualities of color or texture can save a painting that has undistinguished shapes and unreadable values.

PLANNING

I made this study of a sugar house in fine-point marker. An alternate lighting is tried on the second one. If I must use such a fine line instrument, I make the drawings quite small to avoid laborious rendering of value areas.

I used a black fine-line marker and sepia wash to study this Colorado gold mine. This procedure tells me before I paint whether or not a design works. I plan before I paint. If you fail to plan, you plan to fail.

PLANNING

A Long Island country store, post office, and a covered boat are drawn with a fine-line marker. A drawing such as this might be used as an underlay, that is, tracing paper may be laid over it and combinations of values tried.

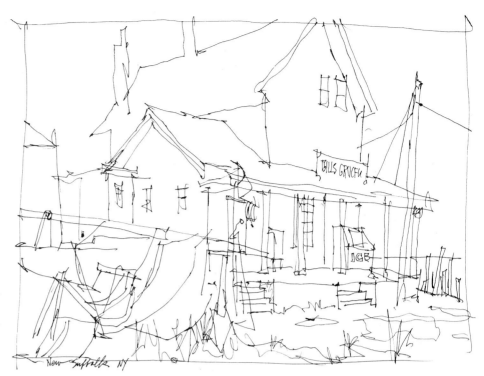

Below. A partially dry marker is used much like a pencil to make values. The vertical direction of strokes is no mannerism — somehow the vertical scribbles help to keep you thinking of flat patterns. If you make slanting strokes, they seem to suggest directions of planes and movements into depth, which are undesirable at this time. Vertical strokes are the next best thing to pieces of collage grays, marker grays, or wash grays.

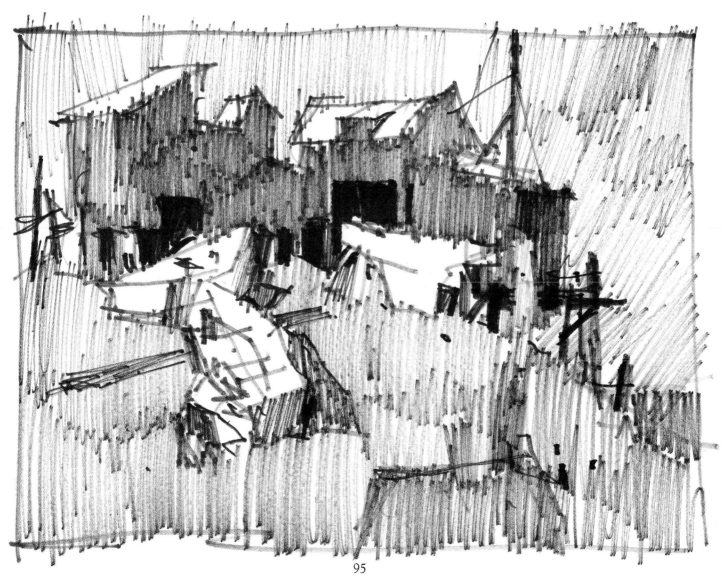

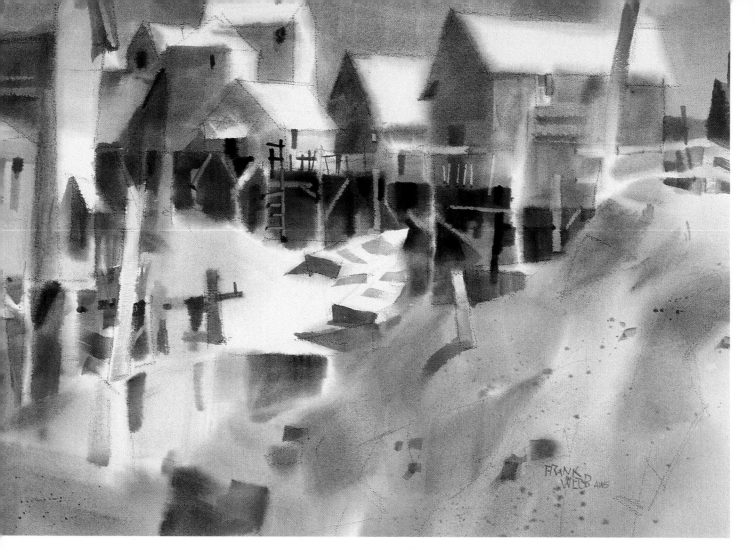

Low Tide, 22″ × 30″. Here I use soft, out-of-focus edges to create contrast with the in-focus sharp edges. Hard edges usually compel a concentrated visual attention.

The center of interest is established by the darkest dark adjacent to the whitest white. There you also find the highest intensity of color. There is a resting place where the boats are beached. As the schematic drawing at right shows, the tidewater propels us into the cove, huddled houses gesture toward it, while the hill nudges to the same area. In most of the picture's periphery, and especially at the corners, I have sacrificed contrast so that there is a gain at the more interesting centers. I have also developed secondary and tertiary areas of interest.

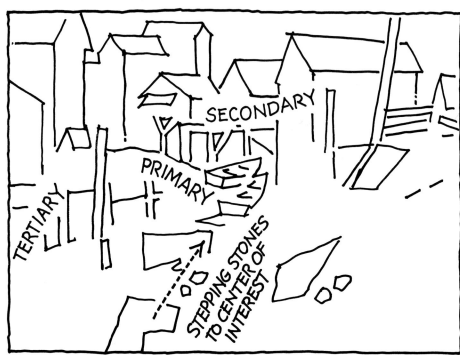

Center of interest

The center of interest is the graphic or psychological organization of a picture in which contrasts are increased in selected areas. As musical sounds need orchestration, so do visual elements. Unity cannot be achieved except through progression, dominance, rhythm, and pattern.

A center of interest expresses anticipation, culmination, and ebb and flow. The desirability of choosing a center of interest is expressed philosophically by Will James: "In the emphasizing, choosing and espousing of one rather than another, in the saying to it 'be thou the reality for me' there is ample scope for our inward initiative to be shown. Here, it seems to me, the true line between the passive materials, and the activity of the spirit should be drawn."

And in the words of Renoir, "Nature abhors a vacuum, say the physicists; they could complete their axiom by saying that she abhors regularity no less." Irregularity was a capital point made by Renoir. In pictorial terms this means some areas are deemed more vital than others, though all, like the human body, have an office.

A center of interest is a strategy to capture the spectator's attention. Just as in life, we must be introduced to others and to subjects, so in a painting we actually beckon the eye of the beholder. If the eye is attracted, it will linger.

A center of interest also establishes "containment" for a painting. A oneness or at-once-ness is a result of guiding the eye away from the picture's borders into the picture. As the eye should not be attracted to the borders, so it also should not be drawn to the true center of the picture. Such a bull's-eye is too obvious and too boring.

To have no center of interest is either to have a blank surface or an all-over busy picture. Without a theme or center of interest, we might have merely visual repetition. Its audio equivalent is background music. Such optical democracy becomes only chewing gum for the eyes. Small wonder that repetitive patterns are used for backgrounds such as wallpapers and drapes. If there is no center of interest, there is confusion, boredom, or anarchy. In such a scattered scheme, parts become overly important. To the degree that parts dominate, beauty is forfeited. While some very busy paintings might be admirable, the best of them manifest a center of interest, though it might not be immediately obvious.

Determining factors

The picture's format, be it circular, square, rectangular, or attenuated rectangular, helps determine the function of the center of interest. Closely allied to the center of interest is the manner of the picture's opening path. The opening of the pictorial space should lead to the center of interest.

The center of interest is fashioned with contrasts of line, shape, tone, color, texture, size, and direction. The use of the human figure also creates attention, especially in an otherwise non-human context. The center of interest can be the result of directional arrows and the isolation of shapes, such as in a bull's-eye. Obviously, any contrast becomes a center of interest only in a given context, that is, by way of opposition to what is around it.

Containment

Unlike nature, a picture has a definite border. In the Middle Ages mapmakers would draw the known world and in the regions beyond their knowledge they would letter, "Beyond this there be dragons." It might be good strategy for us to think about our pictures that way. In Chapter 6 we discussed the problem of opening the picture. Perhaps we should also close our picture in the sense of making it feel complete to the viewer. We call this idea "containment."

Very simply, containment is accomplished by avoidance of contrasts at the borders and especially at corners. This also means avoidance of a white corner because white is the strongest value we have. Therefore, I dislike seeing it in a corner. On a true vignette, a white corner will be large and connected to a generous background of white. In that case, white corners are fine. The caution is not to call attention to the border. I am not saying that you cannot have the shapes bleed off the edges. Often a unique and concentrated image results from having shapes cropped by the borderline.

The paintings below and below right are vignettes. A vignette should have one of the four corners larger than the others. The total shape should be made of mid-values and darks. The edges should be interlocking and most of the edges should be the normal edges of objects. The topmost point should not be immediately over the lowest point. The extreme left and right points should not appear on the same horizontal line. Reserve the faded-off edge for less than one-fourth of the perimeter of the shape. Calligraphy might be employed in the blank areas to add conviction. The vignette gives perfect containment to a picture.

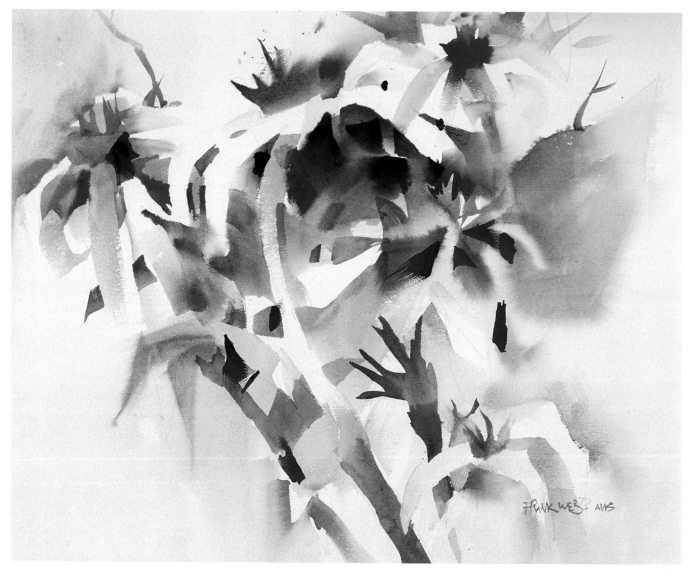

Flat Musicians at Market Square, 22" × 30". Here the interest is mostly human interest.

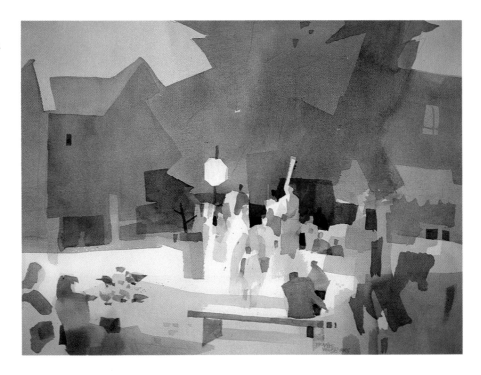

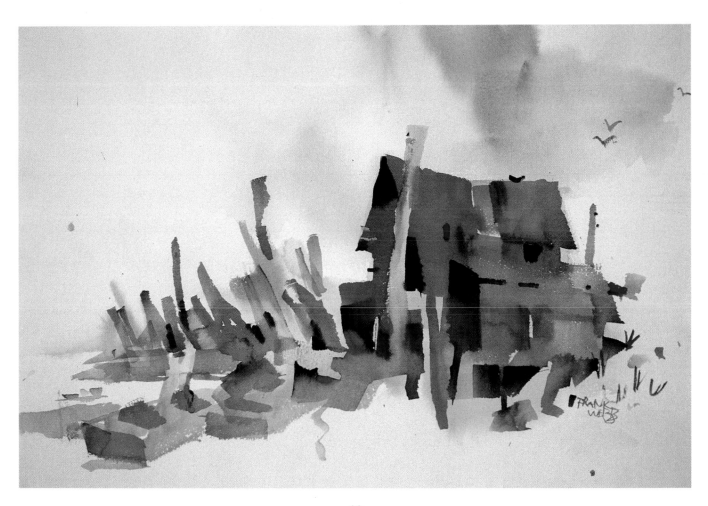

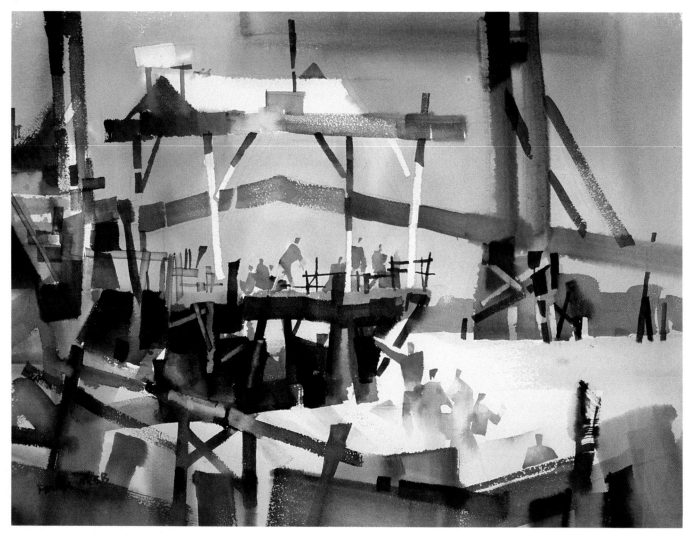

Cove, 22″ × 30″. Figures cavort at one of New England's popular attractions, Perkins Cove. This painting was awarded the Bronze Medal of Honor at an American Watercolor Society annual.

Hints for pattern-making

Pattern directs attention to the creative concept, while detail is subordinated to big lines, values, and shapes. The art is in the pattern. Do not paint things. Do not paint light and shade. Paint patterns.

- Investigate and absorb the motif.
- Look for continuations, parallels, and repetitions.
- Start when you feel moved to start.
- Decide on a vertical or horizontal paper format, whichever expresses the motif.
- Put a borderline around the pattern to become more aware of shapes.
- Draw a borderline with the same proportions as the paper on which you will paint.
- Keep the size of the pattern within seven inches.
- After an initial long look at the motif, concentrate on your drawing.

- Think of contour as a disappearing plane (Cézanne).
- Think of contour as silhouette (Van Gogh).
- Think of contour as pieces of straight line (Feininger).
- Shape the whites by scribbling midvalue around them.
- Shift and alternate the sizes and locations of whites.
- Put in the darks, shifting and alternating, in the same manner as the whites.
- Draw with broad strokes of a soft pencil, held at the top end.
- Keep patterns flat-looking by scribbling values in the vertical direction.
- Avoid static shapes such as circles, squares, or equilateral triangles.
- Make one area larger than all others.
- Open up passages among shapes. (There should be a way in or out of any shape or value.)
- Avoid excessive tickling and linear elaboration.

- Try a high or low horizon.
- If you don't like the natural lighting, create a better light.
- Separate or combine shade and cast shadow according to design needs.
- Plan edges (even though the crudeness of a thumbnail rough might provide a means to refine them).
- Feel the weight of the mountain, the hardness of rock, and the softness of the cloud.
- Make landscape and living things convex, not concave. (Suspended vines, sand, snowdrifts, and the tops of waves are exceptions.)
- Write notes of interest in the area outside the pattern to help recall present awareness of nature and design.
- Use erasers to regain lost whites.
- Do not work mindlessly, like a machine.
- Stop when finished.

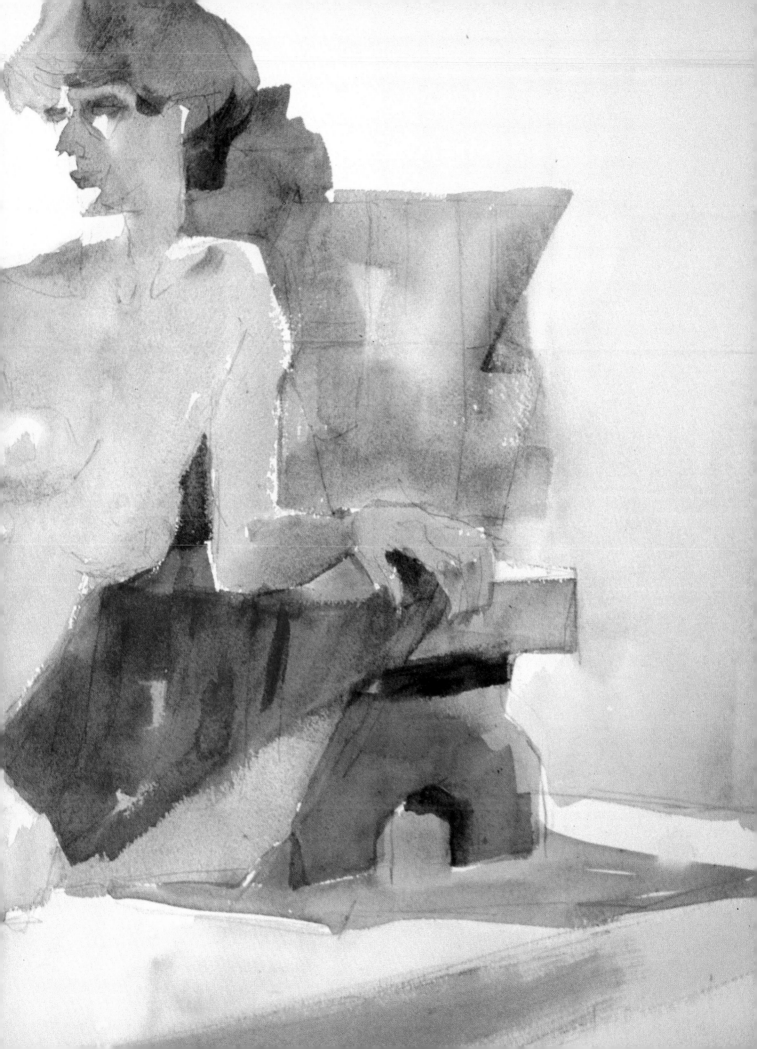

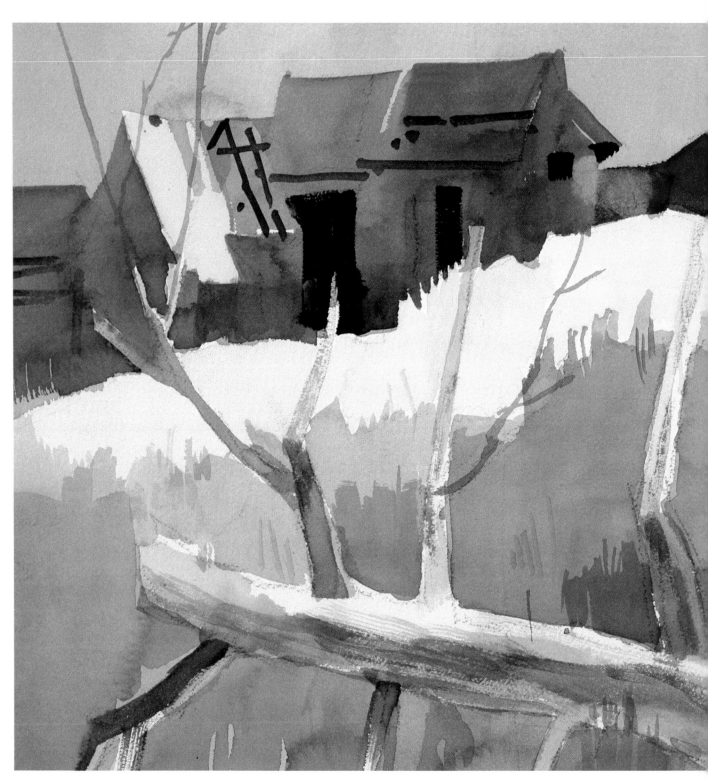

Shaker Ruins at The Dalles, 11″ × 15″. This small painting uses flat layers of wash. The fallen tree was introduced to help foster the idea of abandonment, to open the picture, and to give substance to the foreground.

ENCOUNTER

The act of painting is the encounter. Art is not in the subject but in that encounter of the artist. The work of art itself is a byproduct of the encounter during which the artist is caught up in a heightened state of awareness.

The scope of encounter here is broadened to include a response to the materials and actions of painting. We are accustomed to speaking about the musician's "playing" an instrument. The visual artist, no less, participates in performance. Some painters such as Sargent, Hals, and Duveneck are known for their virtuosity while others are known for their creative concepts. Most artists agree that technique is a means and not an end. Many thoughtful painters avoid too much emphasis on tricky and flashy effects of technique.

A very personal thing is the creative encounter. It is you, alone, facing your paper. It is not a committee or a gang or a class. All of your personal history, knowledge, loves, fears, anxieties, and confidence must now be dealt with as you face the blankness of that page.

I offer the following demonstrations not as ways to paint but as ways to encounter a subject, and to help you (and me) imagine certain possibilities and qualities, and how to seek them. Your search will prove more fruitful and less boring than following a routine procedure. To study this way will not inhibit your style. You will find the real you by equipping yourself with choices and then making a synthesis. Style will come of itself out of constant production.

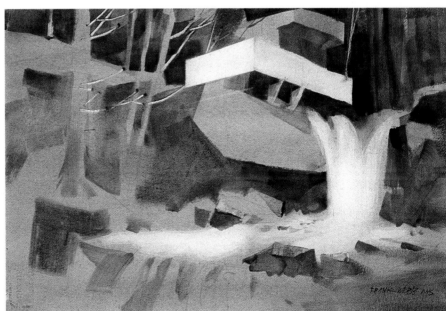

Fallingwater, 15" × 22". Neutral color gives a quiet mood to the setting of the famous house by Frank Lloyd Wright.

Calligraphic painting

A calligraphic painting is a painting that stresses directly made graphic marks—beautiful graphic marks. Generally, the word calligraphy applies to writing. Letters of the alphabet are symbols. Painting also may use symbols that are direct representations. For instance, if you make "V" shapes in a sky area, they will say "bird." In a foreground they will say "grass." Through practice each painter will develop a personal set of symbols.

For personalizing your work, calligraphy is as distinctive as your own handwriting. A calligraphic painting is bursting with visual suggestions—it is the shorthand of painting, addressed as much to the mind of the beholder as it is to the eye. The most notable calligraphic master to research is Raoul Dufy whose calligraphy is dramatized by its synthesis with simple areas of open and out-of-register color shapes.

Calligraphy accomplishes four purposes: It defines areas as contour, ties areas together, enlivens dead or inexpressive areas, and helps to stabilize depth, maintaining a sense of the essential flatness of a painting. Broadly speaking, it is calligraphy's function to delight the eye—it is decorative. Its beauty is akin to the beauty you get when you throw down a coil of rope.

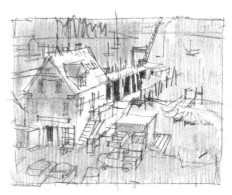

The initial sketch emphasized the required symbols: clapboards, pilings, ribbons, spots, dots, hatchings.

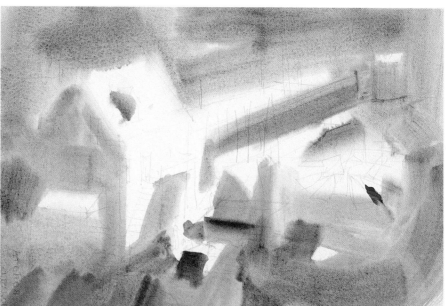

My 140-pound hot press paper is wet, front and back. I literally smash mushy paint onto the surface using a two-inch flat brush. I avoid hard edges, reserving crisp hardness for the upcoming calligraphy. I initiate a blue dominance, hold onto some whites, and eliminate darks. This is allowed to dry. Notice the curves at the bottom right which help to express the cove in that area.

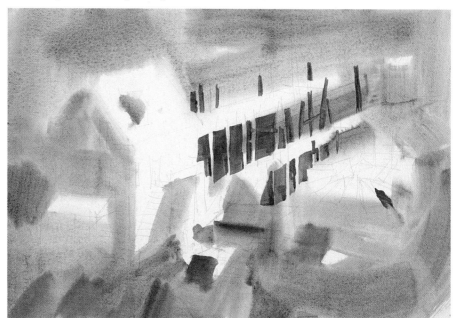

On the dry surface I begin near the center of interest with some negative darks between pilings using a one-inch brush. The sizes are varied and the wharf ends with positive marks.

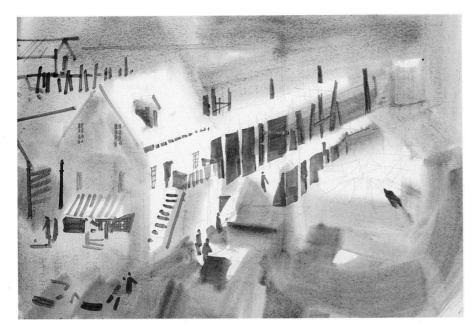

Now I put my size 8 lettering brush to work, making linear marks here and there. I try to express the "openness" of the earlier fluid washes by not enclosing any area. This creates an interesting tension between the soft and the hard. These marks are symbolic—they hint and suggest, inviting the viewer to complete the picture in his imagination.

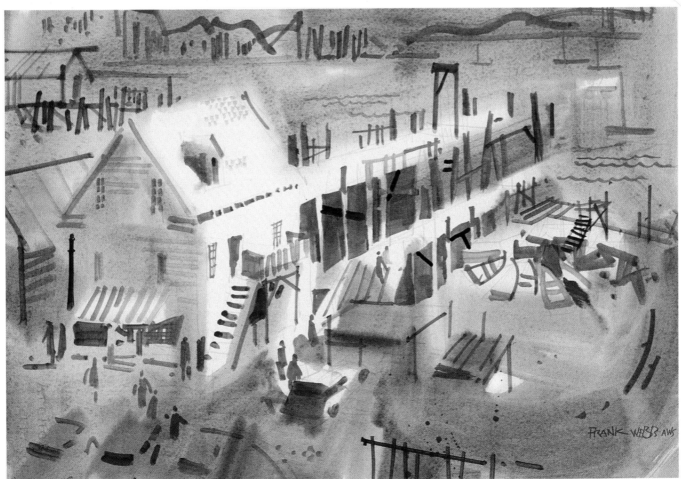

Port Clyde, 15" × 22". The painting is completed with the addition of details such as handrails, waves, people, and shingles. *Note:* There was no awning on the storefront. It was added to exploit the use of stripes and to give some relief to the wall. I define calligraphy as a direct mark, as opposed to built-up shape. Showcards made of single-stroke lettering express the beauty of direct marks.

Patch against patch—damp paper

This approach is a modified Impressionism. Instead of small spots of contrasting color, I paint flat patches using a different color for each stroke. Its purpose is to set up a vibration in the eye, suggesting outdoor light.

After soaking the paper I take off most of the surface water with a hard rolled towel, in the manner of rolling a pie crust. The paper is now neither wet nor dry but damp. The dampness allows a hard edge, but delays drying of the paint so that if I touch one stroke beside another, the edges can still fuse. The result is a transition from one patch into another. The aim is to paint each large area with multiple color changes, but with each touch the same value. Obviously, this approach is not possible without a simple value rough.

You might think that this is a color exercise, and so it is. But what I am really doing is trying to control values. In theory, if I were to photograph such a painting in black and white the color breaks would not show. What this exercise teaches is value control. It is a very insistent method. Much of its spottiness is curtailed by the soft edges.

Caution:

1. Don't use too much water or a patch will completely merge with its neighbors. You want only the edge to merge while holding the identity of the patch of color.

2. Try to keep the bottom half of the paper damp while working at the top. Otherwise you will get an inconsistent bottom with hard edges.

3. Use a shallow water pan and bang the color out of your brush against the bottom of the pan after each stroke. The tiniest amount of leftover paint will sully your next stroke.

4. Deliberately place complementary color patches next to each other. This is what causes vibration. I often resort to this method on very damp days, especially outdoors where nothing dries.

The subject is drawn with a dryish black marker.

Detail. I soak my paper, then, using pressure, roll it with a wrapped towel to squeeze out excess water. This allows me to put down a patch of color with a hard edge, but the moisture in the paper prevents it from drying. Then I put a stroke next to it with just the right amount of moisture so the strokes fuse at the edge but do not combine. Each stroke retains its identity. This way I proceed across the page, stroke by stroke.

Other areas are covered with a mid-value. I must be consistent in using this patch idea all over the painting.

Darker areas are struck in. I must know in advance from the sketch how these areas are to be differentiated by value contrasts.

Detail. In making darker values I must use thicker paint and less water. This means that the edges don't quite merge as the lighter values did. Generally, I want edges to merge, but not so much that I lose the identity of that separate color. Darker, thicker paint will usually contain more of the thicker vehicle which makes a less fluid merger. For this reason I must sometimes lightly stroke such junctures with a clean, moistened brush.

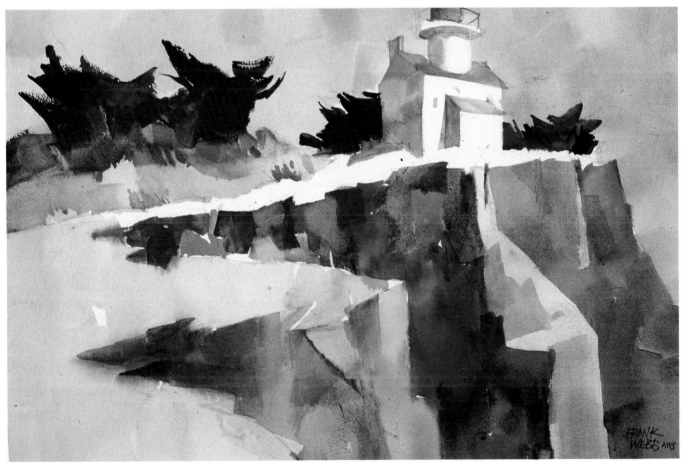

Point Loma Light, 15″ × 22″. I used the darkest values on the trees, which led me to and dramatized the whites, the center of interest. These darks must be made of color breaks just as the mid-values are.

Layering (dry paper)

We all overpaint from time to time — usually as a corrective measure when the first layer is wrong. Here I plan to use overpainting not as a corrective, but as a positive procedure that exploits transparency while ignoring gradation and wet fusions. A pencil rough already indicates three or four simple values. I paint in simple, flat, hard-edged washes, each application made on a dry surface. Washes are painted over one another with a deliberate out-of-register and overlap. Where one color laps another an optical mixture is created. These optical mixtures of color have a character of their own, different from palette mixtures.

To keep color clear I use the most transparent paint on the first layers. The most transparent paints are: alizarin crimson, Hansa yellow, new gamboge, phthalo blue, phthalo green, Prussian blue, and raw sienna. There are others, but one need only use alizarin, phthalo blue and Hansa yellow to produce any desired hue.

The advantages of this procedure are:

- White shapes are assured.
- A color dominance is initiated.
- Transparency is declared.
- A simple flat feeling is created.
- Optical color results.
- Shape is intensified.
- It gets you away from ordinary local color.

Qualities sacrificed are:

- Gradations.
- Variety of edge.
- Modeling.

Above. A vertical format requires several vertical movements. This sketch shows an interesting oblique shift of the large dark value. This helps to avoid the boredom of one effect placed directly above another.

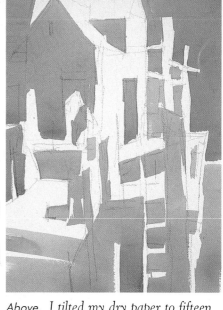

Above. I tilted my dry paper to fifteen degrees and ran a flat wash made from Prussian blue warmed by a touch of sepia. Tilting helps flatten the wash by gravity. I try to respond to new shape possibilities while running a wash like this. I always make this first wash with dye paint to preserve the clarity under heavier, pigmented paints I expect to apply in the second and third layers.

Below. For color balance, I next superimposed some brighter, complementary color. As far as I can manage, I try to generously overlap these shapes with earlier ones to prevent making nervous edges and to foster transparency. I use the printer's term, "out of register" for this effect. I cannot foretell how these overlappings will work. I take a risk and find that this intuitive groping is almost always rewarded.

Below. Darker midvalues now provide the needed structure. These are guided by the sketch but they are also discovered en route. The brush wants to speak and I must respond to that urging of the brush.

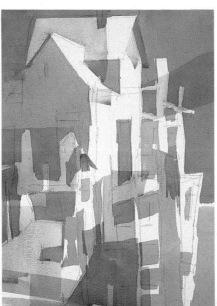

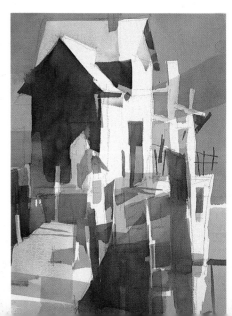

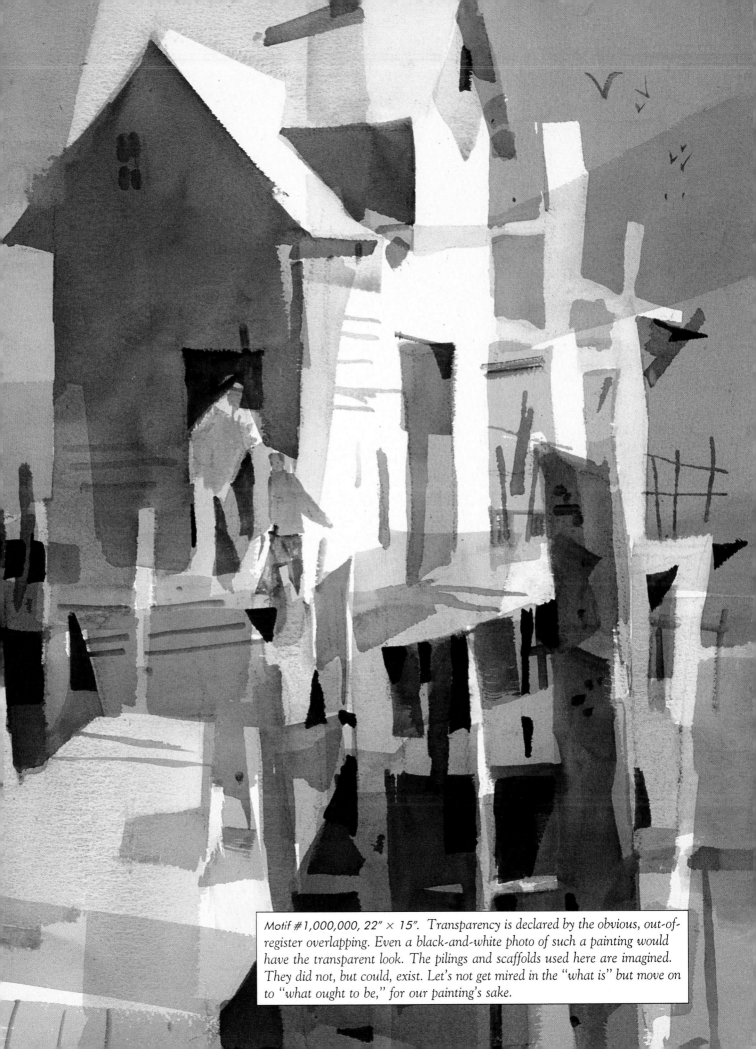

Motif #1,000,000, 22″ × 15″. Transparency is declared by the obvious, out-of-register overlapping. Even a black-and-white photo of such a painting would have the transparent look. The pilings and scaffolds used here are imagined. They did not, but could, exist. Let's not get mired in the "what is" but move on to "what ought to be," for our painting's sake.

Push-pull (dry or damp paper)

The aim of push-pull is to use graded values as positive and negative shapes to suggest objects and to give the viewer a sense of an object's interaction with space. I try to keep 50 percent of the paper untouched. Value areas are begun with a sharp edge to suggest a contour and then the value is arbitrarily faded or graded away. This requires plenty of clean water to really clean the brush. Even a small amount of residue in the brush will dry on the paper as a dirty wash shape. Generally, I use less intense color, as the quality sought is primarily a spatial effect resulting from values.

In making gradations I occasionally pre-wet a selected area and then stroke paint into it. Other applications are simply painted, and then with clean water and a clean brush the edge is treated to soften it. A color value can be graded slowly across an area or it can be quickly graded as a soft edge to an otherwise flat, continuous patch.

Notice that the indications of subject matter are achieved by accenting the points where the most important planes converge.

A couple of tentative gradations are made. Color changes are also fused into these value gradations.

I work over several places trying to get the feel of the whole scheme. Each time a sharp edge is used it is gradated back to white paper. I try to keep at least half the paper untouched.

Above. People are added as the painting nears completion.

Detail of tower. Here you can see how warms and cools are combined.

Left. The pattern sketch was made with push-back values. I was as much interested in the spatial possibilities as I was in the exotic subject.

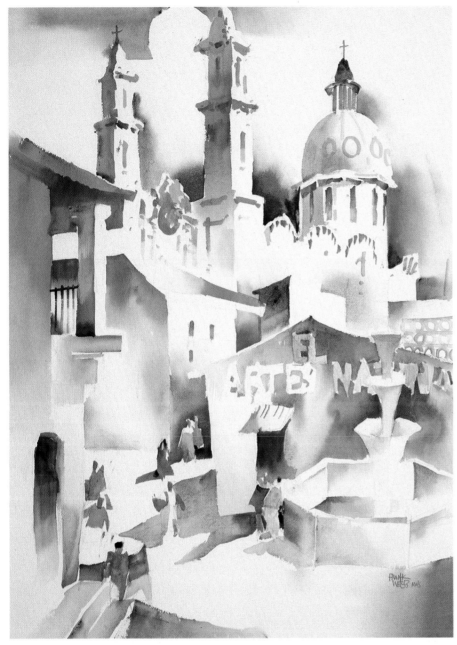

The same Taxco subject is conceived in a layered painting. Thus, we see the artist's concept often contributes more to style than technique.

Taxco, 30" × 22". The subject is indicated as bits of color and value. Such a partial statement can only be visually rationalized by the use of generous amounts of white throughout. It comes into being only by way of hints and suggestions.

Push-pull values are used in this floral subject to dispel the notion that only architectural volumes and straight lines are appropriate for this concept.

Wet into wet

My paper is dipped into water or is sponged on both sides and placed on a Masonite board. After the surface water is sponged off, I apply large areas of midvalue around the whites. The whites are untouched for now. I use rather thick paint because the water is in the paper. With a light touch and a soft brush, I can put cools into warms and vice versa. All large areas are painted. The only hard edges sought at this time are the edges around the whites. As the paper begins to dry, clips are attached at the corners of the board. Harder edges and darker values are now applied. Finally, calligraphy and indications of texture are made.

Wet into wet is usually the most dramatic, loosest, and most immediate of presentations. Its wetness emphasizes one of watercolor's greatest glories. If you don't linger, these passages will be quite beautiful.

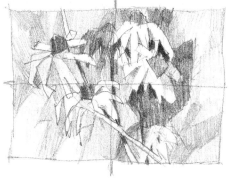

Flowers are subjects that beg for wet into wet, since they are thought to be soft, delicate, colorful, fresh, and full of gradations.

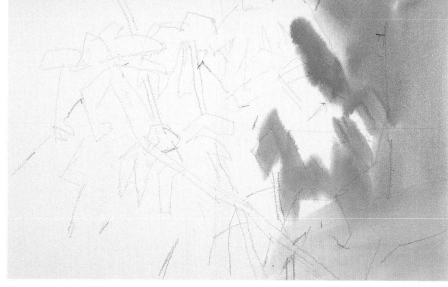

Using a two-inch flat, I start to paint around whites, delaying the actual edge until just the right degree of control is assured. My brush is kept free of excess water. Remember, the water is in the paper.

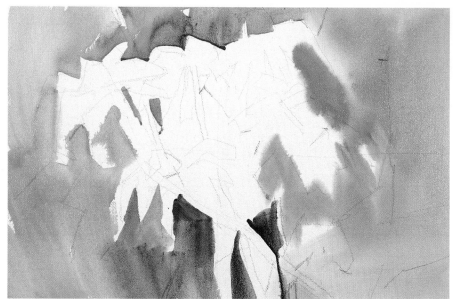

Some darker, cooler midvalues are introduced.

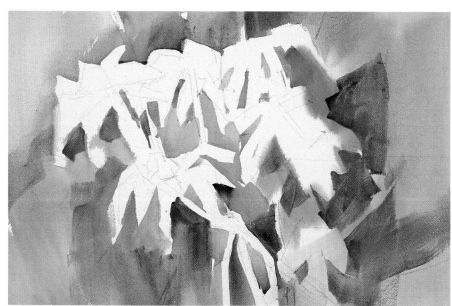

Dark negative shapes partially push back between and under petals.

Meadow Gold, 15" × 22". A cool, positive flower shape is put at the top to add excitement and to break up the bouquet look. This cool has some cousins to wave to, but the yellow-orange dominance is not threatened. A wet-into-wet painting is essentially a study in gradations and varied edges. No other medium or procedure offers such edge options as wet into wet.

LIFE

A certain sympathy lies in our interest in figure painting. We understand humankind more completely than we can know nature, for it is through other humans that we come to know the self and vice versa. In other people we recognize not only an anatomical unity, but our own thoughts, feelings, and aspirations.

If you like to paint life studies as I do, you will eventually remember valuable data such as lighting, construction, modeling, color, values, shapemaking, and psychological insight. Newcomers to life painting might be intimidated by a model. If you are inexperienced, why not find a group with which to work? You'll receive some encouragement from the group.

Not only is life painting fun, it will, when sufficiently mastered, instill a significant amount of confidence and self-esteem. Switching from landscape to other subjects adds excitement and variety to your paintings.

One of the most difficult concepts to communicate to the inexperienced painter is how to use the model creatively. The neophyte feels bound to slavishly copy what he thinks he sees. It is almost impossible to convince him that the old masters changed the values, sizes, color, and shapes of models they painted. With more experience an artist will learn to select only what is significant to an idea or theme for any one picture.

The beginner is also apt to draw a single figure against a blank background—a procedure that might produce a good work but is more often the result of bypassing the design problem. Why not include the model's background and design a complete picture along with an articulated space? It's almost always unfruitful to sail into a figure painting while ignoring the background. The background should be started at the same time as the figure. Charcoal or pencil sketches and roughs help me to come to the painting with clear intentions and technical gusto. Even when the aim is a vignette, it should be deliberately designed.

As in any representational painting, use design principles to recreate a new reality. Use the model, don't let the model use you. Chapter 10 discusses the basic design principles you use to organize a creative painting. Don't think that posing a model, arranging a light, hauling in a gold chair, draping velvet, or taking a photo will ensure your success. A figure painting requires the same creative approach as any other painting. You will need a creative concept and a unified design.

Placement

A common fault is to make the figure too small for the format. Though such a painting might be improved by cropping, why not give more attention to the placement and size before reaching for paint? To assist me, I sometimes use a viewfinder that has grid lines scribed on acetate. While holding this at arm's length, I find a reference point on the model so I can manage to hold the viewer in place while drawing.

These warm-up studies were made on sketch paper using flat brushes and working directly without any drawing.

Before I began painting, I washed a tint of alizarin crimson over the entire surface to impart a warm off-white glow. When this was dry, I began to paint directly, paying particular attention to alternating the positive-negative relations of the figure to the ground. For this reason, I inserted a background value against the model's left shoulder. The indication of print on the costume adds a contrast to simple shapes elsewhere.

Flat, hard-edged shapes may also be employed for life paintings. A flat, continuous wash was applied over much of the paper. Later, red violets were introduced adjacent to and over some of the greens.

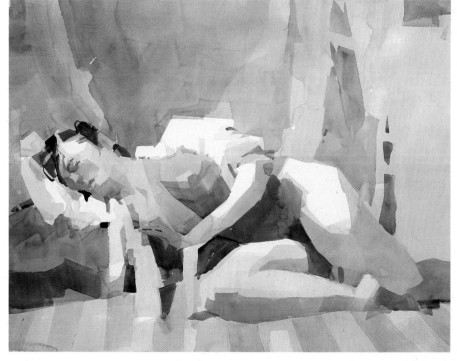

Left. Wendy Larson, 30″ × 24″, oil. This quick painting was made at a public demonstration where hundreds of onlookers gathered. Speedy execution was possible because I painted atop a blue imprimatura. This principle is workable in various media.

A young model was posed for a class in Tennessee. Soft charcoal helped plan values. Close attention was paid to the correct positioning on the ordinary sketch paper, 30" × 22". It is always surprising how the individual character of each model varies. The model's hair-do made an exciting shape.

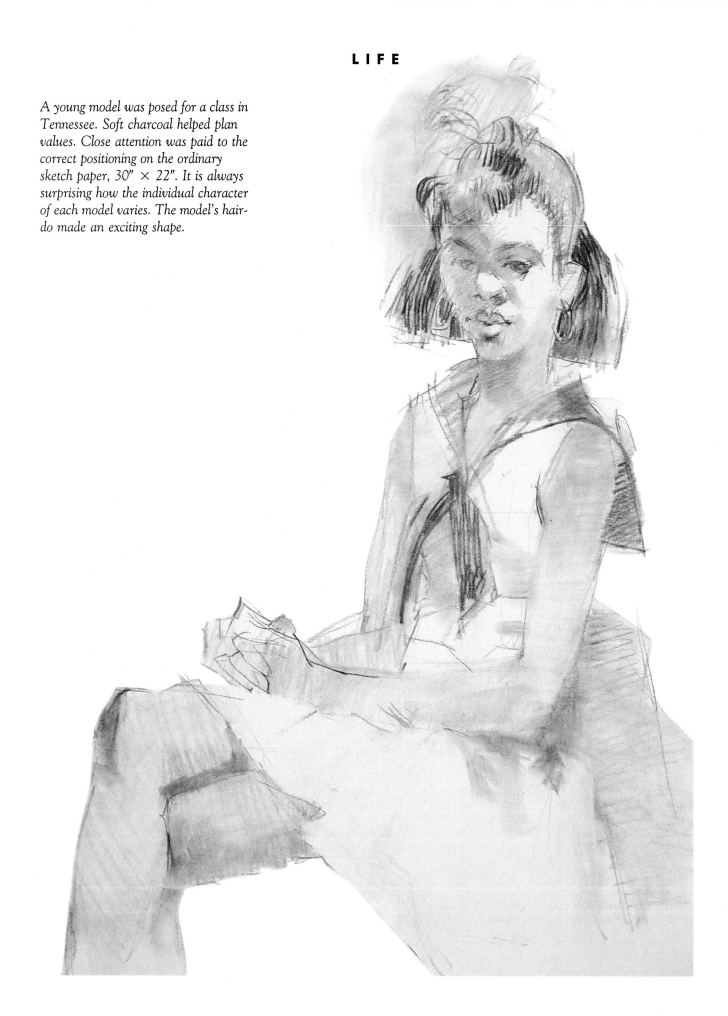

The painting was made in an hour or less as a demonstration for the class. I chose a vignette because of its immediacy, its containment, and its simplicity.

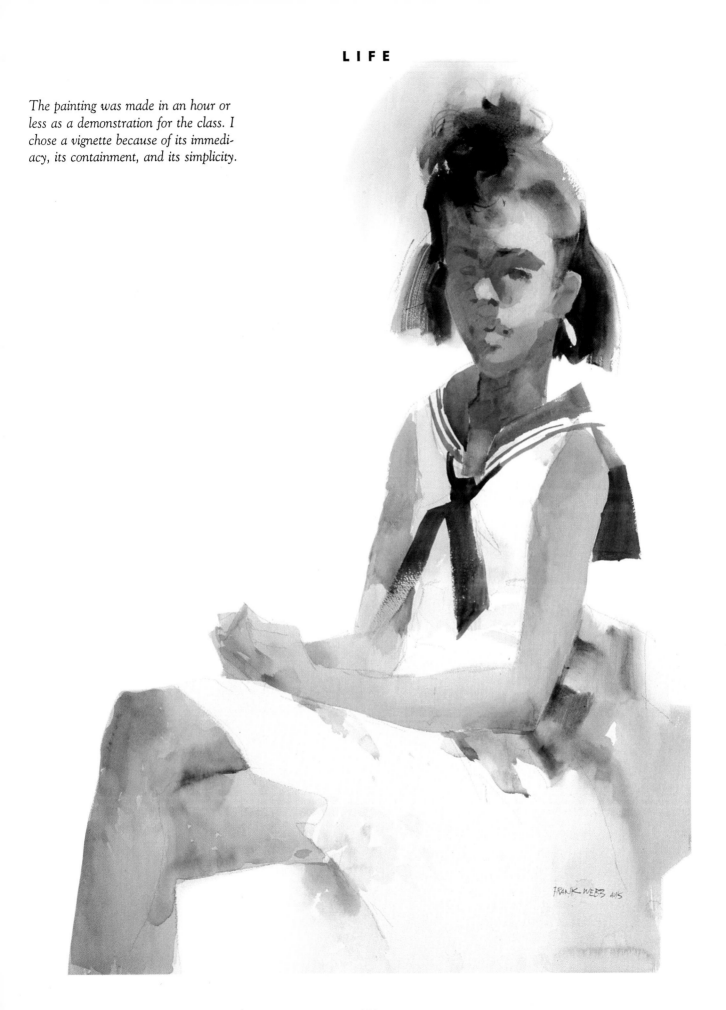

This painting turned out to be pale. I left the costume white so that the figure's tones appear to be darker and richer than they are.

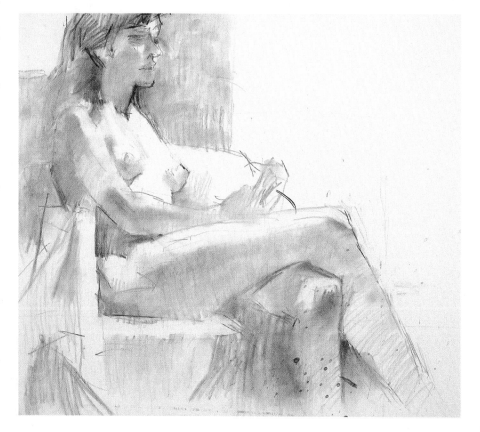

Local color

I find no reason to match values or colors as they are seen. It is more creative to imagine your own. At first the life student feels bound to match tints. There is a certain tyranny that the model exerts over the student. Use the model for your own pictorial purposes.

Likeness is not essential in a life painting unless you're making a portrait. If watercolor is overworked to get a likeness it will lose its charm. Here again, a charcoal or pencil study will assist you. I often make a full-scale charcoal study which is then traced onto watercolor paper by using a light box or a window. The drawing is placed under the 140-pound watercolor paper, which is sufficiently thin to allow light passage for tracing.

Another warning. You might be tempted to over-model, using too many values to make things look round. Values must be simplified. Congregate the light values and contrast them against the consolidated dark values. Try to see the model's values as flat pieces of value joined.

122

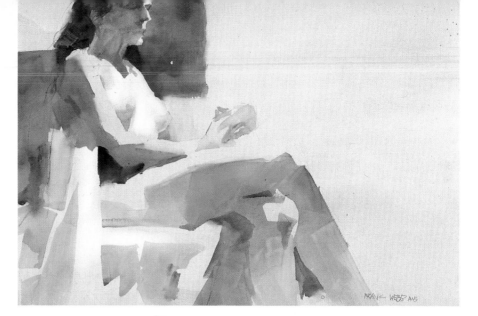

This series was made from one charcoal drawing, shown below left. The drawing was made from the model and is the same size as the 22" × 30" paintings. The drawing was transferred to watercolor paper by tracing at a window during strong daylight.

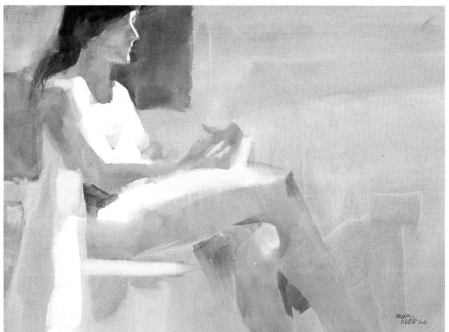

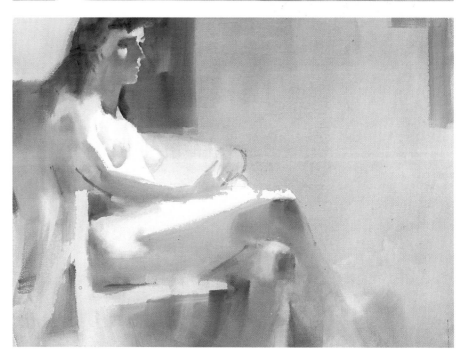

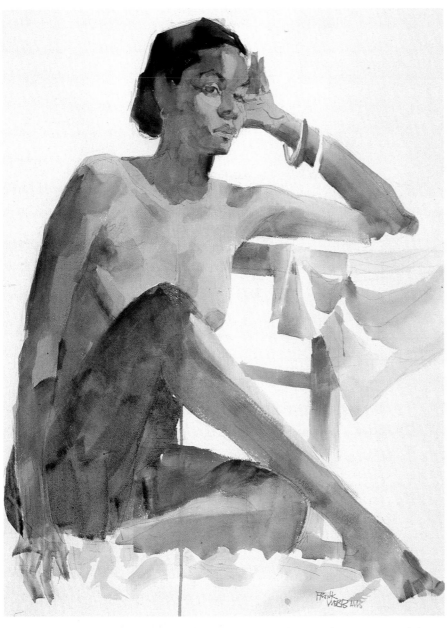

The seated figure has a shade applied to the leg, which gives the sensation of the recession of the torso. The detail of the head shows a minimum of strokes while aiming for maximum effect of shape, color, and value. Almost full-intensity cadmium orange is used at the temple and cadmium red for the ear. These intense colors, by contrast, induce a new richness to the greens and purples which make up the shaded side of the face.

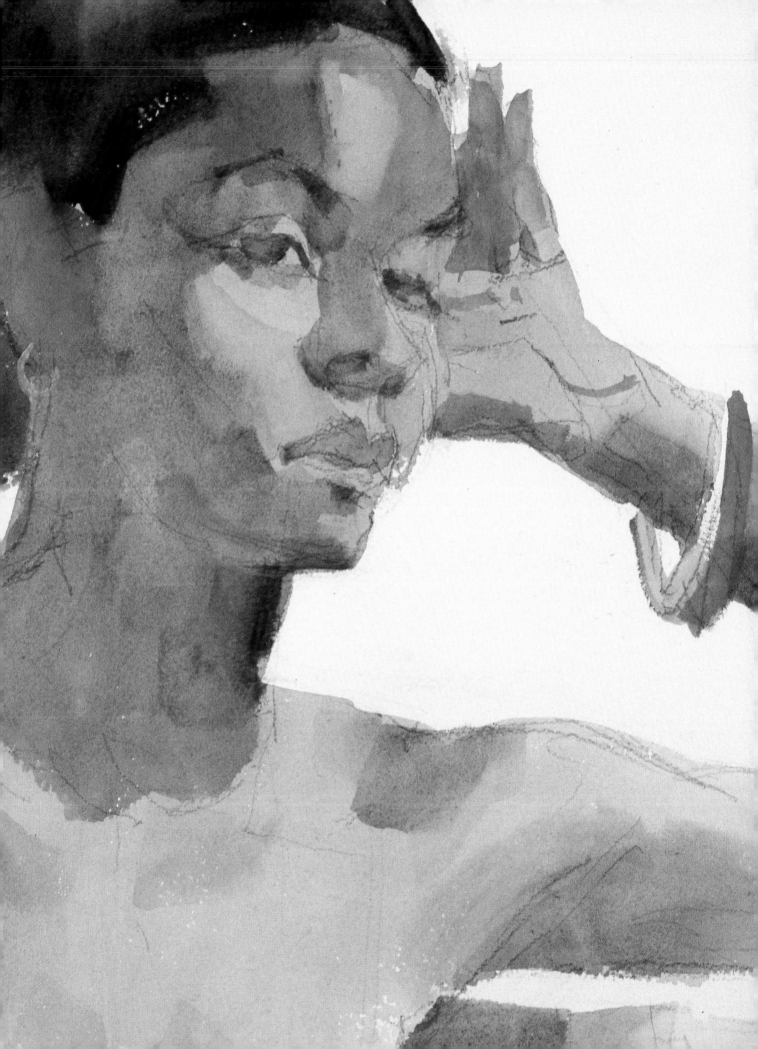

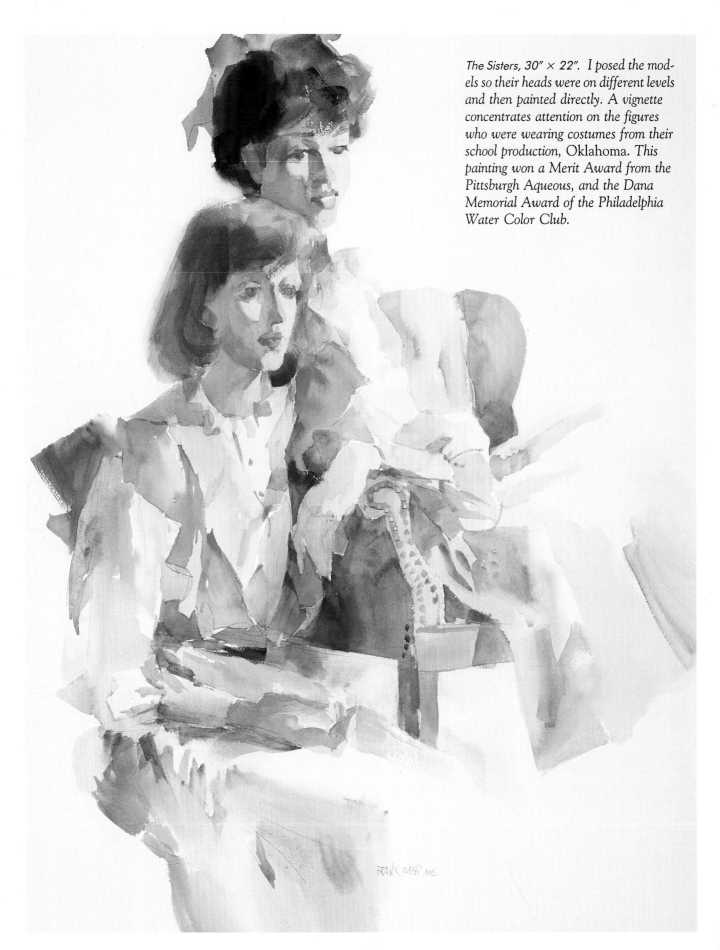

The Sisters, 30" × 22". I posed the models so their heads were on different levels and then painted directly. A vignette concentrates attention on the figures who were wearing costumes from their school production, Oklahoma. *This painting won a Merit Award from the Pittsburgh Aqueous, and the Dana Memorial Award of the Philadelphia Water Color Club.*

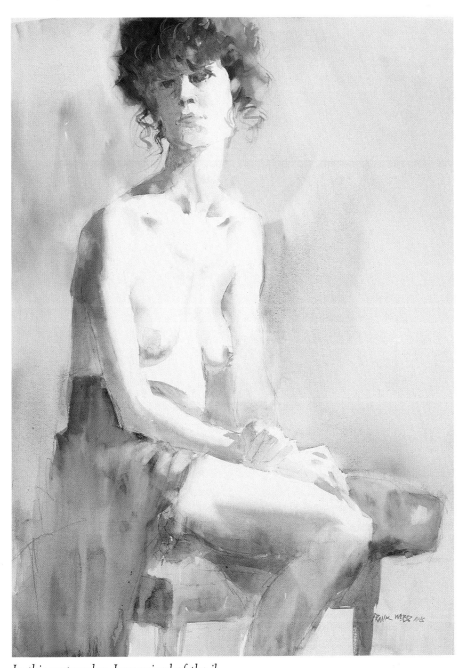

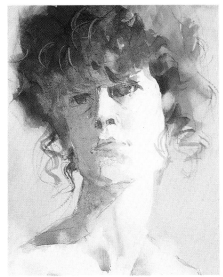

In this watercolor, I conceived of the illuminated skin tone as white. Of course it was not white; I made it so because I was creating a painting, not matching a model. The detail above right shows the understated shade effect I got by the use of cobalt violet. The eye is turquoise because I felt the need for that color in that place, in relation to the red hair.

I sometimes use an acetate viewfinder, held at arm's length. It helps establish proportion and placement. The shape of the acetate should be the same proportion as the intended painting. Three grid lines each way divide the acetate into sixteen divisions. The same division is made on the sketching paper.

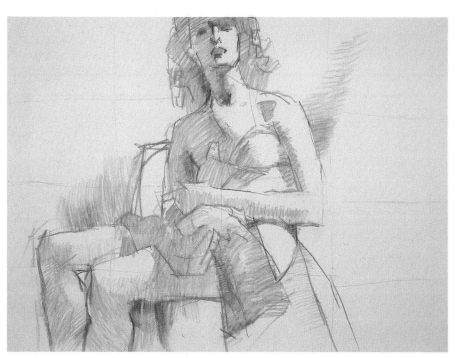

Miss Grand Junction, 22" × 30". I at-
tempted to clearly show whether the
parts of the model advance or recede
from the picture plane. Although the
model was present until conclusion, she
could have been dismissed after the
charcoal drawing was made.

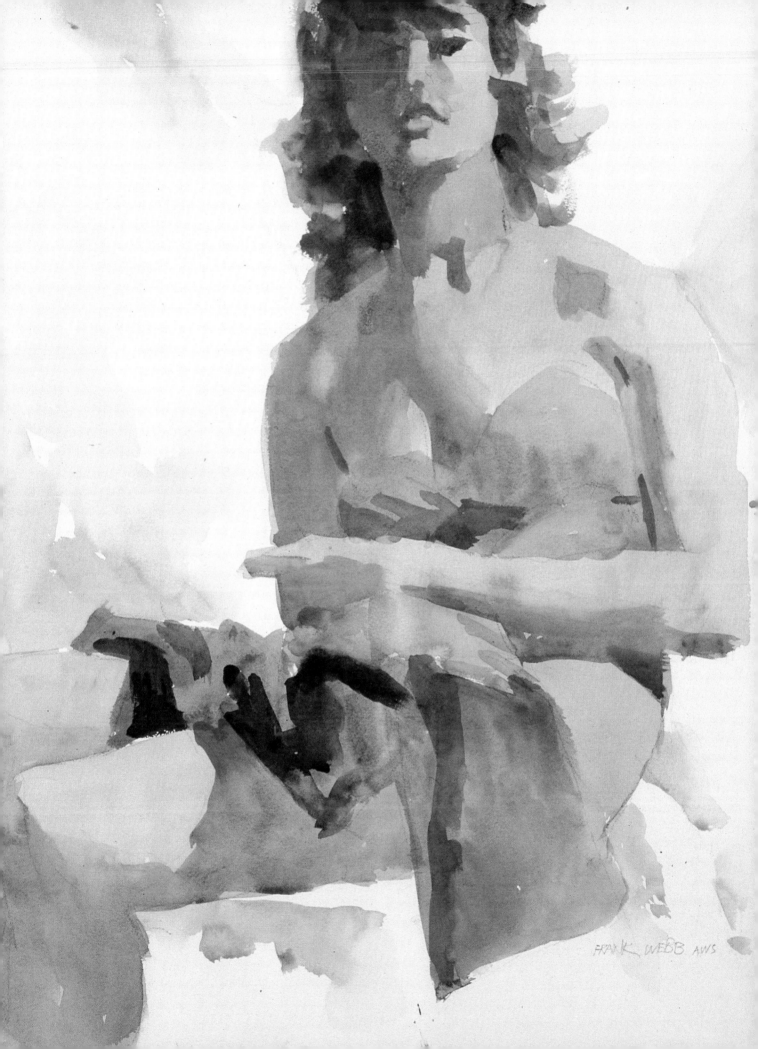

These oil portrait sketches were painted from life. There is no reason for a watercolor artist to avoid other media. Knowledge in another medium helps to cross-fertilize the major medium. These studies give me insight into craft, expression, and knowledge of design.

CHAPTER 10
DIAGNOSIS

Ofttimes in the solitude of the studio we wish we were able to see our work more objectively. We want to know more than whether a painting is good or bad—we want to know *why* it is good or *why* it is bad.

Design principles give us the criteria to judge our works. This judgment should happen both during and after painting. If you plan your work with a pencil sketch, it can also be judged before execution.

Synonyms for design are form, order, composition, and structure. Design is evidence of a trained intelligence at work. You should not be a slave to design principles, rather they should serve you. They are valid because they create bonds between parts, as the Constitution made one country out of many states.

When we congratulate an artist for being creative, however, it is not because he was able to obey rules that were known before he painted his picture, or wrote his novel or poem, so that thereby he succeeded in doing what had been done before. We congratulate him because he embodied in colors or in language something the like of which did not exist before, and because he was the originator of the rules he implicitly followed while he was painting or writing.

— Vincent Tomas

Renoir said that nature abhors a vacuum and regularity. He said furthermore, "One can state that all truly artistic production has been conceived and executed in conformity with the principle of irregularity." Design principles enable us to establish the necessary irregularity in works of art.

While some artists design intuitively without visual planning, most will benefit from the use of design criteria during execution and when beholding finished works. Thus, the aim of the designer is to become a critic. Once you become an adept critic of your own work, you will no longer be wafted by every wind of other critics. Remember George Rhoads' words, "Claptrap criticism thrives in this world where everybody is wondering what everybody else thinks so they will not have to decide for themselves."

During the act of painting we judge each stroke with a mind to change that stroke (or its neighbors) to take its place with all other strokes, past and future in the single painting.

Unlike literature, drama, and music, which present their effects successively, painting is judged whole and all at once.

In Chapter 1 we considered the seven elements of art: line, shape, value, color, size, direction, and texture. In diagnosing a picture, the seven elements are the *nouns* or *things* in your visual language, but the design principles are the *verbs*. These eight words *activate* your design: contrast, dominance, unity, repetition (resemblance), alternation, harmony, gradation, and balance. We are going to use these "verbs" to judge, sift, build, savor, weigh, edit, choose, reject, and accept.

131

Contrast

A painting is essentially the creation of contrasts. Take a look at your painting. Does it have good value contrasts, color differences, a variety of sizes? Contrast is interest. Look at your painting from thirty feet away. Does it read well? Perhaps you need to give more attention to the contrast among the large areas. Be sure to plan some contrasting directions for some of your painting's largest gestures. A painting with no contrast is *boredom*. All contrast is *chaos*. In art as in life, you must resolve any equal conflicts with a dominance.

Dominance

Integrity in a painting results from dominance and subordination. If your painting has a lack of color dominance — create it.

Does the work lack a directional dominance, a shape dominance, a line dominance, a value dominance? Could a textural dominance be initiated? And how about a size dominance? These must be created.

Unity is the oneness your work possesses if you have created contrasts, but have resolved those conflicts by the principle of dominance.

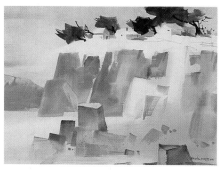

Line contrast. Straight line is contrasted with curved line. To give character to your lines make them definitely straight or curved.

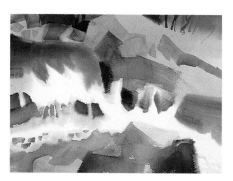

Shape contrast. Notice how some shapes are angles, some rectangular, and some round.

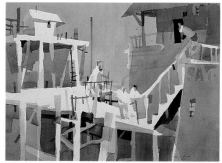

Value contrast. No quibbling. These values are contrasted, some light, some middle, and some dark.

Unity

Take a look at your painting. Does it hold together as a unity? Is it possible to add something or subtract something? When a work is unified, nothing can be added or subtracted. Does your painting have contrast of sizes, values, line, shape, texture, size, and direction? Or do you have too much contrast without dominances? Here are some clues to treating your work for disunity:

- Have contrasting colors, but make one color a dominant.
- Make one shape larger than all other shapes.
- Give your shapes a unifying resemblance, but put in some contrasting shapes.
- Sacrifice any part, however alluring, for the sake of the whole work.
- Are your value intervals well separated? If not, readjust the values of the larger. They are the body of your painting.
- Check your edges. Combine straights and curves, but make one of the two a dominant. Make one line longer than all others.
- Is your picture consistent in its degree of realism/abstractionism throughout? You must modify any or all parts so your aesthetic idiom is all of one concept.
- Is your painting a balanced unit? Try to feel its forces and weights. It should feel right in your muscles and bones.
- If your contrasts are out of control, try to subordinate some contrasts and make others dominant.
- If your elements are not integrated, try to forge some repeats or resemblances. Any lone element will consort if given some companions.
- How about gradation? It can enliven large areas.

Nothing is more important than this need for unity. Perhaps artworks are the most unified of objects created by human beings. Rather than worrying about whether a tree looks like a tree, worry about whether the tree in this picture relates to the other parts of the picture. Unity is the result of bonds. You are in the bonding business. Don't try to create trees, create bonds.

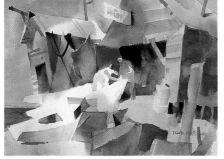

Color contrast. This contrast comes close to chaos. Color contrast is dependent on the sizes, hues, and intensities of the color shapes.

Size contrast. One size is king. The other sizes vary. There is no place in painting for optical democracy.

Directional contrast. In this painting of a lakeside port are all three directions: horizontal, vertical, and oblique.

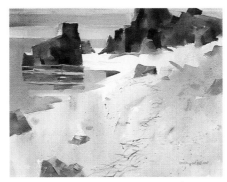

Textural contrast. The wetness of water, the hardness of rock, the grittiness of sand, the vapors of the sky; these contrasts create interest.

Repetition (resemblance)

If there is disunity in your work, see if you can make some echoes and similarities. If a color is lonesome, repeat it. If the important shapes are angular, try angling the others. Beware of mechanical, exact repetition; it is deadly monotonous. This is why I have used the word "resemblance"—an idea that allows for the desired variety of your repeats.

Alternation

Rhythmical, alternating repetition is well known in poetry, music, and dance. It is also called counterchange. A checkerboard is a mechanical counterchange. This element can build a sense of pulse into your picture with its ebb and flow. If a shape is lackluster and seems to be pasted down, try alternating its value contrasts along its edge—dark against light here and light against dark there. This alternation will weave your shape into the fabric of the picture and will energize the entire circuit of the painting.

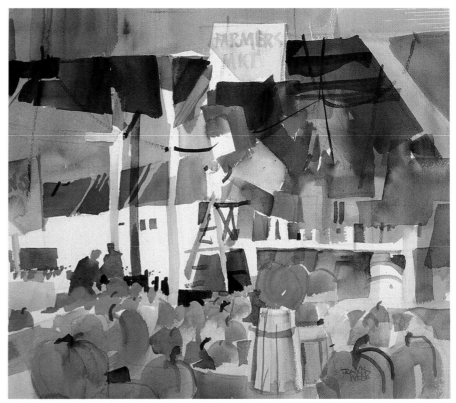

Resemblance. Pumpkin Party, 15" × 22". The pumpkin color at the bottom calls for companions at top left and at other places. Repeats of color should vary somewhat, not only in hue, but in value, intensity, size, and shape.

Alternation. Sunflower II, 22" × 30". All elements alternate here—sizes, colors, values, directions, lines, and textures.

Harmony

If your painting has harsh contrasts, try a little harmony. Harmonious effects are repeats with one or more differences, such as ovals with circles, or blue with green. If the effects of harmonious units are equal, they will cancel each other, so one of the effects must dominate.

Gradation

Examine the large areas of your painting, such as a sky. Is it all one value? Try making it darker at the top and gradually lighten it as it comes down. Now that you've graded the value, can you also gradate the color? Try making the hue more a purple-blue at the top and a green-blue at the bottom. Is your color now all the same intensity? Make it grayer as it approaches the horizon. There are other ways to help your ailing picture with the principle of gradation: from fatter to thinner, from large to small, from vertical to horizontal.

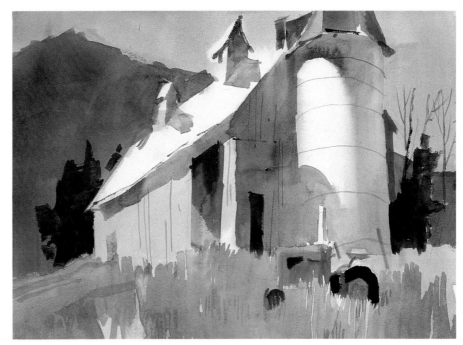

Harmony. Vermont Barn, 11" × 14".
This is a harmony of warm colors. In shape, there is a harmony between the mountain shape and the roof shape.

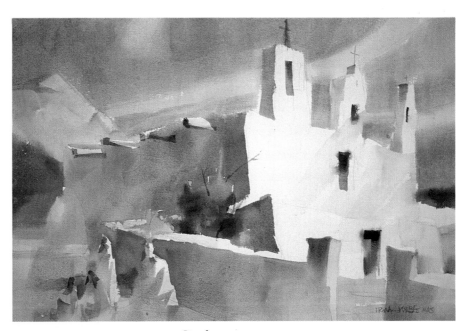

Gradation. Mission, 15" × 22". Gradation here is from warm to cool in the walls, from thick to thin in the streak in the sky.

Balance

If your picture seems to be out of balance, you will feel that in your body. No doubt you feel such a disequilibrirum when you see a hanging picture that needs straightening. Often we need to gain balance by opposing a force with another kind of force, by creating an equivalent force, not a mere duplicate force. For instance, use a color to balance a line, or a texture to balance a shape. Imbalance is disunity. Feel balance with your body's sense of stasis and its kinesthetic sense. Stasis is your orientation in accordance with gravity and the horizon. With your kinesthetic sense you can write your name with your eyes closed. It is also the empathy you feel in your bones and muscles while responding to gestures in a painting. These are your sixth and seventh senses, respectively. The viscera are also involved as you behold spatial effects in a painting. We read paintings with the whole body.

Design devices

Now that we have considered the eight design principles, here are a few more devices to keep our work out of the clinic.

Format

Your subject dictates format. A beach scene is a horizontal while a waterfall could be a vertical. The format should express the subject even before you paint. The square is a less distinguished format since it suffers from a lack of reverberation of depth to width.

Passage

If you follow around the edge of a value and see at its border an area where the value meets another of the same value, try merging them. Thus, pieces of a painting hold hands; areas are linked together.

Schwartzel's, 1965, 15" × 20", acrylic. Dark values of shade are merged at the lower right. The lighted garage door merges with a value on the ground. If I were drawing this today I would avoid making the elm tree trunks so regular in their position. That's the way they were, but nature is not in the picture-making business and I am.

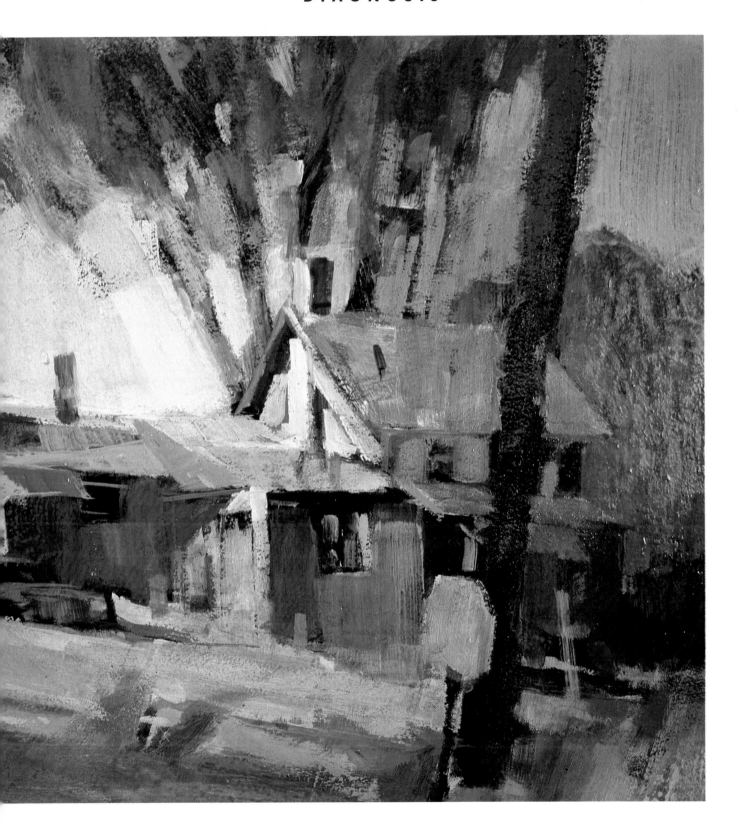

Preview value changes

To visualize a value change try casting a shadow or projecting a light onto a part of your painting. Or, you can place colored papers on areas to preview changes. A piece of Plexiglas or acetate can be placed over the painting, and you can paint on it with watercolor if you include a little soap in the water.

Scrub out

A failed painting can be soaked and scrubbed with a bristle brush while under water. Let it dry and repaint with modifications. Or, turn it around and use the now abstract pale image for an underpainting. Its faint colors will usually add interest to the final effect.

Yin-Yang

An overall interlocking of your picture will hold it together so that two teams of horses could not pull it apart. This yin-yang can be spawned by shapes of values, or colors. It is not necessarily limited to objects, since values and colors often bridge between objects.

Edge

Along any long line or edge, create an incident to interrupt or cross behind that edge. This integrates the edge and cures monotony.

Last resort

If you now have an absolutely failed painting, try using its carcass. Make a two-inch square opening in a mat board and move it around on the surface. Find exciting abstracts, cut them out and mount them on cards. One painting might yield two dozen of these.

Finish

A work is finished and perfect not when it is highly detailed, but when there is not a stroke too much or too little. It must be perfect in the man-

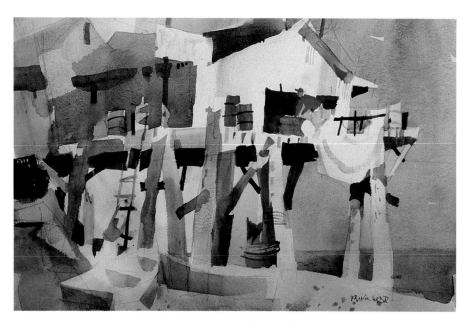

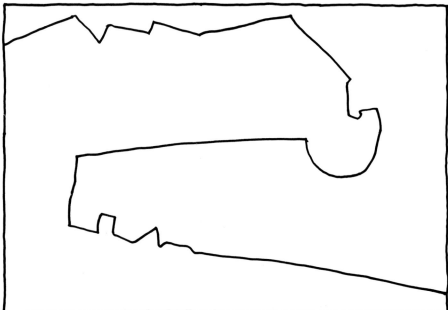

Yin-yang interlocking can be made of color, shapes, objects, values, or textures. When joined in this manner your picture will hold together.

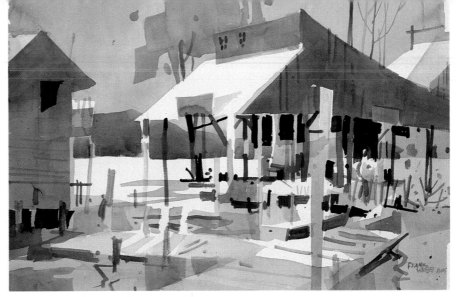

ner of all its parts playing their proper roles in the whole. Thus defined, a work of art is judged by its internal qualities and relations. This judgment is made by use of the principles of design.

To sum up the criticism of a work: Any painting is a bad painting when a part becomes more interesting than the whole. Over-attention to detail spawns confusion and chaos—the opposite of design. In good art the part will always be sacrificed, re-shaped, or combined for the sake of the whole. Over-concern with technique, propaganda, copying, and cloying sentimentality also leads to the corruption of art. An individual work of art must be true to itself.

Get a good book on design. Then read, mark, study, and inwardly digest design until it becomes part of your bone and marrow. Inept design stunts more careers than poverty or obscurity.

Any artist trusts his eyes to make judgments as he paints. More important than making the right decision is knowing why that decision is right in a particular picture. Mastery of design principles enables the artist to create bonds before and during the execution. To be able to create bonds at will is the most coveted ability to be earned.

You are the maestro posed before a complete orchestra in which is posited all possible sounds and intervals.

To create a vision of the harmony of the unequal, balance the infinite variety, the chaotic, the contradictions—in a unity.
—Hans Richter

Smith Mountain Lake, 15" × 22". Check any edge in this painting and see how it is overlapped or has something projecting from beneath it. These edges weave the picture together. This warp and woof is something that comes from you.

Found abstracts cut from realistic paintings. I sometimes paste one of these near my letterhead. I hope the recipient enjoys getting an original mini abstract.

139

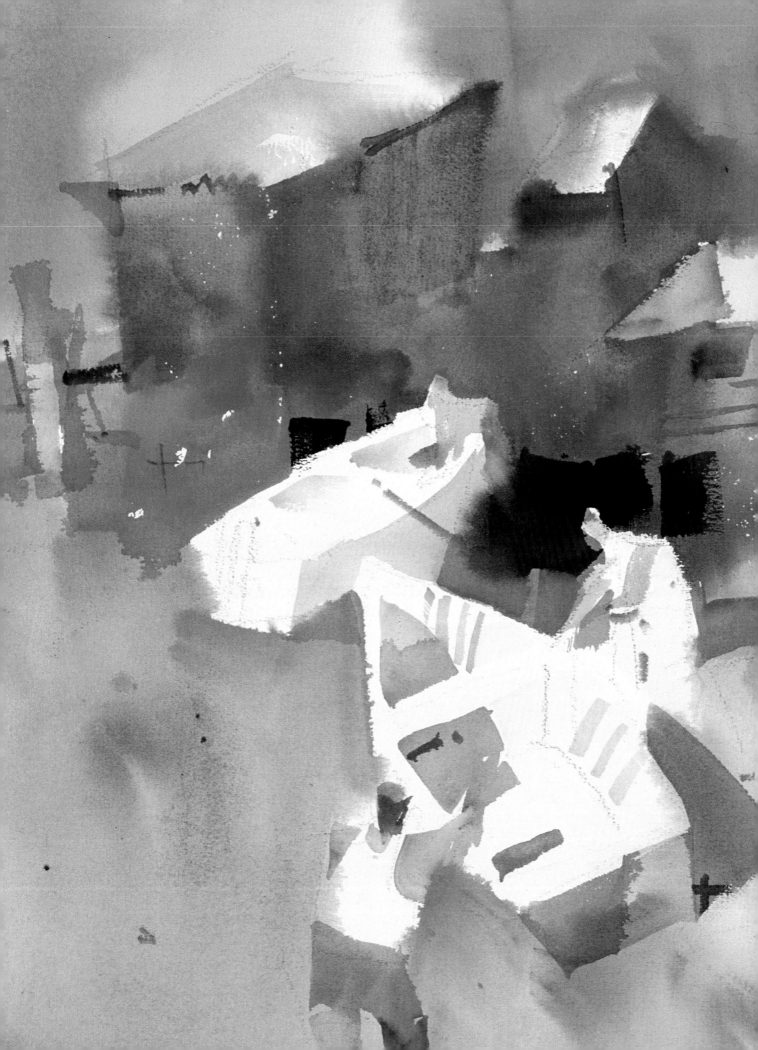

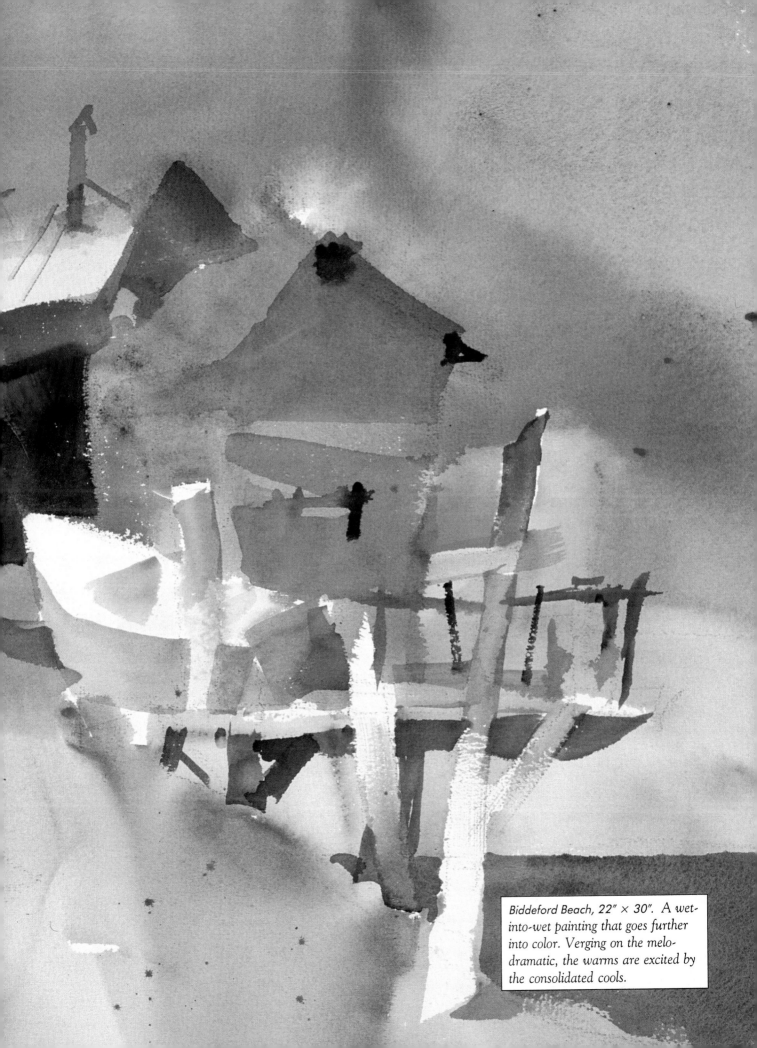

Biddeford Beach, 22" × 30". A wet-into-wet painting that goes further into color. Verging on the melodramatic, the warms are excited by the consolidated cools.

PHILOSOPHY

Theories of art abound. The last hundred years have seen mighty engines of aesthetic propaganda telling us what to admire and whom to extol. Since the days of Cubism, it has seemed that art must be explained.

In all this confusion an individual painter needs a place to stand while opposing ideas and practices rage around. Philosophy is a framework from which one might choose appropriate conduct, formulate goals, and intensify and enjoy life. With mass production, mass marketing, and mass media, it seems all the more obvious that the artist needs to be independent of pressure groups and have the courage not only to say "no" to superficial values but to say "yes" for his or her own emotions, thoughts, and creative actions.

Creativity

Creativity has much to do with choice, will, medium, temperament, habit, training, and most of all, desire. I often say to students "All of you who want to be more creative hold up your hands." All hands go up.

From the world of actuality, creativity transforms conditions as they are into conditions as they could be, and even further to conditions as they ought to be. You create only when you bring forth something that was not there before. What is that something in a painting? Very simply, it is qualities and relationships within the four borders of an individual, indivisible drawing or painting.

In recent years we have seen increased attention to creativity, especially as it might apply to management and to the technological fields. Applied psychologists have written hundred of articles dealing with

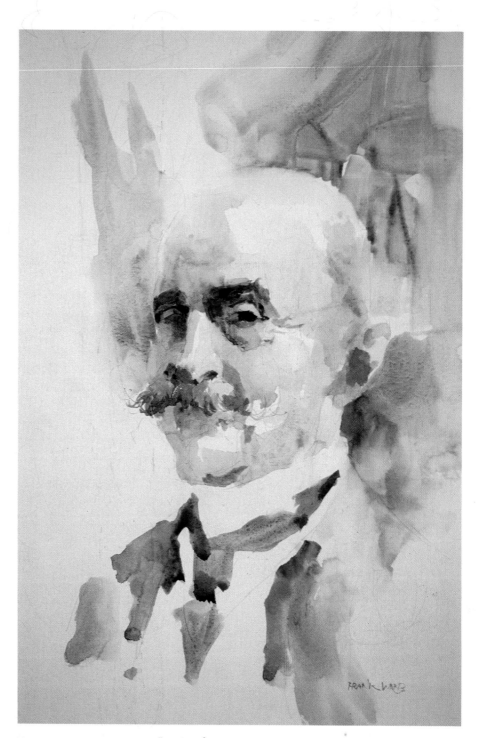

Happy Homer, 22" × 15". I painted on hot press paper with round brushes, life size from a photo. When Winslow Homer moved to Prout's Neck, Maine, in 1883, he said, "The sun will not rise, or set, without my notice, and thanks."

142

understanding creative production, process, and behavior. Left brain, right brain theories have proclaimed the separation of artistry and logic. But the field of psychology still cannot claim to have a comprehensive understanding of the creative act.

Creative behavior is not even defined consistently. Some of the various definitions follow:

- The production of ideas.
- Apprehension of possibilities.
- Response.
- Problem solving.
- Problem finding.
- A collaboration with a work of art.
- An attribute of the personality.
- Occupational adroitness.
- A sudden fusion of two schemata.
- To change context and adapt.
- A reorganization of existing elements within an indeterminate fullness.
- Destroying one gestalt in favor of another.
- The conscious adjustment of the new and the old.

The Creative Vision: "A Longitudinal Study of Problem Finding in Art" by Getzels and Csikszentmihalyi, describes how art students solved a series of problems. They reached some interesting conclusions about the creative process. First, how the students defined the problem for themselves was as important as finding the solution. Some spent more time considering possible interpretations of the problem before seeking solutions, and in general, the longer the problem remained in question, the more creative and original were the solutions. Creativity and originality resulted from the redefinition and restructuring of old ideas, particularly when the artist approached the problem with no preconceived solution in mind.

Creative people are similar to children. They have not yet learned to not care too much. Just as creativity is the establishment of a context for a work of art, so this discussion on creativity is an exhortation for each of us to live our whole lives more creatively.

Creation is a possibility only when there are options, and options are available only in freedom. Each creative action risks failure. Attitudes that inhibit creativity include the wish to avoid anguish and the wish to avoid work.

The aim of creativity is to create another reality. A reality in which the mind can dwell, where desire is satisfied, where the hitherto unknowable is given form. Here everything is in its perfect order.

I demanded a realm in which I should be both master and slave at the same time: The world of art is the only such realm.

— Henry Miller

Those of us who draw and paint can put creativity into everyday practice, here and now. We can simply start to make our own shapes, lines, values, colors, sizes, directions, and textures. This is "on the job" training. It begins with the encounter and it is forged out of the commitment of the artist to the work to be made. Making the work is the result of love and skill.

Creativity is within your grasp. It is to be found not on cloud nine but on your paper as you begin to make your own shapes, your own values, and your own color. It means you being you, thinking your own thoughts, and responding to what you feel. There is no need for you to go abstract or realistic if either of these is uncomfortable for you.

The first step in making your own shapes, values, and color is to want to. So often we resort to a model-bound passive acceptance of what we see when the possibilities are endless. We take a giant step when we commit ourselves to making our own shapes, values, and color despite the tyranny of the model.

Catskill Mountain Post Office, 15" × 22".
A calligraphic painting with a blue color
dominance. The figure entering the door
adds interest and color.

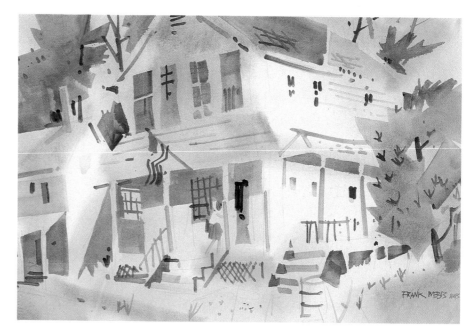

Fruit at Five o'Clock, 15" × 22". Cast
shadows tie these separate pieces to-
gether and initiate color and value con-
trast. Notice how these spherical vol-
umes are expressed with bits of straight
line. This helps avoid flabbiness.

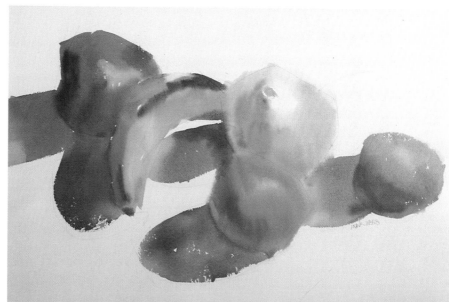

Abandoned Village at The Dalles, 11" ×
15". A distant view with size domi-
nance given to the hill. Each picture
should have a size dominance and a
color dominance to distinguish it from
all other pictures.

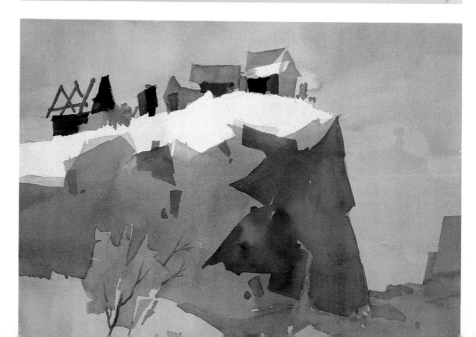

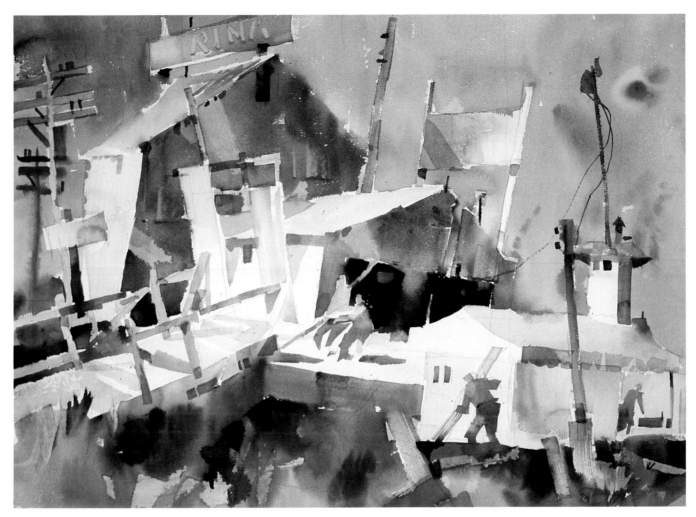

Faust Marina, 22" × 30". The subject was given a little more tension by deliberately tipping the riverside buildings. Floating buildings offer a natural excuse to angle or tilt shapes.

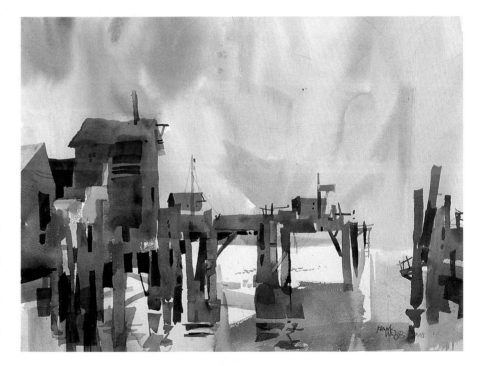

Sam's Place, 22" × 30". A wet-into-wet sky was allowed to dry. Then a burnt sienna shape was slapped in with a large brush. Into that hard-edged, still-wet wash I charged intense colors and dark values. To dramatize the warm dominance, I had earlier placed cool washes to diffuse in the warm sky washes.

With historical and philosophical insights you can see with a thousand eyes. The following quotations echo and articulate felt realities.

This is true of all art; the ennui of living and willing ceases at the door of every workshop.

— Jacques Maritain

The secret of great art — to rob the moment of its impermanence.

— Ivan Lissner

The philosophy which is so important in each of us is not a technical matter; it is our more or less dumb sense of what life honestly and deeply means. It is only partly got from books; it is our individual way of just seeing and feeling the total push and pressure of the cosmos.

— Will James

I had to learn to think, feel, and see in a totally new fashion, in an uneducated way, in my own way, which is the hardest thing in the world. I had to throw myself into the current, knowing that I would probably sink.

— Henry Miller

In the ultimate sense, the world itself is pregnant with failure, is the perfect manifestation of imperfection of the consciousness of failure . . . the artist expresses himself by and through imperfection. It is the stuff of life, the very sign of livingness.

— Henry Miller

I had learned to harness ignorance with presumption. I was ready to become an unacknowledged watercolorist.

— Henry Miller

The way of a creative mind is always positive, it always asserts; it does not know the doubts which are so characteristic of the scientific mind.

— Naum Gabo

No passion so effectively robs the mind of all its powers of acting and reasoning as fear.

— Edmund Burke

Photography does not create eternity as does art. It embalms time and rescues it from its proper corruption.

— A.D. Coleman

Who told you that one paints with colors? One makes use of colors, but one paints with emotions.

— Chardin

Chase taught them to use their eyes, Henri to enlist their hearts, while Miller insisted that they use their heads.

— Rockwell Kent

Utterly disregardful of the emotional values which Henri was insistent upon, the contemptuous of both the surface realism and virtuosity of Chase, Miller, an artist in a far more precious sense than either, exacted a recognition of the tactile qualities of paint and of the elements of composition — line and mass — not as a means toward the recreation of life but as the fulfillment of an end, aesthetic pleasure.

— Rockwell Kent

The beginning and end of all literary activity is the reproduction of the world that surrounds me by the means of the world that is in me, all things being grasped, related, created, moulded and reconstructed in a personal form and original manner.

— Goethe
(carried in Hopper's wallet)

I believe that the great painters, with their intellects as master, have attempted to force this unwilling medium of paint and canvas into a record of their emotions. I find any digression from this large aim leads me to boredom.

— Hopper

Nothing in the world can take the place of persistence. Talent will not; nothing is more common than unsuccessful men with talent. Genius will not; the world is full of educated derelicts. Persistence and determination are omnipotent.

— Calvin Coolidge

To pursue an interdisciplinary subject is to pursue an echo, since in either case one must be reconciled to endless pursuit and uncertain victory.

— William Charles Libby

What the painter adds to the canvas are the days of his life. The adventure of living, hurtling toward death.

— Sartre

When Van Gogh painted a field, he did not pretend to transfer it to his canvas; he tried, through deceptive figuration whose sole criterion was the dictates of art, to incarnate on a sticky vertical surface the fullness of an immense world with its field and men, including Van Gogh. Our World.

—Sartre

Remember, we're all in this alone.

—Lily Tomlin

It is not by his mixing and choosing, but by the shapes of his colors, and the combinations of those shapes, that we recognize the colorist. Color becomes significant only when it becomes form.

—Clive Bell

The avoidance of pain is the cause of all non-creative work.

—M. Scott Peck

Sick, battered, defeated, home I came and sat and stared with envy at the clock for which dark or bright days are the same and every moment either tick or tock.

—E.A. Whitney

How blessed I am with an inordinate delight in the simple amenities.

—E.A. Whitney

Art is pleasure objectified.

—E.A. Whitney

The passion of the human soul for the wayward, the irregular, the unexpected, the miraculous.

—Jacques Barzun

The first impression of a work of art is its otherness from reality.

—Suzanne K. Langer

The fastest way to make enemies is to be competent.

—Alexander Pope

And then I began to realize that however professional my work might appear, even however original it might be, it still did not contain the central person which, for good or ill, was myself.

—Ben Shahn

Conception is the choice, the decision, of which emotion to transmit. Composition is the choice of means capable of transmitting this emotion.

—Le Corbusier

It is not the worldly eclecticism of knowledge of many things that enriches, but perserverance in a favorable furrow and loving, silent effort of a whole life.

—Rouault

Color is the fruit of life.

—Apollinaire

To think effectively in terms of relations of qualities is as severe a demand upon thought as to think in terms of symbols, verbal and mathematical. Indeed, since words are easily manipulated in mechanical ways, the production of a work of genuine art probably demands more intelligence than does most of the so-called thinking that goes on among those who pride themselves on being 'intellectuals.'

—John Dewey

Watercolor condenses time and consolidates experience.

—Frank Marcello

In our minds are ideas, before our minds are objects.

—Mortimer Adler

In the last analysis don't mind whether your work is good or bad so long as it has the completeness, the enormity of the whole world which you love.

—Stephen Spender

Art is a form of supremely delicate awareness and atonement—meaning atoneness, the state of being at one with the object.

—D.H. Lawrence

Sometimes I feel like I'm a piece of sculpture that's being chipped till I'm becoming myself.

—Nat Youngblood

I paint only because I love to cut mats.

—Arthur Alexander

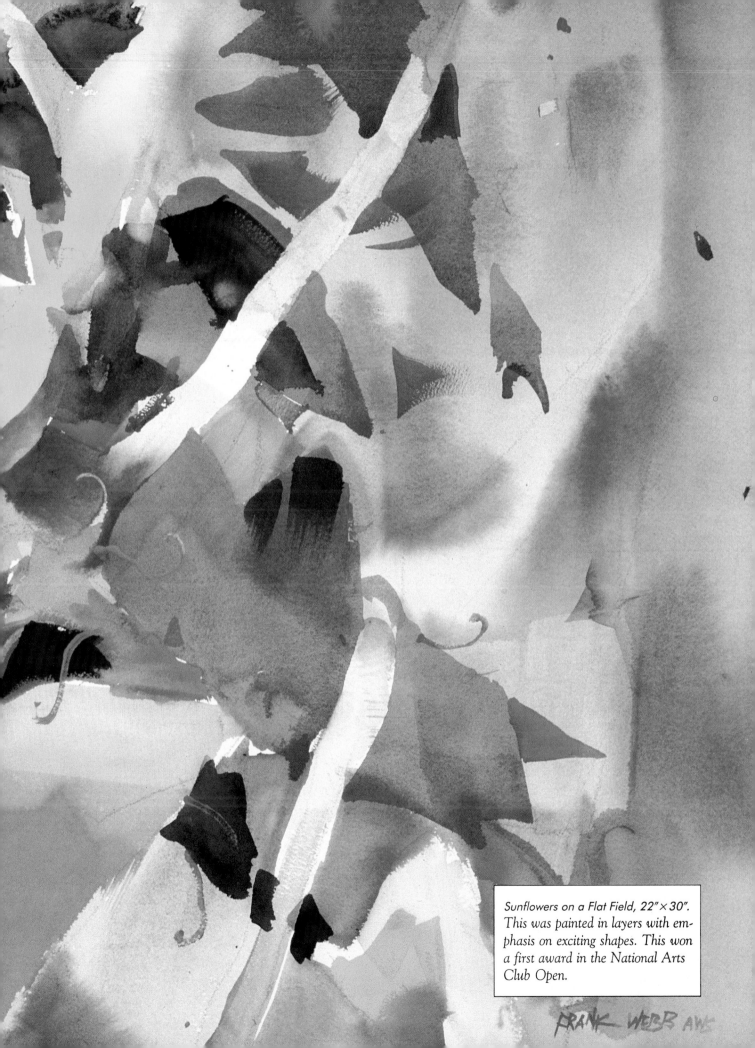

Sunflowers on a Flat Field, 22" × 30".
This was painted in layers with emphasis on exciting shapes. This won a first award in the National Arts Club Open.

FRANK WEBB AWS

EPILOGUE

I look upon this book as a collaboration. I have said these things not only because I believe them useful to you but to affirm and encourage my own study. An art career is not built by taking answers from a teacher, but by formulating your own questions. We must each settle these things for ourselves. Your own vision must be cherished and communicated. It is a very personal matter. My job is not to become Sargent or Homer but to become Webb as he should be. Yours is to become you. Let us both rejoice in the wonder of ruminating on art, for this matter of putting things together with deep appreciation—love—is a high and noble calling.

We each have an obligation to build a bridge from the world outside us to the world inside us.

Soli Deo Gloria!

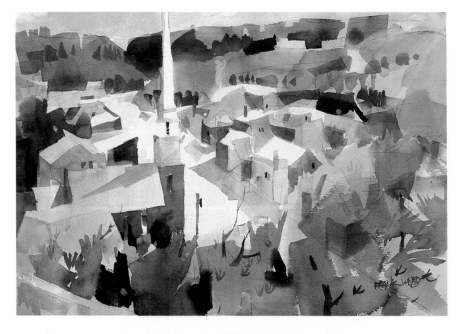

Index